MODERN CALLIGRAPHY BIBLE

SCHIFFER
PUBLISHING

4880 Lower Valley Road • Atglen, PA 19310

TABLE OF CONTENTS

INTRODUCTION by
FREDERIC CLAQUIN

France

[image] @publicdomain.paris

TRACKLIST:
Souls of Mischief - *93 'Til Infinity*
James The Prophet – *Unimaginable Storms*
Miles Davies – *Kind of Blue*
A Tribe Called Quest - *The Anthology*
Hans Zimmer – *Live in Prague*

Writing is the foundational element of civilizations. Indispensable for the hierarchy of societies, communication, and transmission of information, religions, knowledge, and even commerce. It is one of the first art forms that each of us comes across. Not everyone is necessarily an artist, but everyone (or almost everyone) has access to learning of writting. And once this knowledge has been acquired, it is up to everyone to be able to appropriate it and integrate their DNA and their style into it. A simple sentence, in its form, can be a piece of art.

This book presents, for the first time, the art of more than 100 international artists whose work has to do with the alphabet and the letter, creating artworks and interpretations around traditional or imaginary alphabets.

You will discover a selection of international artists from the world of graffiti, tattooing, graphic design, painting, illustration, poster art, and comics. Each artist will present their graphic interpretation of this series of signs that allows us to communicate. Whether it is the central piece of a work or an element integrated into a visual, a drawing, the letter, the words, the message, the title are distinctive and often essential elements of an artistic work.

At a time when communication is achieved mainly by screens, with voice, or by using a keyboard, it was interesting to revive and evolve this magnificent system of communication and organic transmission that is at the base of our modern civilization.

ADAM COCKERTON

London, United Kingdom

@adamcockertonart

TRACKLIST:
Blondie - *Eat to the Beat*
The Police - *Outlandos d'Amour*
AC/DC - *Back in Black*
Ramones - *Ramones*
Herbie Hancock - *Thrust*

Adam is an art director who has been working for the entertainment industry for over a decade. He's a relative newcomer to illustration. As he says: I just know I need to draw more; it fills a gap in the creative process that is often overlooked with client work.

Adam has had a passion for the illustrated poster for longer than he can remember. The cinema in his town used to keep quads stacked up in a locked cupboard. As a ten-year-old he used to find a way in through an open window and borrow them!

He'd collected some of the finest movie poster art he could get his hands on. Much later, he'd find out that he had art by my design heroes Bob Peak and Drew Struzan—and boom: hooked. Who says nothing comes of a misspent youth!

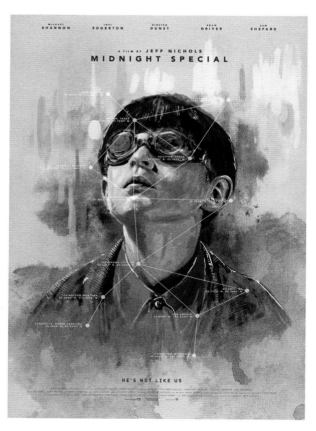

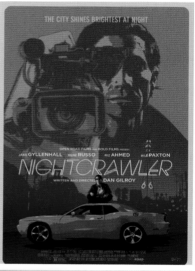

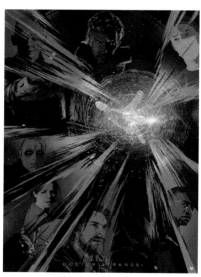

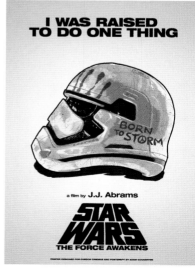

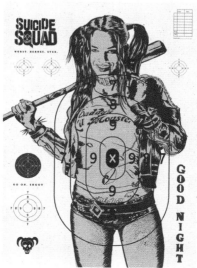

QBoY

ABCDEFGHIJK
LMNOPQRSTU
VWXYZ &$*?!
123456789

ALEX RICO

Izhevsk, Russia

📷 @alekseyrico

TRACKLIST:
Rammstein - *Deutschland*
Rage Against the Machine - *The Battle of Los Angeles*
Horus - *Рифмономикон*
Muse - *Simulation Theory*
3FORCE - *Divide & Collide*

Aleksey Rico, real name Aleksey Soloviev, is an illustrator based in Izhevsk, Russia. Obsessed by smooth lines and other vectorized curves, he creates magnificent posters in which we find the modernity of vector art while keeping this tone and colors specific to Russian cultural identity and iconic Soviet propaganda posters.He started at the age of 14 with graffiti but soon understood that it was paper that attracted him, not walls. So he studied graphic design at university.

In 2004 he started making alternative posters for his friends' events, working on logos, brand identities, and album covers. Aleksey really loves video games, movies, and music. He has a true geek side. He particularly appreciates projects related to music because that is, for him, a special exercise to interpret a sound or an atmosphere, to transform music into a graphic form. In the ARTtitude collective, he took part in various projects in the field of video games, and his posters were exhibited during the 2017 and 2018 editions of Paris Games Week. He is also known in his country for having collaborated on projects related to the world of skateboarding and snowboarding. His works are exhibited in first-rate galleries: Creature Features Gallery and Bottleneck Gallery. Don't be fooled by his youthful appearance—this young artist can quickly become the Ivan Drago of vector art for years to come!

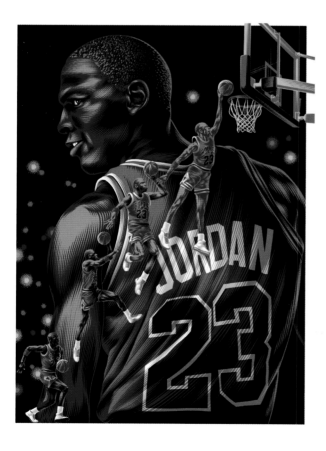

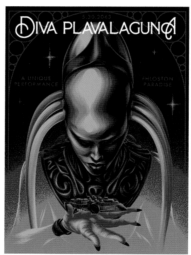

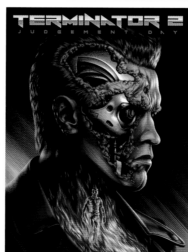

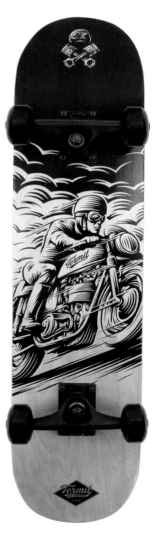

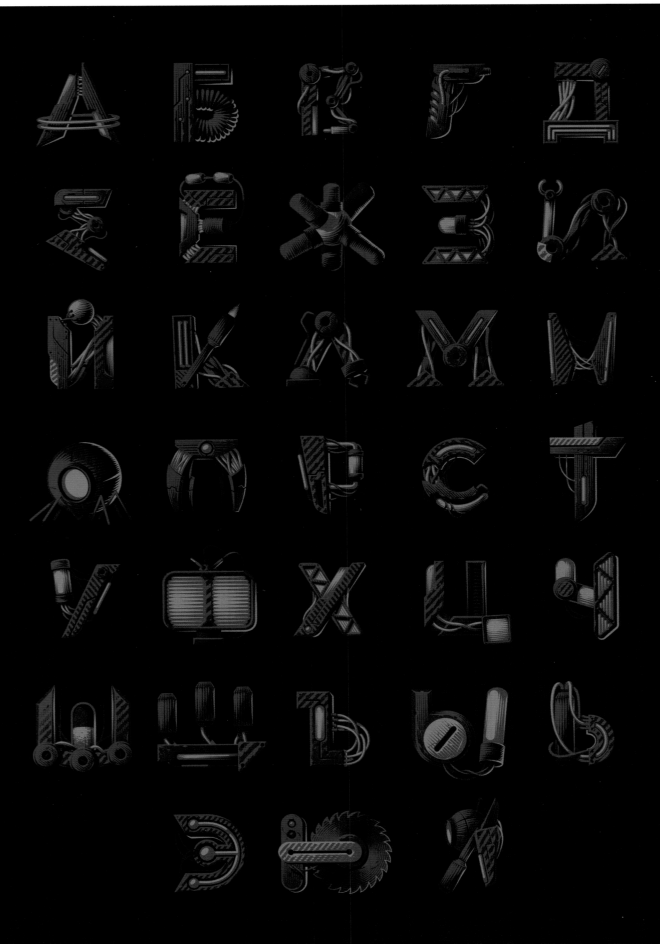

AROE

Brighton, United Kingdom

📷 @aroe_heavyartillery

TRACKLIST:
Clipse/Re Up Gang - *We Got It 4 Cheap Vol. 2*
Gza - *Liquid Swords*
D'Angelo - *Brown Sugar*
Apollo Brown & Guilty Simpson - *The Dice Game*
Sean Price - *Monkey Bars*

A true graffiti legend, Paul began with the arrival of breakdance in England around 1983. He thinks graffiti is the best and the worst thing that has ever happened to him, but he admits that he cannot imagine his life without it. Graffiti was the answer to his attention problems; everything he did seemed too slow until he found spray cans. Then his ideas could come at the speed of his thoughts, and he began to find an identity that made sense to him. At first he had fun with the notion of vandalism around this scene. It was exciting for him, the forbidden, the challenge. Over time his approach changed; he applied himself to making beautiful pieces, and the view of the public changed at that time. Is a very beautiful piece, placed illegally on a train (for example) still vandalism? Is it still a crime if it's beautiful? For him, graffiti is one of the last real acts of rebellion in today's society. It is also the only way for an isolated individual to make his voice heard. For Paul, a great music lover, graffiti works like rap: we take bits of things that we reclaim—that we sample, transform, tweet—in order to come out with something new. His inspiration comes from the classic New York scene, Berlin at the end of the 90s, the wild style of the US West Coast, the 2000s, the skateboard scene etc. Everything goes through his mental blender and comes out with a personal and highly consistent style.

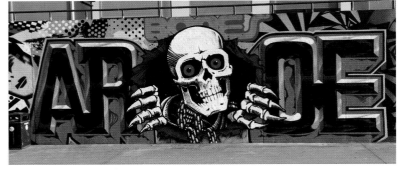

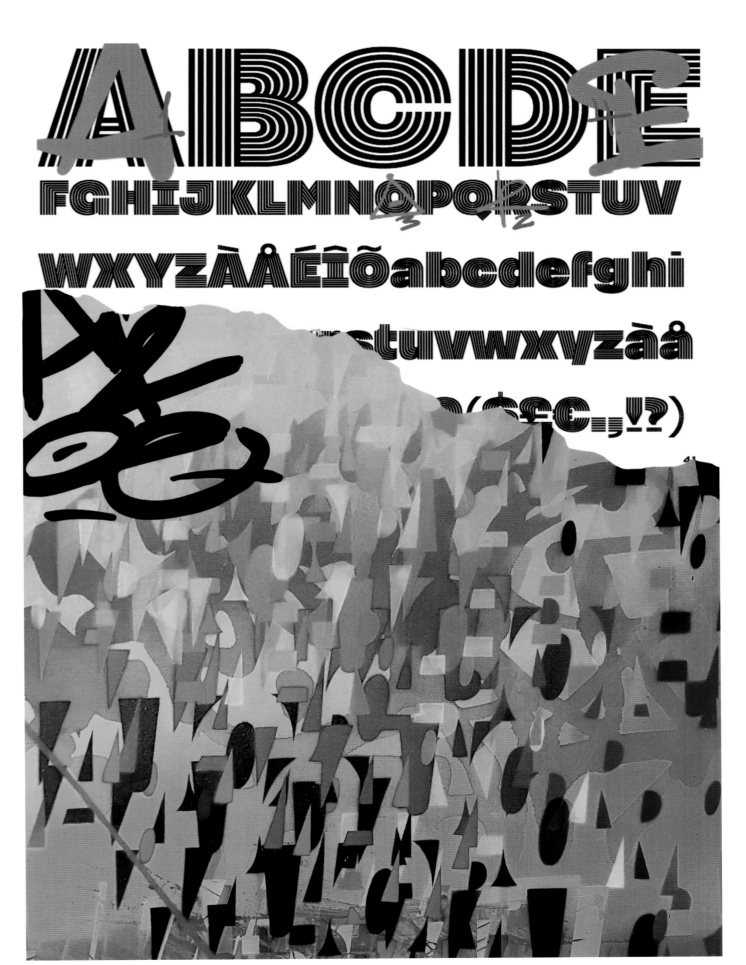

ABCDE
FGHIJKLMNOPQRSTUV
WXYZÀÀÅÉÎÕabcdefghi
rstuvwxyzàå
(§£€.‚!?)

ASROTH

ASROTH

Reims, France

📷 @asroth_fred

TRACKLIST:
Rammstein - *Sehnsucht*
Seiji Yokohama - *Saint Seiya soundtrack*
Daft Punk - *Random Access Memories*
Cecile Corbel - *Arrietty's Song*
Stromae - *Racine Carrée*

Frédéric Tomé, alias "Asroth," was born at the end of the 70s in France, the same year *Goldorak* (UFO Robo Grendizer) was first broadcast on French television. Much later the influence of giant robots and other Japanese animations, such as Saint Seiya, influenced his style and greatly inspirde him through the colors and pop universes that emerge from them. Frédéric took applied arts classes and oriented his early career toward product-packaging design. He then worked as a graphic designer in a corporate agency. In 1995 he discovered video games with Sega's Saturn, and the love story for this new medium began. He worked locally for Activision, producing press kits, then with Pix'N Love and Third Editions, both French art-book publishers focusing on video games contents. His local fame allowed Fred to later work with OrdiRetro and various other players from the industry. His posters were showcased in Cologne at GamesCom and in Paris at Paris Games Week. He's famous for his fan art but also well known for his drawings.

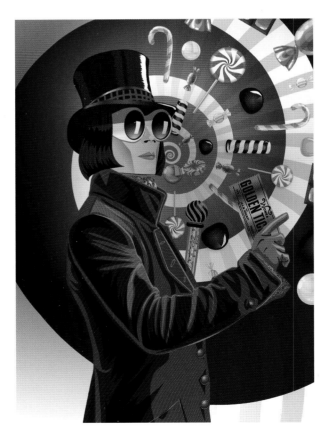

BAD CED

Troyes, France

@bad.ced.international

TRACKLIST:

Dax Riders - *Backintown*
The Clash - *Sandinista*
DJ Koze - *DJ-Kicks*
Public Enemy - *It Takes a Nation of Millions to Hold Us Back*
Derrick May - *Mix-Up Vol. 5*

Cédric Azencoth, a.k.a Bad Ced International, was born in 1969. After a quick stop at the Beaux-Arts in Paris for architectural studies, he quickly turned to painting. He started doing art shows pretty quickly but abandoned brushes for samplers, drum machines, and other synthesizers, plunging into the world of raves and techno in the early 90s. He then joined up with DJ Sonic, one of the very first French electronic music labels, Omnisonus. Among other things, he takes care of the graphic charter: album covers. This led him to turn to computer-assisted graphic design. Computer also allowed him to make and produce music under various nicknames (Oxo, H2O...). After the purchase of Omnisonus by BMG, he left the label to create a new Subscience with his sidekick from Dax Riders (a group he started with Olivier Daxman). The success was immediate: a first album was released by Warner Music (1999), then two others with Universal (2001–2005). It was only after all these years dedicated to electronic music that he devoted himself solely to graphics and painting in 2008. A first series of screenprints, Authentik Fake (real fake vintage film posters), was born and exhibited in the Art Jingle gallery. It marked the start of a new international adventure for Bad Ced, who now spends his time between vintage posters, paintings, and drawings.

17

BAHIA SHEHAB

Cairo, Egypt

@bahiashehab

TRACKLIST:
Cesaria Evora – *Best Of*
Nina Simone – *Best Of*
Sheikh Imam – *Best Of*
Souad Massi – *Best Of*
Ziad Rahbani– *Best Of*

Bahia Shehab is a multidisciplinary artist, designer, and art historian. She is a professor of design and founder of the graphic design program at the American University in Cairo. She frequently lectures internationally on Arab visual culture and design education, peaceful protest, and Islamic cultural heritage. Through an investigation of Islamic art history, she reinterprets contemporary Arab politics, feminist discourse, and social issues. Her artwork has been on display in exhibitions, galleries, and streets in over 26 cities internationally. The documentary *Nefertiti's Daughters*, featuring her street artwork during the Egyptian uprising, was released in 2015. Her work has received a number of international recognitions and awards, including a TED Senior Fellowship, the BBC 100 Women list, and a Prince Claus Award. She is the first Arab woman to receive the UNESCO-Sharjah Prize for Arab Culture. Bahia holds a PhD from Leiden University in the Netherlands and is the founding director of Type Lab@AUC. Her publications include *At the Corner of a Dream*, *A Thousand Times NO: The Visual History of Lam-Alif*, and the co-authored book *A History of Arab Graphic Design*. Her latest publication, *You Can Crush the Flowers: A Visual Memoir of the Egyptian Revolution*, marks the ten-year anniversary of the uprising.

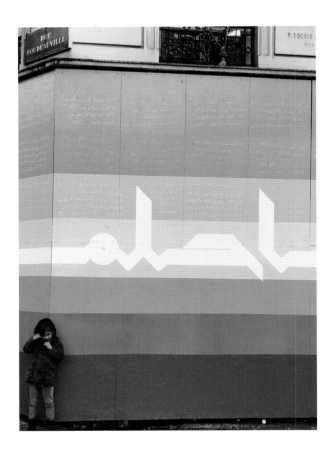

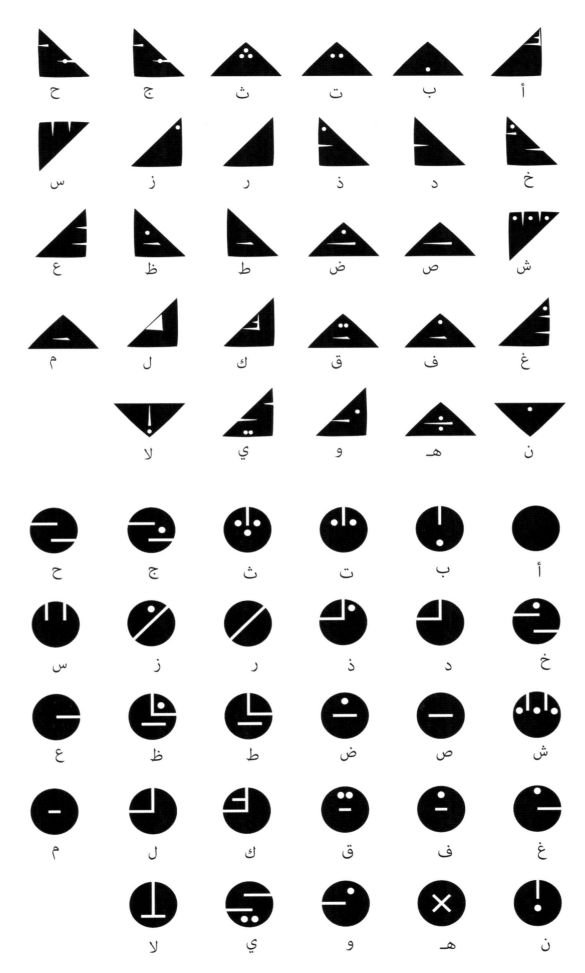

BERNIE DAVE

London, United Kingdom

@berniedave

TRACKLIST:
The Killers - *Hot Fuzz*
The Strokes - *Angles*
Daft Punk - *Random Access Memories*
The Shins - *Wincing the Night Away*
Gorrilaz - *Plastic Beach*

For as long as he can recall, Bernie has been fascinated by films and film posters. Growing up in Warsaw, Poland, in the 80s, he still remembers artworks on the streets from the Polish School of Posters, when under the Communist regime Polish artists created beautiful works of art for commercial films. Later in life, when he was studying graphic design in London, Bernie had an epiphany: that he could be a film poster designer! He has experience working in the entertainment industry for nearly a decade. Recently, he wanted to develop his own voice and started creating alternative movie posters, mainly as part of competitions. His posters were exhibited in London, Paris, and Los Angeles. Style-wise he's exploring more and more a polygon or just an angular design, because he really likes the idea of simplifying the form as much as possible while still conveying the essence of the movie. His other passion is video games, especially those you can only describe as interactive movies: cinematic, story-driven, and engaging experiences. Bernie used to be a video game reviewer. Nowadays he occasionally writes an article on his blog, where he talks about video games from a design perspective.

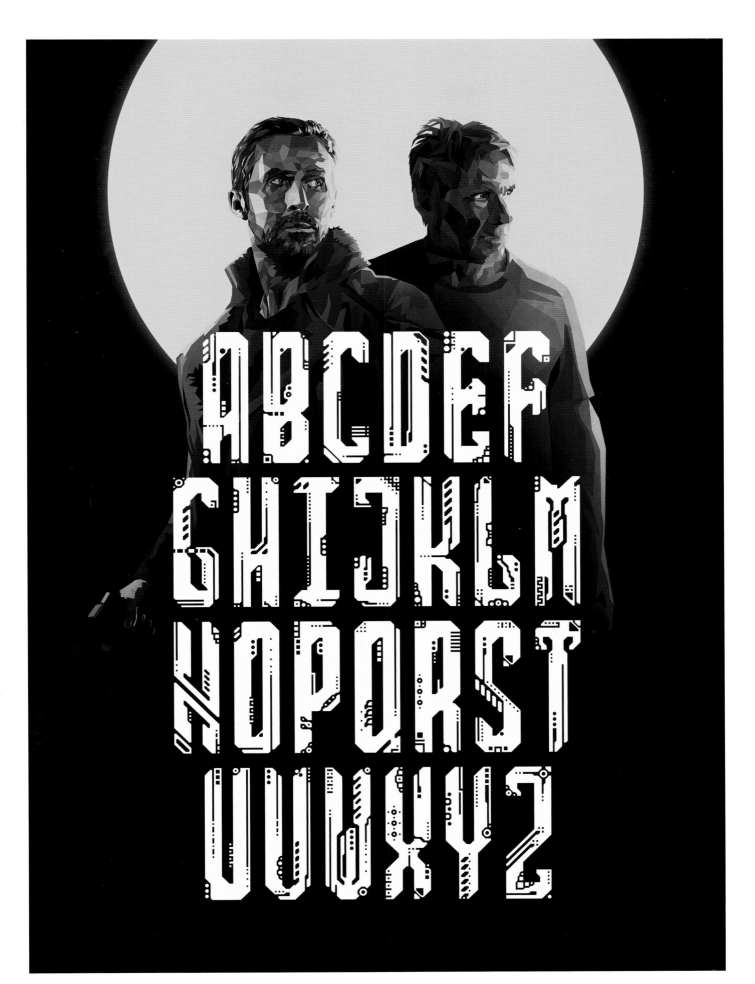

BRETT PARSON

Mill River, USA

@blitzcadet

TRACKLIST:
Something Weird Greatest Hits - *Various Artists*
Mudhoney - *Superfuzz Bigmuff*
Thee Oh Sees - *Carrion Crawler / The Dream*
T Rex - *Electric Warrior*
Iggy Pop and James Williamson - *Kill City*

Brett "BlitzCadet" Parson is a Massachusetts-based cartoonist. He is best known for his work on multiple Tank Girl titles with original writer and co-creator Alan Martin. He has also worked with DC/Vertigo, Boom!, 2000 AD, Albatross Funny Books, Warner Bros. Animation, Dream Works TV, Sony Music, ARTtitude, and more. His universe is made up of cult movies, comics, Saturday morning cartoons, and all the culture revolving around it. His style is recognizable, with a subtle balance between the lines and colors. It's retro, pop, kitsch; it smells like 80s sci-fi, beer, and popcorn. Everything that made the Gremlins, Ghostbusters, and Goonies generation together in a single pencil stroke! It's a great mix of Troublemakers Studio and Creepshow. Brett has been drawing since he was old enough to hold a pencil. He's always found it hard to get passionate about anything other than drawing. He even became obsessive to the point of wanting to make a living from it and one day to see his name on the cover of a comic book. His only motivation is, and it's laudable, to have fun!

When not drawing comics, Brett is hanging out with his family, eating pizza, and working on their old house.

ABCDE

FGHIJK

LMNOP

QRSTU

VWXYZ

BRISK ONE

San Diego, USA

 @briskone

TRACKLIST:
Mobb Deep - *The Infamous*
Sade – *Best Of*
PRhyme - *Royce 59 and DJ Premier*
Freddie McGregor - *Big Ship and Barrington Levy - Poor Man Style*
Runner Up: Planet Asia and Apollo Brown - *Anchovies*

Brisk One is a San Diego–born artist who has been painting for over 30 years. Studying under the masters, he feels he has been given the knowledge and wishes to carry on tradition. Traveling to different countries and painting large-scale murals with many other artists has given him the experience to expand his current view and take his art to the next level. His work is a diary of over three decades of practicing, perfecting, and evolving letterforms. For him, there is a beauty in taking letters and exploding them into something that is futuristic. Taking what people know as graffiti and evolving it, chopping it and abstracting it into something that has a new life of its own. He completely understands that the word *graffiti* may have controversial connotations, but he's trying to shed light on an art that has saved his life and given him a voice. Brisk is taking letterforms and deconstructing them, adding flowing brush- or spray-can strokes to create movement and vibrant colors that may represent futuristic cities, sunsets, or galaxies in outer space.

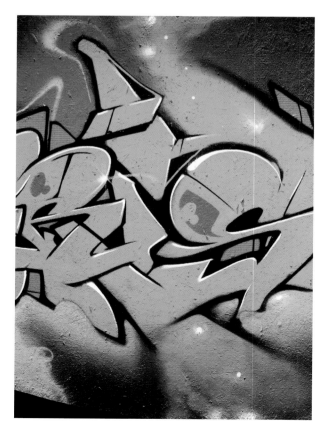

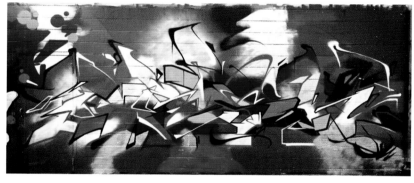

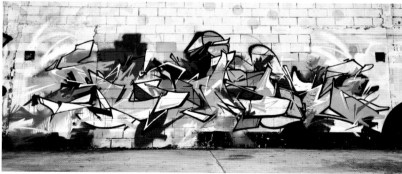

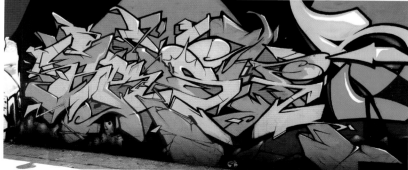

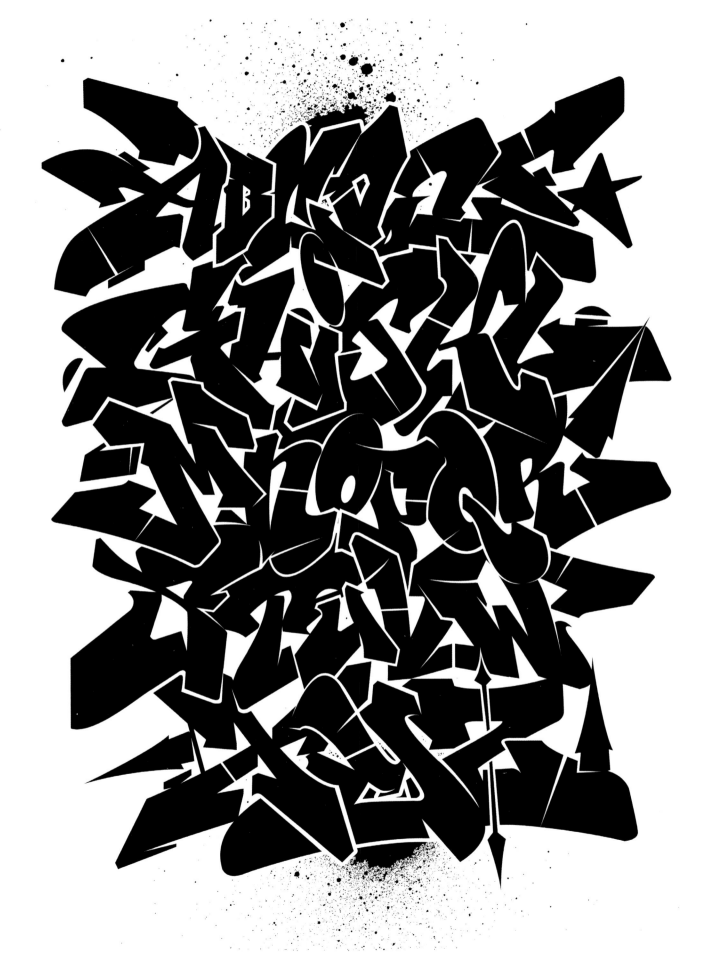

BRUNO LEYVAL

Mulhouse, France

○ @brunoleyval

TRACKLIST:

Patti Smith - *Horse*
Alejandro Jodorowsky - *The Holy Mountain*
Soundwalk Collective - *The Peyote Dance*
Frank Zappa - *Hot Rats*
Sweet Smoke - *Just a Poke*

Bruno Leyval is a contemporary French artist who explores the complex relationships between cultures, beliefs, nature, life, and death to create an inspired and profound work, imbued with spirituality. He's been drawing since his childhood, almost every day. Drawing became a form of meditation that naturally imposed itself as a spiritual practice and that accompanies his inner journey. Specializing in black and white and Indian ink, his works have been exhibited in London, Berlin, Bristol, Strasbourg, Vienna, and Paris. For Bruno, art has a deep meaning only if it is therapeutic. It contributes to healing, whether emotional or spiritual. Everyone has the power to heal themselves within them. Everyone has the innate capacity to realize themselves and to free themselves from an illusory worldview that originated in the mind. Creativity is a way to access this liberation. When he returned from a trip to India, Bruno drew on his research and his experiences to develop a simple artistic method, based on the energetic act of creating and whose goal is to find a balance between the inner world and outside world.

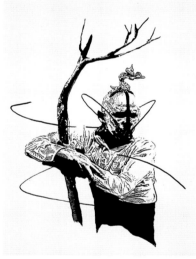

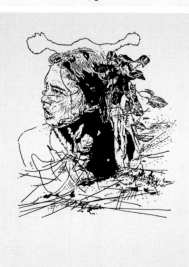

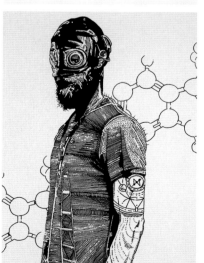

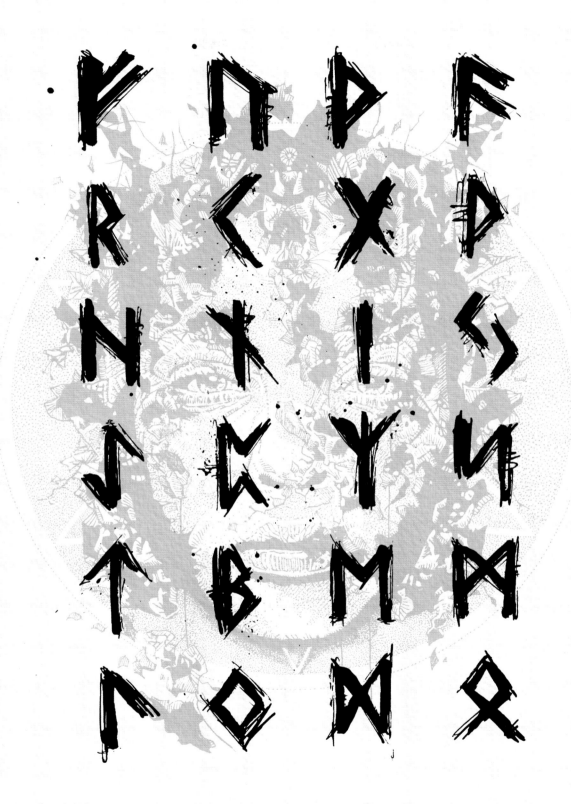

COMBAT BASE

CHRIS HAUETER

Los Angeles, USA

📷 @chrishaueterart

TRACKLIST:
Dean Wareham - *Mistress America*
Barn Owl - *Shadowland*
Cocteau Twins - *Treasure*
Tycho - *Epoch*
Dirty Beaches - *Stateless*

Chris Haueter is a fifth-degree Brazilian Jiu Jitsu black belt and member of the dirty dozen (the first 12 non-Brazilian black belts). Chris was the first American to submit a Brazilian in competiton and the first American to compete as a black belt at the Mundials (World Championship) in Brazil, and he continues to travel the world spreading his Jiu Jitsu philosophy of think street, train sport, and practice art. He is known for his Golden Rules of grappling, coining the term *combat base* as the base with one knee up and one knee down. He says, "It is not about who is good but who is left. It's time on the mat. You will be somewhere in ten years; you might as well be a Black Belt too. Just don't quit." Chris also has a passion for art, history, philosophy, science, and politics. He is a multimedia artist based in Los Angeles. His work includes print and sculpture, and he has shown his art in Los Angeles and Singapore. Much of it pays tribute to his years of martial arts experience.

ABCD

EFGH

IJKLM

NOPQ

RSTU

VWXYZ

CHRIS NOONAN
DESIGN CO.
DESIGN. ILLUSTRATION. BRANDING WIZARDRY.

CHRIS NOONAN

Eagles Wood, USA

@thechrisnoonan

TRACKLIST:
Patti Smith - *Horse*
Alejandro Jodorowsky - *The Holy Mountain*
Soundwalk Collective - *The Peyote Dance*
Frank Zappa - *Hot Rats*
Sweet Smoke - *Just a Poke*

Born into a family where his father played guitar while his mother wrote poetry, Chris is a pure child of the 80s. He grew up with TV cartoons, video games, and action movies; then followed the rise of Japanese animation and skateboarding. This last one was a big thing for him and even his first paid job, working in a skate shop. He loved the graphics for each board company and, most of all, the DIY spirit of this culture. That's when he really started doodling.

Chris began his martial art journey at age twelve, doing karate/kenpo. He even ended up teaching karate but stopped when BJJ and MMA surfaced in the US. He turned to BJJ, training at various places. The year 2013 was one of changes. Among other things he opened his own academy: The Hive Martial Arts.

Chris was a purple belt at the time but did it anyway, with the approval of his teacher, leaving the regular jobs he had. He finally reached brown and black belt. Beside his academy he's also a graphic designer, working with clients and partners such as Monkey Tape, Clean Hugs, and Aesthetic. They pushed him to seriously work on his own brand: Mikoto. This project, beside the Hive, is the perfect way to combine the things he loves: jiu-jitsu, music, contemporary design, typography, vintage logos, badge designs, and tattoo art/illustration.

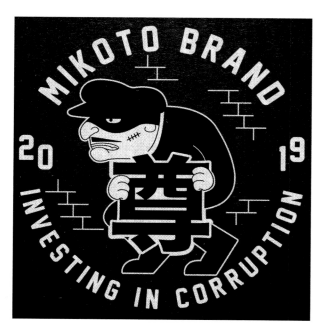

ABCDEF
GHIJKL
MNOPQ
RSTUVW
XYZ

CLEMENT LAURENTIN

Montreuil, France

@clementlaurentin

TRACKLIST:

Public Enemy - *Fear of a Black Planet*
Miles Davis - *Sketches of Spain*
The Jimi Hendrix Experience - *Are You Experienced?*
The Congos - *Heart of the Congos*
Baden Powell & Vinicius de Moraes - *Os Afro Sambas*

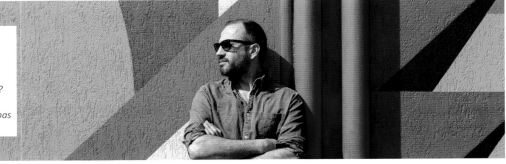

Clément Laurentin was born in 1978. He lives and works in Montreuil. After studying applied arts at the Ecole Boulle, he joined the Parisian collective 9ème Concept in 2001, working as a graphic designer, illustrator, painter, and then artistic director on the group's various projects. Along with his involvement in the collective, he develops a hybrid and cosmopolitan personal oeuvre that is rooted in a childhood surrounded by works of artists from five continents. He retains a visceral desire to embrace all cultures to create his own mixed race, bestowing a benevolent gaze on the world around him. This universalist vision is reflected by the plurality of media, techniques, subjects, and sources. The raw expressiveness of the primitive arts, the formal research of the supremacists, and the simultaneity of the cubists are implicit in his works. He thus approaches portraiture, calligraphy, abstraction, free figuration, or even automatic writing as so many languages that he seeks to master in order to nourish and transcribe this transcultural ideal. Tinted with a strong musicality, his artistic expression takes shape between the head and the heart. He thus composes rhythmic and melodic architectures that leave the field free for a more sensitive and spontaneous writing. Fundamentally humanist, Clément questions the place of the individual and his spirituality within a materialist society. He draws a poetic iconography of it, resolutely turned toward the other.

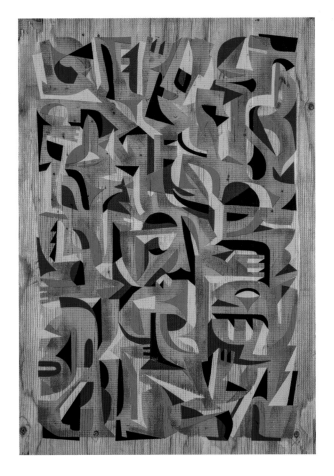

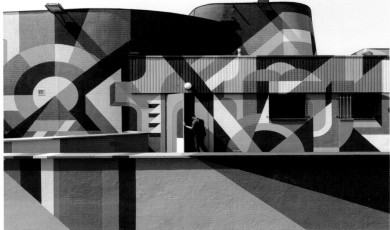

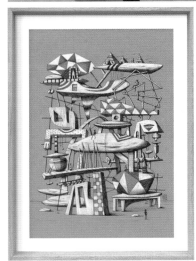

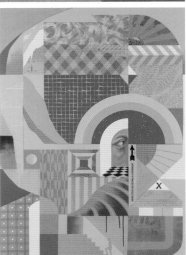

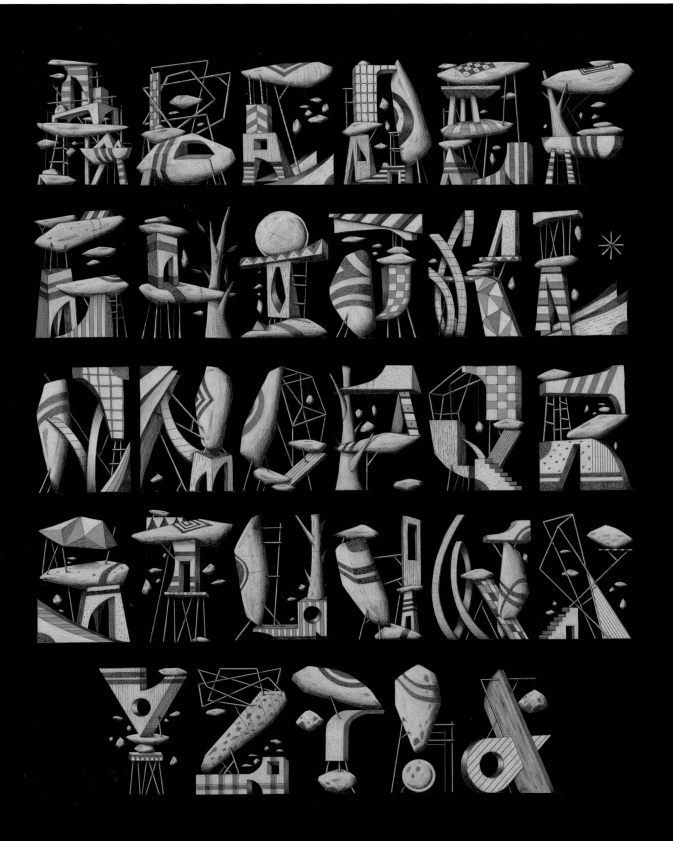

Cranio Dsgn

CRANIO DSGN

Valencia, Spain

@craniodsgn

TRACKLIST:
Lagwagon - *Hoss*
No Use for a Name - *Making Friends*
NOFX - *Punk in Drublic*
Jeff Rosenstock - *No Dream*
The Vandals - *Hitler Bad, Vandals Good*

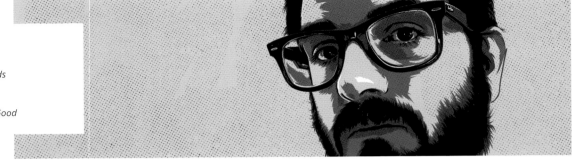

Alex Garcia, aka CranioDsgn, is an illustrator, lover of vector art, and graphic designer with very pop and tangy lines. He works as a freelancer for magazines, fashion brands, and a wide range of studios, agencies, and clients. He has also participated in various exhibitions and collective projects for art galleries. Alex loves working in vector, creating, designing, experimenting, and conveying tastes and hobbies through his works. Born in Valencia, where he studied graphic design and collaborated with various local design agencies and studios, he then decided to pursue a master of digital creation, followed by a one-year residency in Barcelona, where he worked with new agencies and clients. Back in Valcenia, he decided to go freelance, continuing to collaborate with diverse and varied clients and working on more personal projects. His works are presented to the four corners of the planet: Gauntlet Gallery (San Francisco), SoHo Gallery for Digital Art - ArtHouse SoHo (New York), the Mustache Mr Smith (Barcelona), Circuit Illustration VLC, Bakheda (New Delhi), Paris Games Week (Paris) . . . The list of its clients will also inspire envy: Warner Bros, Nike, *Newsweek*, FIFA, Red Bull, ESPN, *Variety*, *Fortune*, *Forbes*, *Hollywood Reporter*, *Entertainment Weekly*, *GQ France*, *Popular Mechanics* . . . and the list goes on and on.

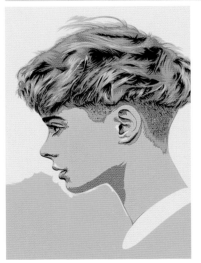

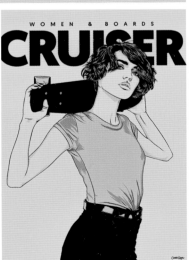

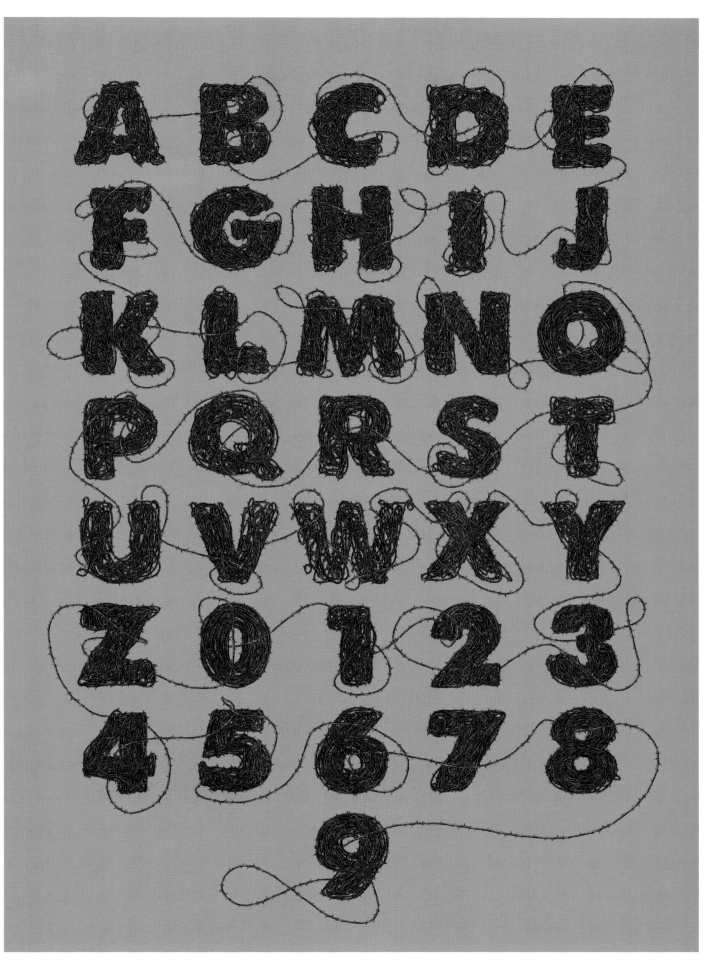

CRISTHIAN HOVA

Lima, Peru

 @cristhianhova

TRACKLIST:

Led Zeppelin - *Kashmir*
The Doors - *The Crystal Ship*
Pink Floyd - *Arnold Layne*
The Pixies - *Gouge Away*
Nirvana - *Serve the Servants*

Cristhian Hova is a Peruvian graphic designer, based in Lima, specializing in advertising illustration. After studying graphic design at the university, he set out on his own and occasionally produced posters for film and television as well as the theater. His clients include StarGold Channel, Dynamite Publicité, Greatworksbcn, Locked (Barcelona Electronic Music Festival), Coca-Cola, McCann, J. Walter Thompson Peru, Bundesliga Germany, and New Century Films (Warner Bros. Peru and 20th-Century Fox Peru). Over the past two years, he was probably one of the biggest exploding artists in Europe and the United States, which is all the more remarkable for an artist based in Peru.

Cristhian's particular style brings a graphic touch to each project: he twists it, infusing it with his own particular universe. The result: he is one of those rare artists whose work you recognize at first glance, whether it is a poster for *Batman*, a poster for the Bundesliga, or for a video game. A discreet figure on the contemporary graphic arts scene, he is no less effective: his style, which is reminiscent of a certain infantile imagination, makes him a key artist on the current scene.

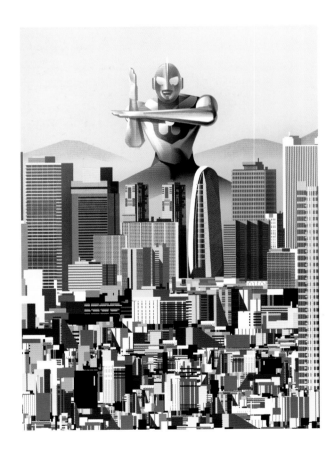

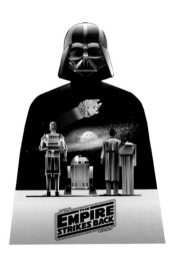

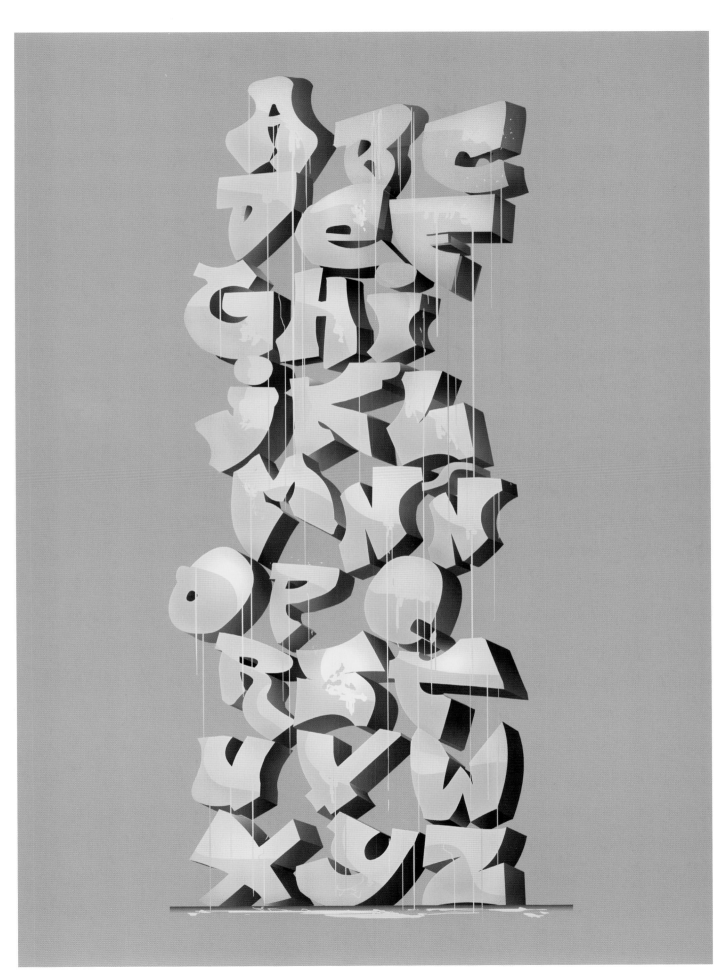

DAVI AUGUSTO

São Paulo, Brazil

⊙ @davi.augusto.insta

TRACKLIST:

Vangelis - *Blade Runner soundtrack*
Raul Seixas - *Raul Rock Seixas*
Gorillaz - *Gorillaz*
Elvis Presley - *ELV1S: 30 No.1 Hits*
Herbie Hancock - *Head Hunters*

An independent illustrator from Sao Paulo, Brazil, Davi Augusto holds a degree in digital design and a another in design editorial. His illustrations and other creations are regularly published in the biggest Brazilian magazines. It was this exposure that allowed his name to cross borders. He is now working on the production of a Canadian animation and a comic book. His inspiration comes from everything around him: people, the metro, an empty alley, street culture. His creative process: reproducing what he sees, in his own way, with his interpretation in order to transmit it to the viewer. Both graphic journalist and anthropologist, this fan of Elvis Presley is mainly inspired by Katsuhiro Ōtomo, Geof Darrow, and Kako. Davi has worked on many projects with ARTtitude, including Paris Games Week, Red Bull, and many more.

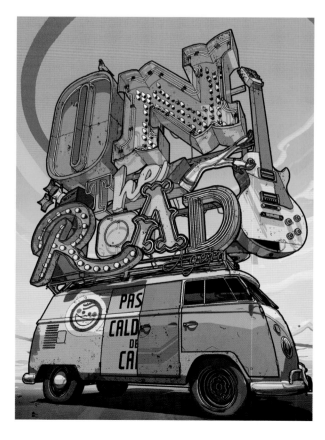

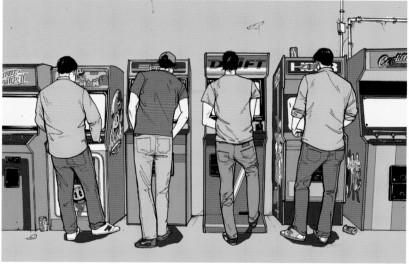

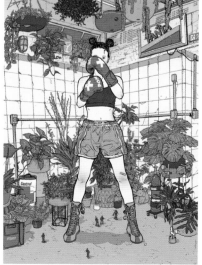

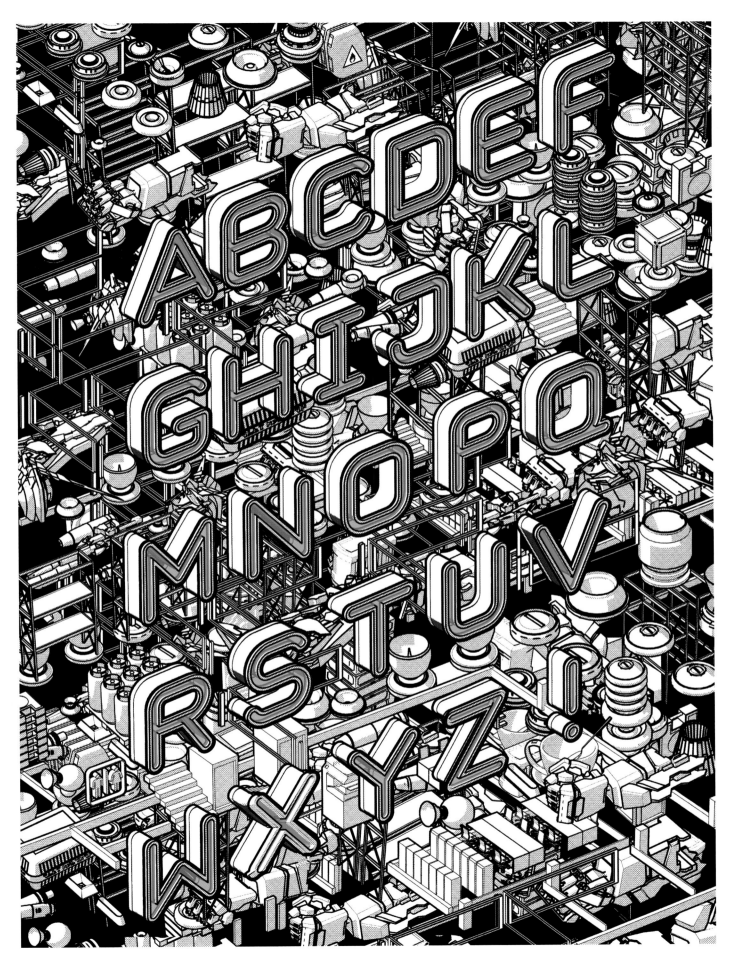

DAVIDE DPA

Lecce, Italy

 @davide_dpa

TRACKLIST:

Colle der Fomento - *Adversus*
Kaos One - *kARMA*
Kyuss - *Welcome to Sky Valley*
Fabrizio de Andre - *Non al denaro non all'amore né al cielo*
Anderson Paak - *Oxnard*

Since 2010, Davide has been writing, day and night, lyrics and poems on the walls of different cities. His stylistic research in the making of murals stems from his study of different calligraphy styles and cultures. The fusion between Arabic, Tibetan, and Latin calligraphy is what makes his unique compositions and style, which naturally aims at bringing distant cultures closer. *Poesia D'Assalto* was born with the intention of spreading poetry in the streets, among the passers-by, in drops of paint. Poetry that plunges into everyday life and finds its space, the redevelopment of dead streets and lost souls.

Beginning in 2013 he spread his texts outside a regional context by participating in social initiatives and urban redevelopment. He took his place among the street poets invited to participate in the International Festival of Street Poetry, an initiative aimed at promoting the dissemination of poetry through different methods.

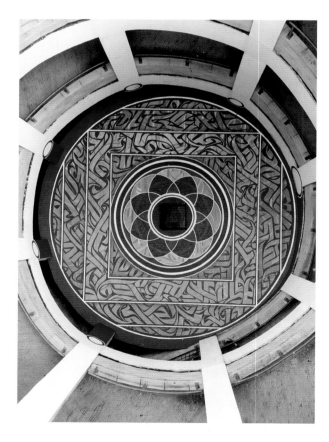

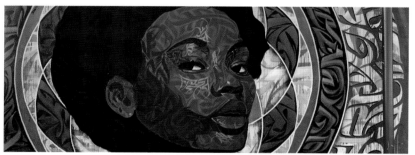

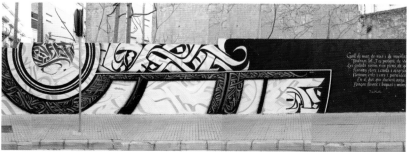

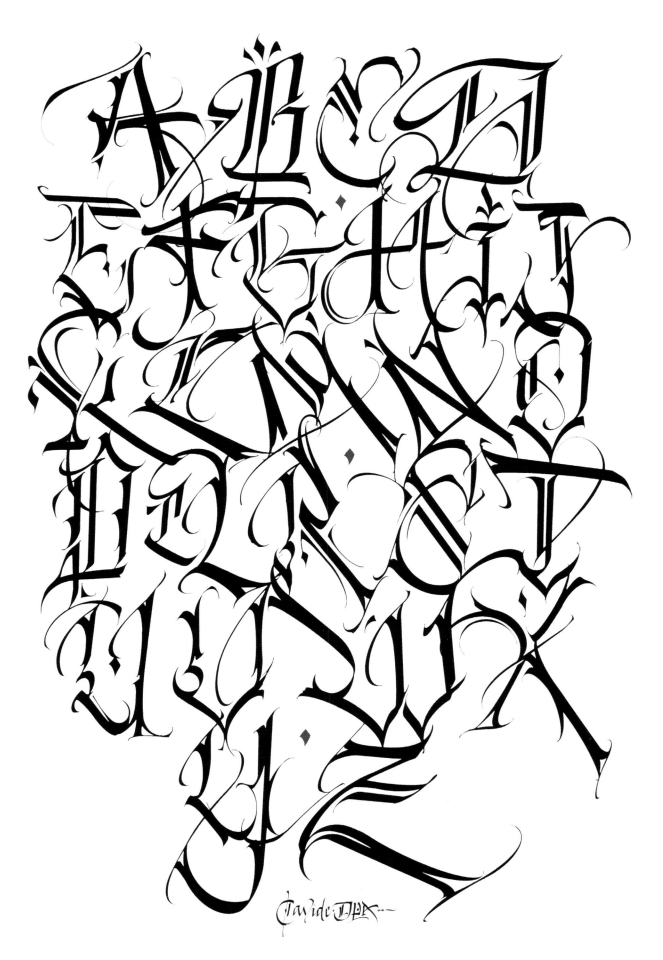

Davide DPK

DEFER

Los Angeles, USA

📷 @deferk2s

TRACKLIST:

Roddy Ricch & Marshmello - *Project Dreams*
Machine Gun Kelly - *Glass House*
Drake - *Deep Pockets*
Da Baby (featuring Roddy Ricch) - *Rock Star*
Mac Miller - *Jet Fuel*

As a founding member of the respected crews K2S, STN & KGB, Alex Kizu has been an integral part of the Los Angeles street art scene since the mid-80s. He is well known for his expertise in rendering beautifully complex letterforms. Defer's work stems from his culture and connection to graffiti and the urban landscape, representing a profound artistic language that distorts the line between street art and fine art. He was one of the pioneer members of the first generation of Los Angeles graffiti writers, and he has distilled the hand-style developed since his youth into abstract pieces that incorporate not only typographic but also cultural motifs and complex patterning. Defer's paintings are highly detailed examinations of line and color, frenetic structures that flow organically, with multilayered abstractions creating a borderless visual depth and complexity. Alex is also a BJJ practioner who did several designs for brands such as RVCA and Shoyoroll. His art became famous in this community when Marcus Buchecha won his thirteenth world title in 2019 wearing a custom *gi* (kimono) done by Defer.

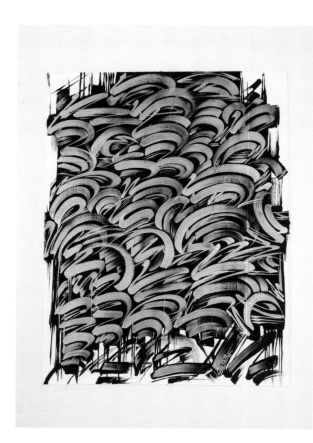

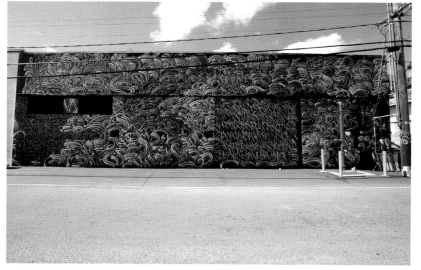

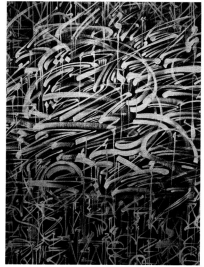

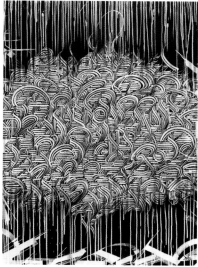

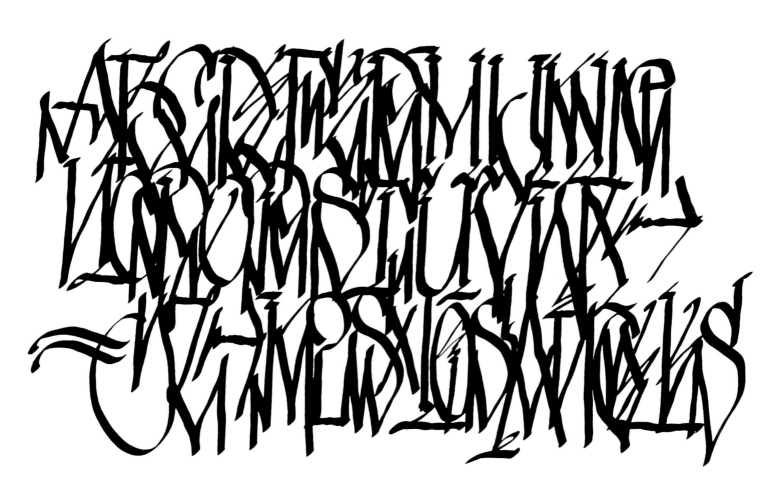

DER
Toulouse, France

@der_graffiti

TRACKLIST:
U2 - *Rattle and Hum*
Les shérif - *Les 2 doigts dans la prise*
Beastie Boys - *Solid Gold Hits*
Judgement Night - *Bo Film*
Sixto Rodriguez - *Cold Fact*

DER entered the world of graffiti in 1989 with the second generation of French graffiti artists. His beginnings, like most graffiti artists, took place in the streets during "Tag Party" followed by "Tops." His perfectionism and his sense of aesthetics gradually pushed him toward "color graffiti" and, more particularly, "wild style" by working the letter and general harmony of his pieces with patience. In 1994, he produced his first 3D piece, a style that he gradually adapted by deconstructing his letters ad infinitum and adding his personal touch, whether mechanical or organic. The letter remains the major preoccupation of DER, faithful to the "calligraffiti" spirit of the pioneers. The three letters of his name are available in any medium and have evolved over the years, gradually making DER a graffiti artist apart, at the crossroads of historical graffiti and contemporary art.

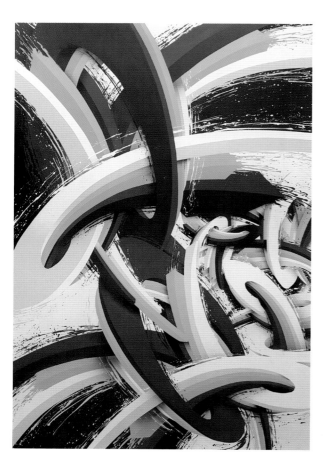

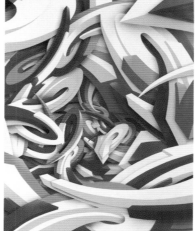

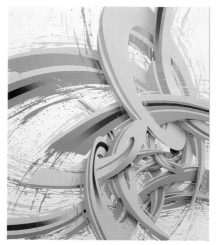

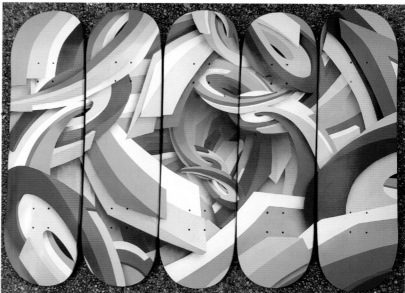

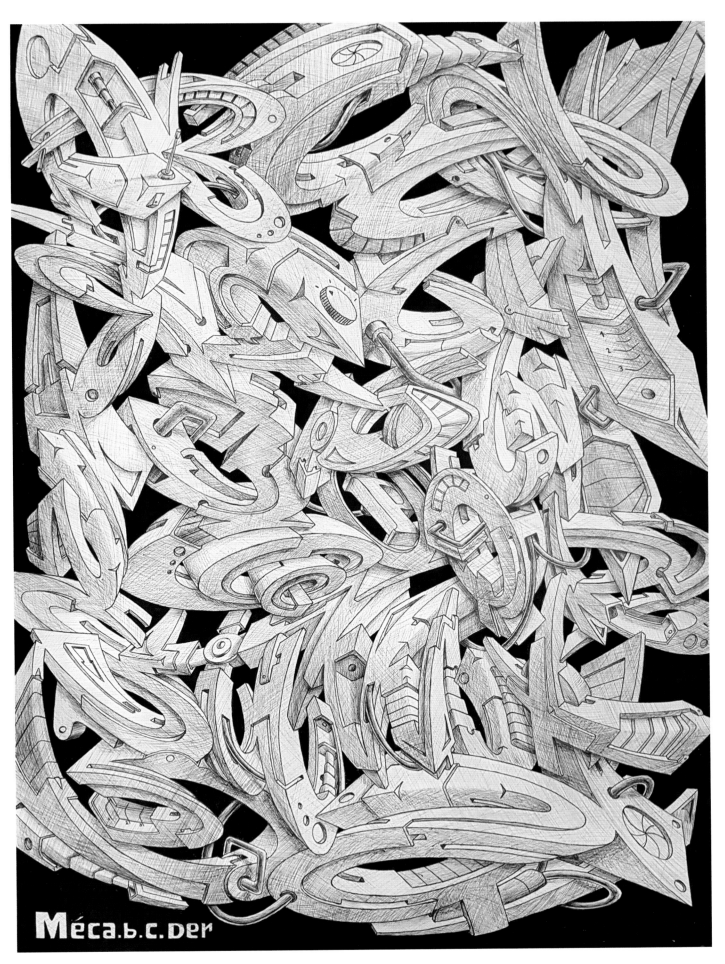

Méca.b.c.der

DEUZ

Marseille - France

📷 @deuzoner

TRACKLIST:
NAS - *I Am*
Lunatic - *Mauvais oeil*
Shurk'n - *Où je viens*
Oxmo Puccino - *Opéra Puccino*
Ideal J - *Le combat continue*

Deuz developed a passion for drawing early on when he discovered graffiti and comics. Influenced by these two worlds, he began to do graffiti in the mid-90s. At the age of 17, he visited the Picasso Museum in Paris and his desire to become an artist took hold. Determined, he completed a master's in applied arts, as well as degrees in design and plastic arts, in order to turn his passion into a profession. Deuz has been teaching applied arts since 2004, and at the same time he flourishes as an artist. Over the years, he has developed a purely figurative style. Using pencil, ballpoint pen, watercolor, a spray can, and Posca markers, he creates caricatures but also portraits inspired by hip-hop culture, which he colloquially calls his "faces." More than a musical reference, hip-hop is a source of cultural inspiration and a drawing companion in its own right. Music is an integral part of his creative process: it stimulates him when he draws and submits the titles of his works to him. Working on the portrait is an obvious choice, because it is addressed directly to the viewer, communicating with the audience. Each of these faces is made from a photograph and chosen for its originality, beauty, ugliness, or expressiveness. Then a real graphic dialogue takes place between Deuz and his model.

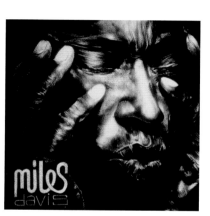

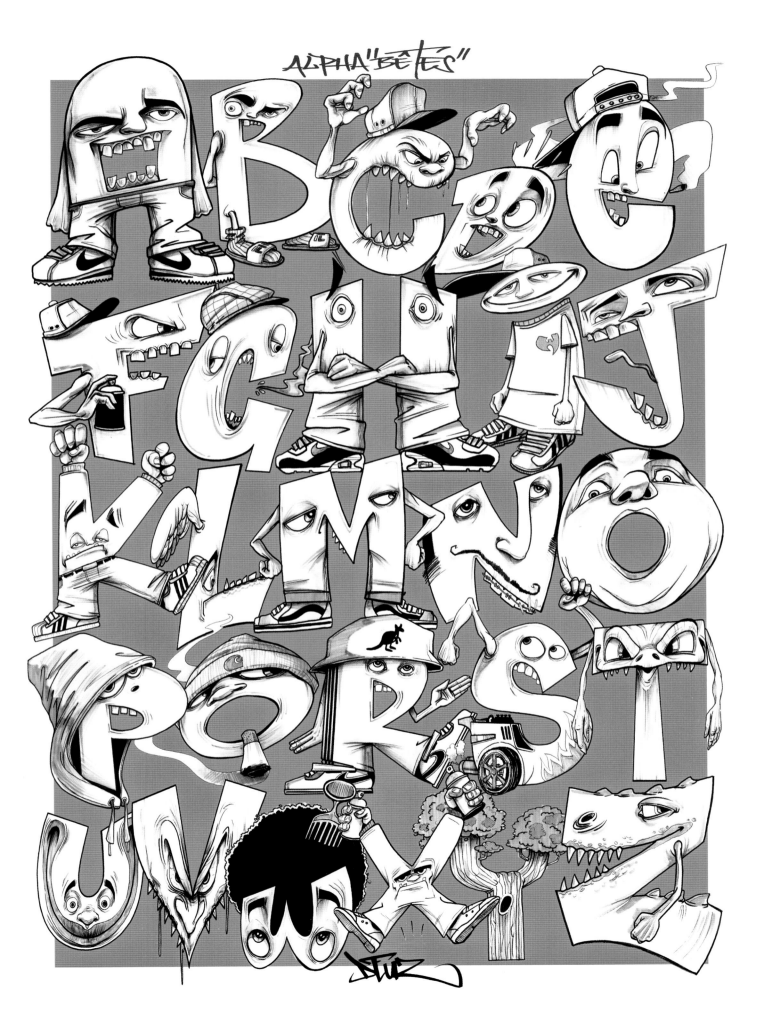

DIZE

Paris, France

📷 @dizaster156

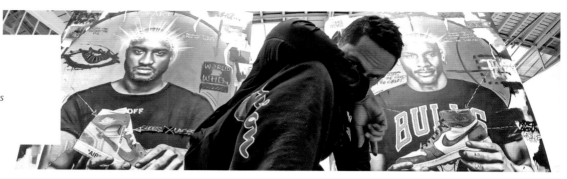

Dize, born in Tahiti in 1977, began doing graffiti in 1990. For more than 20 years he worked to bring graffiti to its purest form, in the tradition of New York artists. At the same time, he has a career as a designer. Founder of VMD and a member of internationally recognized groups such as the 156, he has always pushed the work of the letter further. In 2004 a monograph entitled *Warm Style Dizaster* was devoted to him. An international reputation, warranted by his style and his mastery of many techniques, has enabled him to collaborate with prestigious brands.
Today he continues to create works of art that can be found in exhibitions and galleries worldwide.

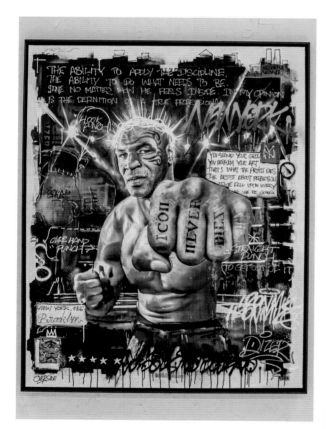

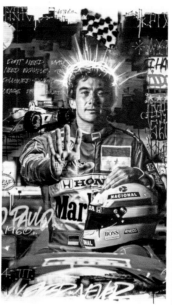

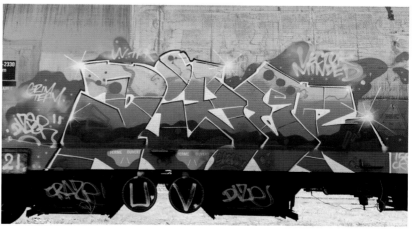

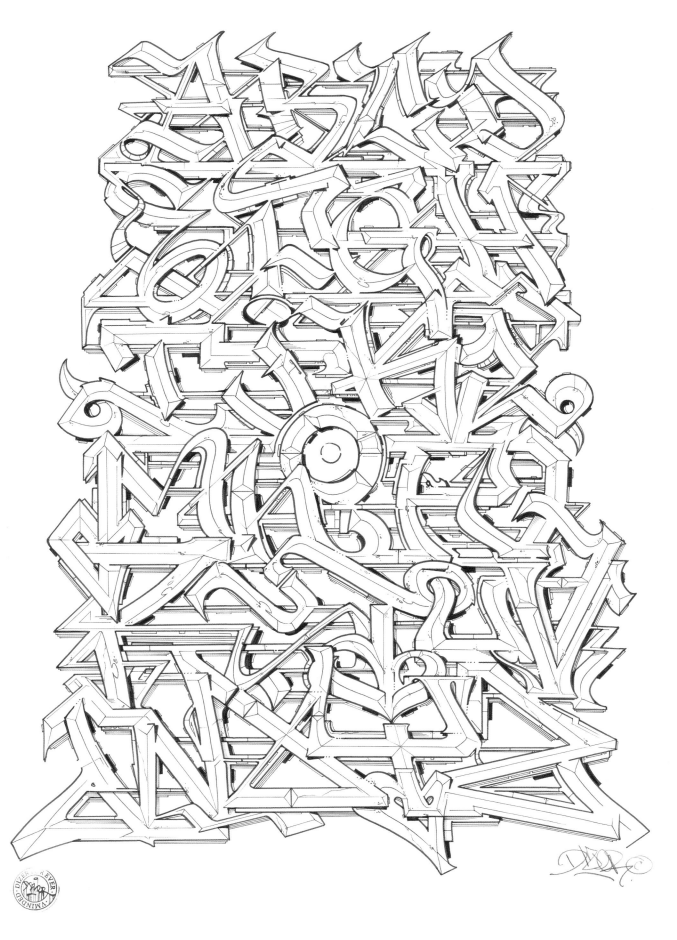

DOSEPROD

Edinburgh, Scotland

@doseprodart

TRACKLIST:
Faith No More - *Angel Dust*
Gojira - *Magma*
Beastie Boys - *Ill Communication*
Tears for Fears - *Songs from the Big Chair*
Fugazi - *Red Medicine*

Sam Hayles, aka Mr DOSE, is a graphic designer based in Edinburgh, Scotland. A big fan of music, street art, and cinema, this dreamer let himself be invaded by an artistic atmosphere during his childhood. He slowly sharpened his eye, spending much of his time contemplating record covers and movie posters. Sam then began to learn on the job, in a completely self-taught way, guided by his passion for the graphic arts. He worked for communication agencies in England and France. At the same time, he worked on personal projects in order to experiment and continue to train while working for bands and record labels. He decided to go on his own in 2005. Street culture, a wide musical panel, and the different genres of films he devoured quickly shaped his artistic personality. His digital art creations—which mix chaos, revolt, the strange, the crazy, the morbid, the post-apocalyptic, the intergalactic, the dark, the horror with a touch of punk—have allowed him to be entrusted with many artistic projects, especially in the music industry. DOSEprod Design Studio has been operating in Edinburgh since 2009.

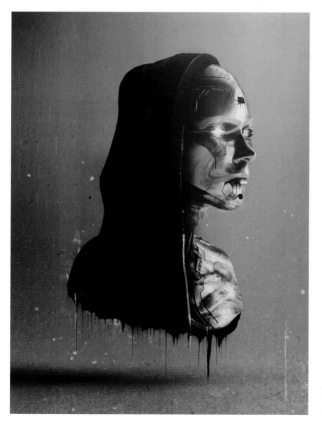

DOUGLAS MILES

San Carlos, USA

@dmiles1_apache

TRACKLIST:
Faith No More - *Angel Dust*
Gojira - *Magma*
Beastie Boys - *Ill Communication*
Tears for Fears - *Songs from the Big Chair*
Fugazi - *Red Medicine*

Douglas Miles is a San Carlos Apache-Akimel O'odham artist, designer, photographer, filmmaker, muralist, and public speaker from Arizona who founded Apache Skateboards and Apache Skate Team. Douglas grew up in Phoenix, Arizona, and then moved back to the San Carlos Apache Indian Reservation in that state. He drew images from cartoons, sci-fi, and comic books and attended the Al Collins Graphic Design School in Phoenix. From 1978 to 1980, he attended the Bostrom Alternative High School and created street art. His work encourages reflection on how art can foster community-building and promote pride and well-being, especially among young people. Rooted in Apache history and deeply engaged with the world of contemporary pop culture, Douglas' swork has been exhibited at Princeton University, Columbia University, the Santa Cruz Museum of Art and History, and the Institute of American Indian Arts Museum in Santa Fe. He has also recently collaborated with Tommy Guerrero and REAL Skateboards on a custom skate deck for Actions REALized. Prior to this, he collaborated with actor and author Ethan Hawke and artist Greg Ruth on a *New York Times* best-selling graphic novel, *Indeh: A Story of the Apache Wars.*

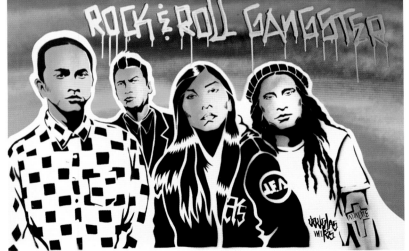

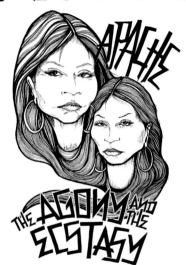

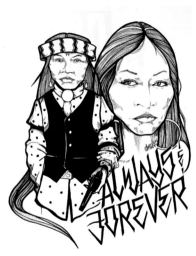

ABCDEFGHIJ
KLMNOPQ
RSTUVWXZ
XYZ @dny

ABCDEFGHI
JKLMNOPQ
RSTUVWXYZ @Jmm

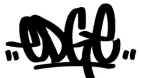

EDGE
Paris, France

@1973edge

TRACKLIST:
Run DMC - *High Profile*
Gang Star - *Full Clip*
Bootsy Collins - *Play with Bootsy*
James Brown - *Funky People*
Gregory Isaacs - *Night Nurse*

Edge, aka Edouard Scarfoglio, was born in 1973 in Paris. It was at the end of the 80s that he discovered graffiti, and it was in the streets and on the walls of the 13th arrondissement, his neighborhood , that he began to paint. At first it's just something fun between friends, but it quickly turns into an obsession that he manages to channel through the practice of painting in all its forms. He switched very quickly from walls to canvas, mixing techniques, aerosol, acrylic paint, and oil paint. The 90s were the decade of learning, not only of techniques and the history of art but also of composition, on canvas and in the street. The 2000s began with the place of man as an individual entity in the magma of our modern societies, and in the streets with collage sessions dealing with the brainwashing of

the media and especially television. His recent work continues to question his place in a world that seems out of control—an actor and helpless witness to his self-destruction. In addition to the question of the stupefaction of the masses, there are issues related to the environment and the future of our planet, as a logical consequence. Save the Planet - Legalize Brain is the title of a recent series on the walls of the French capital, in direct confrontation with the public, reminding them that underground artists remain a conscious and mobilized entity. He perpetuates, with a free spirit, this dialectic between urban art that he practices in different forms (collages, frescoes) and his work on canvas in the studio.

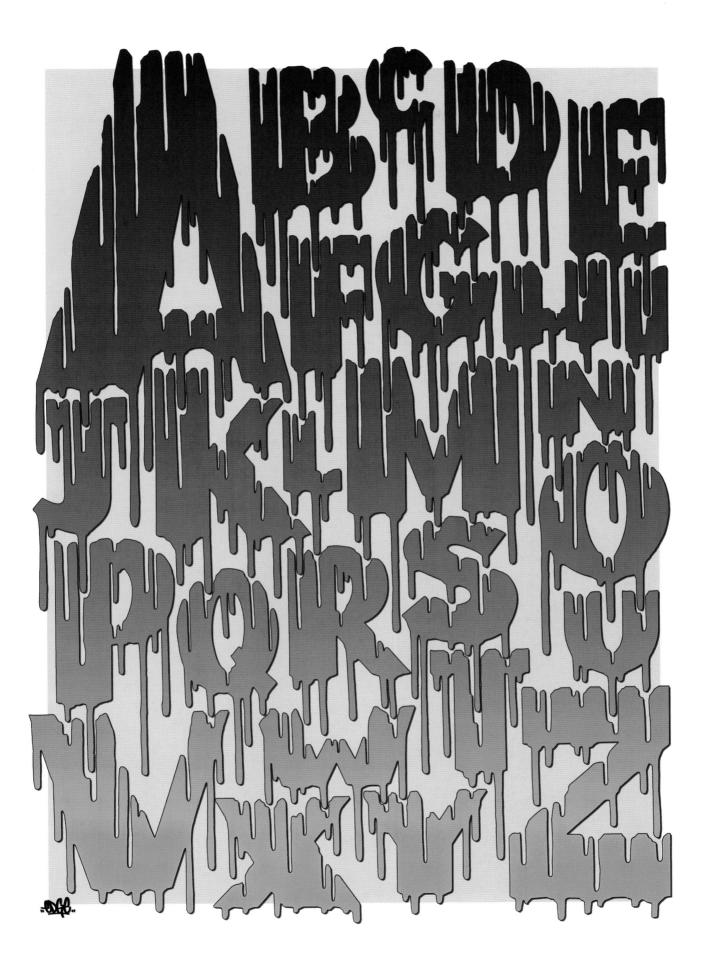

ETIEN'

Grenoble, France

@etien.fr

TRACKLIST:

Mos Def - *Black on Both Sides*
Koffee - *Rapture*
Busy Signal - *Parts of the Puzzle*
Beastie Boys - *Hello Nasty*
Youssoupha - *Polaroid Experience*

Born in 1981 in Grenoble, Etienne remains faithful to his native Alps. Influenced, like many of his generation, by the arrival in France of manga in the early 90s, he began by reproducing the classics of that time (Dragon Ball Z, Cobra, Harlock, etc.). He discovered graffiti in 1996 and practiced it assiduously before appropriating other, more classic mediums (acrylic, watercolor, oils) in the 2000s. After having carried out various jobs, he took the plunge and became a professional independent artist in 2005. Etienne mainly produces murals. Always curious and a jack-of-all-trades, he is self-taught in illustration, computer graphics, and web design. In recent years, he has been invited to participate in mural painting festivals in France and around the world, creating large-format frescoes and anamorphoses. As comfortable working on a canvas in his studio as perched on a gondola paint ing a facade, he is ready for any occasion to vary techniques, supports, and surfaces. His favorite field for several years has been representing the animal world. He appreciates surprising the viewer by integrating powerful and colorful visuals in unexpected and raw or often gloomy places. If you meet him at a festival, say "cheeeesyyy" to him. He will tell you the story behind it.

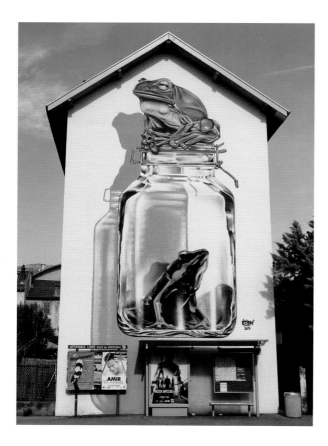

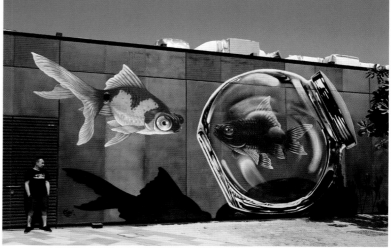

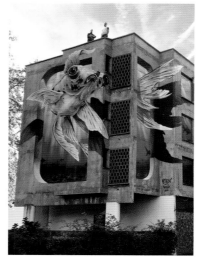

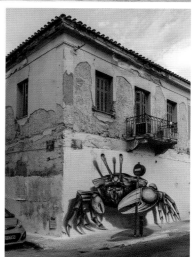

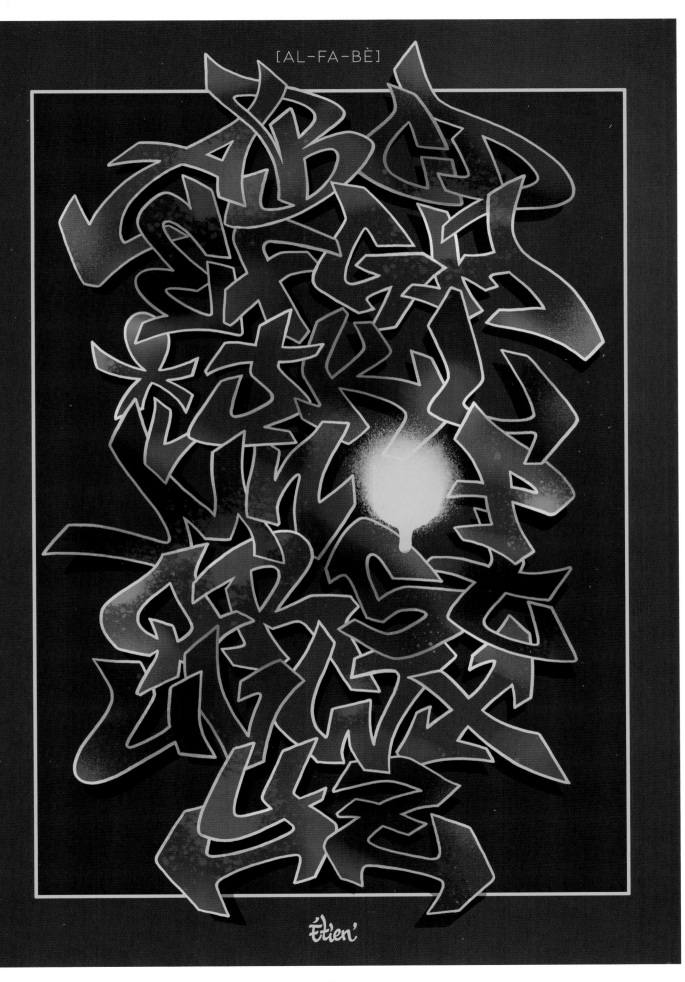

Étien'

Fiori Lorett

FIORI LORETT

Madrid, Spain

@fiori_lorett

TRACKLIST:

Noga Erez - *KIDS*
Anderson Paak - *Tiny Desk Concert*
Cicero - *Cosmo*
Lana del Rey - *Norman Fucking Rockwell!*
Bonobo - *Black Sands*

Born in a small town called Campina Verde, the Brazilian Fiori Lorett grew up in an arty world: her mother was a tattoo artist and her dad a circus artist. She got in touch with the techniques and knowledge of tattooing very quickly. Her family was always on the move in Brazil. That gave Fiori the taste for traveling. She started tattooing in 2002, spent a year in London as a tattoo apprentice, and then moved to Italy for three years in order to expand her knowledge. The next stop was Spain, and she fell in love with the country. Madrid became her base. She worked for the famous "Mao e Cathy" studio and was part of the casting for the *Madrid* *Ink* TV show (under the name Lolyta). The show was a huge experience for her in many ways. In 2014 she opened her own tattoo shop, Forget Me Not Tattoo (FMN). Opening the shop allowed her to grow even more, personally and as an artist. After nine years in Spain, five years running her business and having one of the best times of her life, full of different experiences with ups and downs, she felt that she wanted a bit more of freedom again. It's in her (family) blood. So she decided to hit the road again and keep doing what she was doing before, but this time more focused in a style that she fell in love with: the neo-traditional.

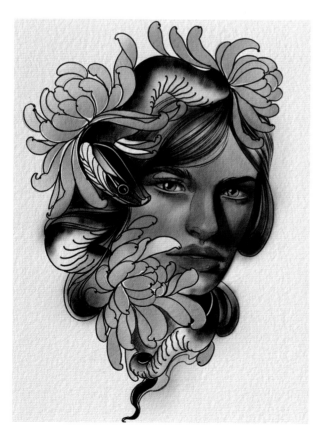

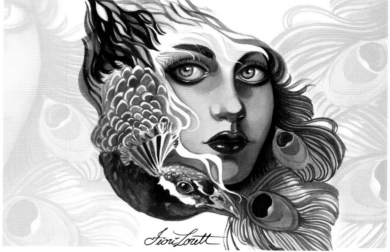

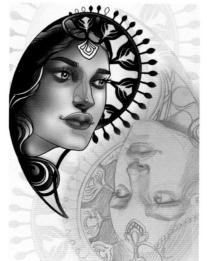

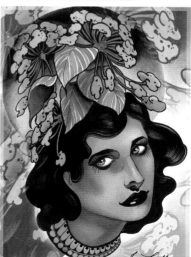

FREDONE
Hamburg, Germany

 @princepastell

TRACKLIST:
Nils Frahm - *All Melody*
J Dilla - *Donuts*
GQ - *A Midsummer's Nightmare*
Lee Fields & Expressions - *It Rains Love*
Jay Daniel - *Audire Vol. 1*

Beat producer, stylewriter, and designer. For more than 25 years, this creative mind has been a traveler when it comes to art and originality. Exhibitions inspire his work as well as observations and excursions into other cultures. The special thing about him: his ideas take off and at the same time work perfectly in the everyday life of a customer, for whom he leads projects with a lot of personal commitment. FredOne is a member of the legendary New York Graffiti Crew TDS (The Death Squad), which laid the foundation for style writing back in the 70s. But he's also a member of the Chosen Few and the VMD (Vector MindeD). He participated in many meetings and festivals as well: Write4Gold, Meeting of Styles, Roskilde Festival, Dockville Festival, Reeperbahn Festival, Back2TheStyle Jam, Sombri Jam, Battle of the Year, Urban Syndrome, and on and on . . .

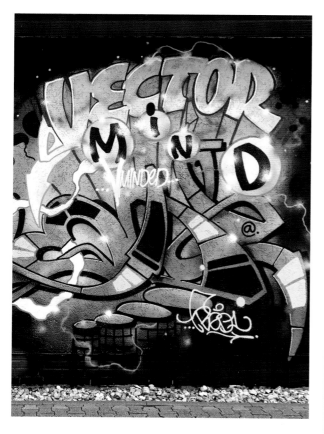

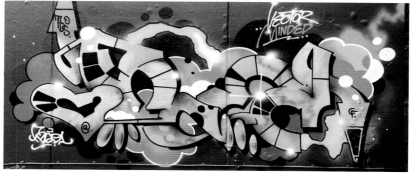

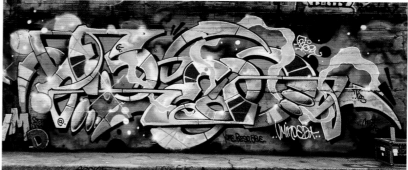

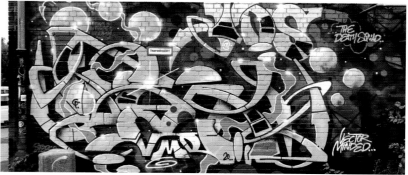

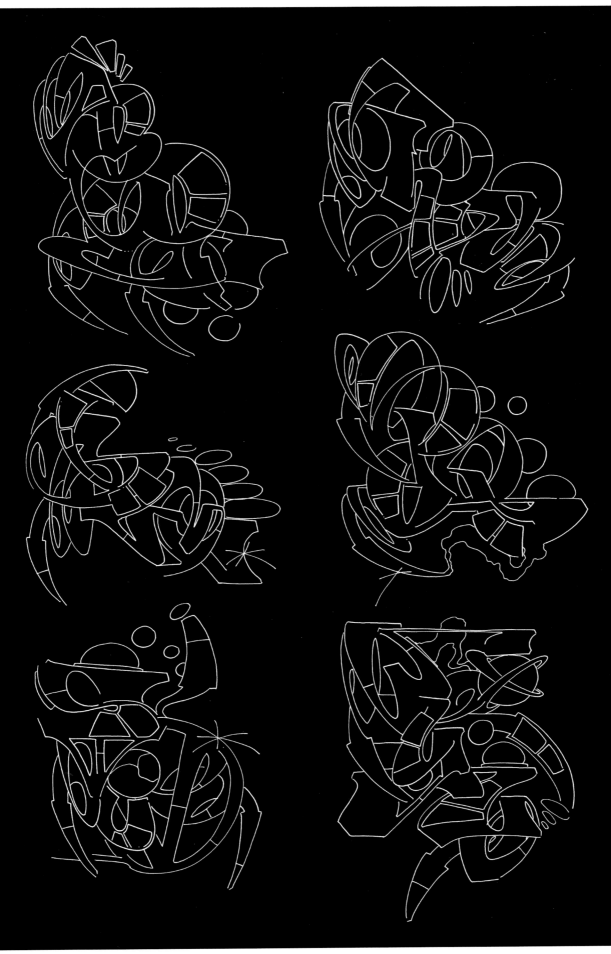

HARIBOW

Paris, France

[] @haribow1

TRACKLIST:

Madvillain - *Madvillainy*
Mobb Deal - *The Infamous*
Tyler the Creator - *IGOR*
Odb - *Return to the 36 Chambers*
Snoop Dogg - *Doggystyle*

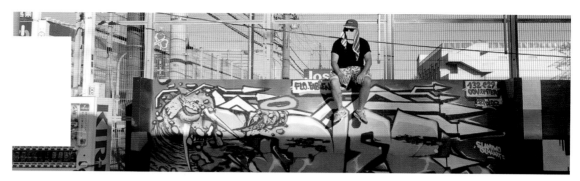

Haribow is a Parisian artist born in 1980. Growing up in a family of artists, from an early age he was lulled by the world of drawing. In 1996 during his studies he discovered the graffiti world. Holder of a baccalaureate in applied arts, a BTS in object desig,n and a master of plastic arts (screenprinting), he decided to turn to graphics, typography, and screenprinting on his own while continuing the graffiti, in which he can mix his different knowledge bases. His graphic universe is similar to comics, which is for him an infinite source of inspiration. His screenprinting workshop allows him to create his own experimental productions but also to pass his digital illustrations to the physical medium while keeping this free and creative spirit. You can follow his work under many names including Ridler or Rmax. It's interesting to see that his graffiti stye is very different from his poster-art style. Generally, from one medium to the other, the style remains the same; you can recognize the DNA of an artist. But not for Haribow. Take someone who would not know his work and it would be impossible to guess that the artist doing the Gremlins or Akira poster is the same one landing huge throw-ups and graffiti pieces.

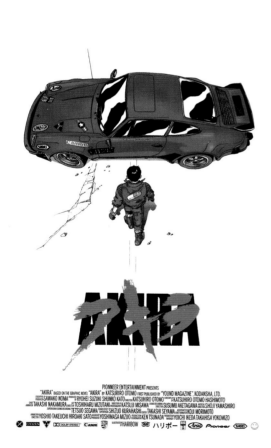

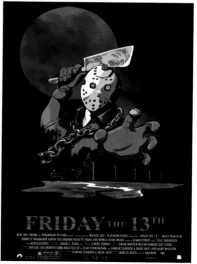

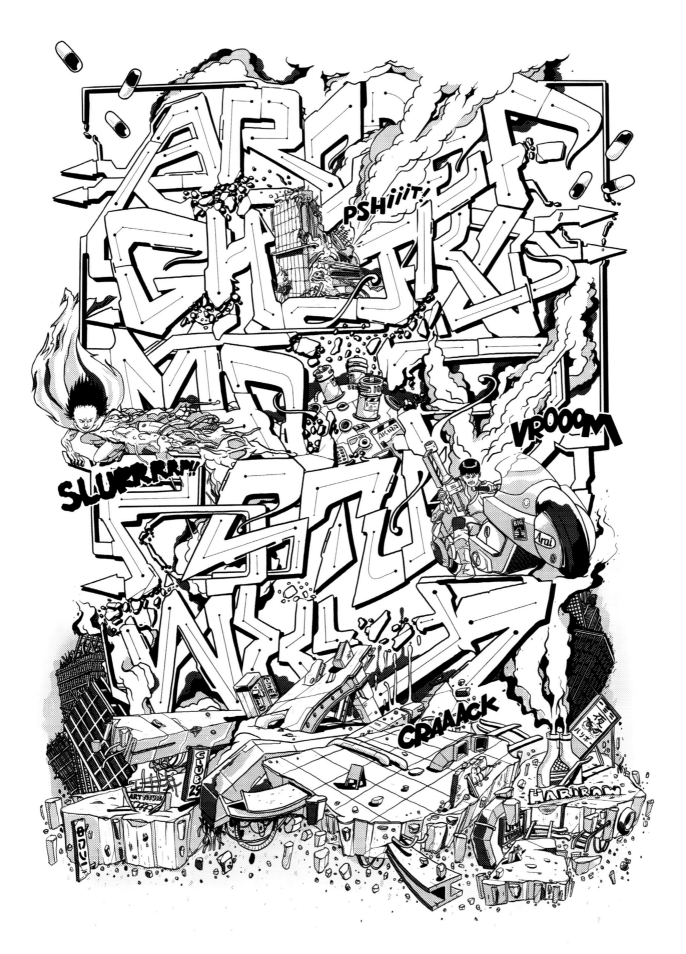

HUIT
Tours, France
 @huit1

TRACKLIST:
Wu Tang Clan - *Enter the Wu-tang*
Ennio Morricone - *Sergio Leon movies Ost*
Cypress Hill - *Temples of Boom*
Daft Punk - *Homework*
Vangelis - *Blade runner Ost*

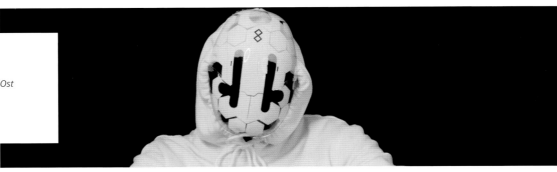

Huit, 8, Right, Ocho, Hachi, Atcht (choose yours!) divides his time of creation and production between France, Asia, and the US. Painter, draftsman, designer, self-taught tattoo artist, he was revealed in California during the 2000s. It was in the Californian Latino, skate, surf, and hip-hop cultures that he evolved among the pioneers of all these movements that have spread all over the world. Huit is living in Touraine (France); he loves the province, but all the travels allow him to gather with all the members of his collective scattered around the world and to propagate his works as much in the streets as in art galleries. A graduate in visual communication, he carried out advertising campaigns for Parisian agencies in the early 2000s. It was in the French capital that he made his place and began artistic collaborations with the first French founding brands of streetwear clothing dedicated to graffiti and hip-hop culture. Presenting himself under one of his pseudonyms as EIGHT, and making illustrations and murals for streetwear companies and Californian surf and skate brands, it was in 2019 that he took an artistic turn by changing his pseudonym: 8. Easier to hear in the different international languages but also a pictorial turn. He began making female portraits based on the gaze, embellished with floral and aesthetic compositions as well as a calligraphic research, in order to highlight the woman and her beauty in this world, where she must constantly fight to be the equal of man. It is an artistic TRIBUTE.

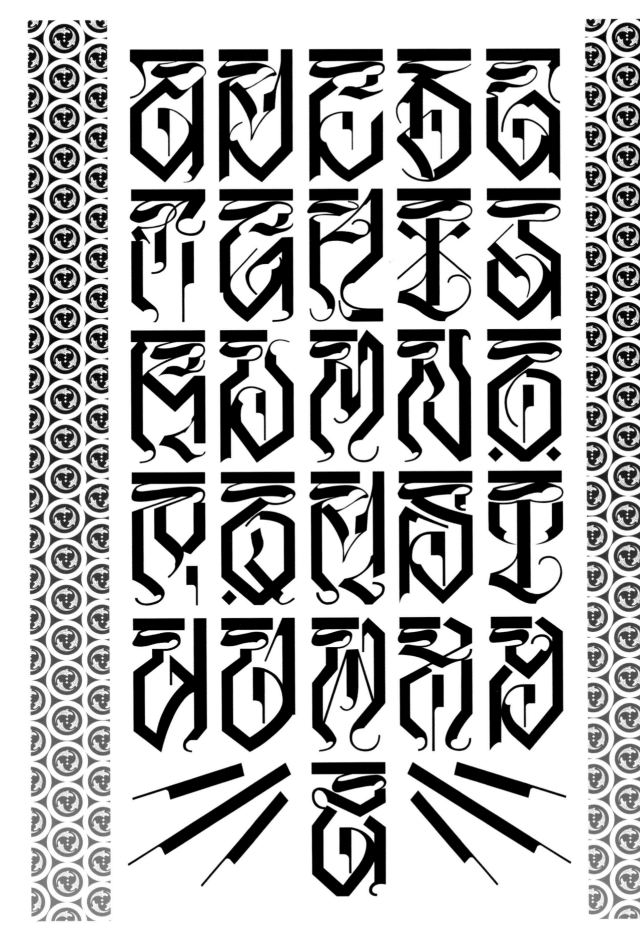

INDIE 184

Hopewell Junction, USA

 indie184

TRACKLIST:

Blondie - *Rapture*
Siouxsie and the Banshees - *Hong Kong Garden*
Los Hermanos Rosario - *Alegria*
Motörhead - *Overkill*
Lil Yachty ft. Cardi B + Offset - *Who Want the Smoke?*

Visual artist Soraya Marquez, aka Indie184, born in 1980, is a native New Yorker, of Dominican descent. She has been active in the graffiti culture for over two decades. Determined to express herself to the world through art, she quit business college to teach herself how to sew, paint, and produce graphic design. Also influenced by abstract expressionism and pop art, her paintings are raptures of color and textures. Fused with her original graffiti and street art, imagery, and designs juxtaposed with personal messages, Indie's art has been exhibited in galleries and museums worldwide, including El Museo del Barrio in New York City; Völklingen Ironworks Museum, in Saarbrücken. Germany; Museo de Bellas Artes De Murcia in Spain; and numerous solo and group gallery exhibtions. Her graffiti and mixed-media murals can be found in streets from the South Bronx to Paris. Her most recent collaborations have been with Rimmel London as chief artistic officer, Apple Beats1 Radio, Lionsgate Films, MTV Networks, and a capsule clothing collection with iBlues. Catch her creating her latest work in the streets, designing, or painting in her studio.

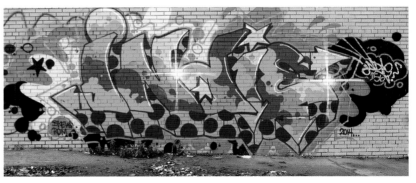

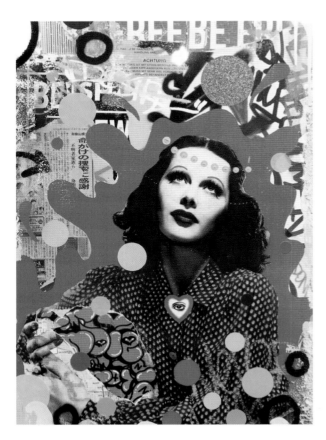

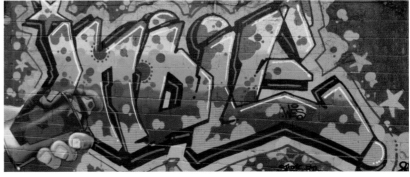

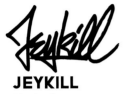

JEYKILL

Biarritz, France

 jeykill_bleunoir

TRACKLIST:

Beasty Boys - *Ill Communication*
Rage Against the Machine - *Battle of Los Angeles*
Metallica - *Master of Puppets*
Serge Gainsbourg - *Cosmic Trip*
Babe Rainbow - *Double Rainbow*

Jeykill was born in 1974 in the Parisian suburbs. After few years working as a graphic designer, he joined the 9ème concept collective in 1999. Within this structure, where artists from different but complementary universes come together, he works on commissions for different brands. Jeykill also participates in numerous group exhibitions and develops on canvas a style that is both ethnic and urban. In 2000 he moved into the art of tattooing and began to practice. On the skin, often freehand, the ergonomics of its parts take precedence. Alternately meticulous or spontaneous, inspired by the ocean, the sky, and human nature, he has created a complex universe between illustrative and abstract, often dreamlike. In 2010, Jeykill opened, along with Veenom, the Bleu Noir tattoo parlor in Paris and in 2016 the one in Biarritz.

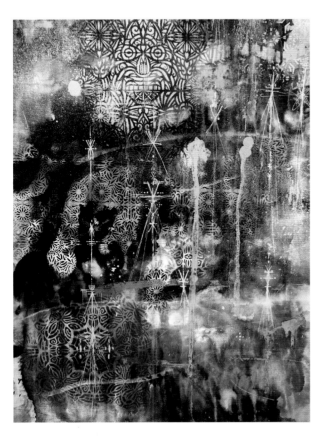

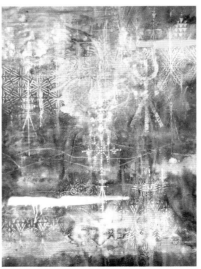

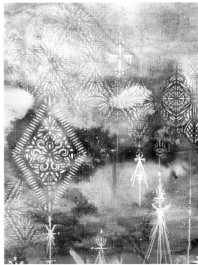

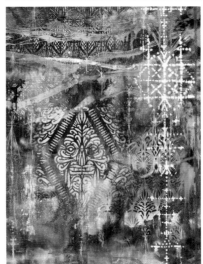

PHILLIPS

JIM PHILLIPS
Santa Cruz, USA
www.jimphillips.com

TRACKLIST:
Miles Davis - *Sketches of Spain*
Herbie Mann - *At the Village Gate*
The Dave Brubeck Quartet - *Time Out*
Lost Legends of Surf Guitar
Ka Moku Takahashi - *Mellow Slack Key Guitar on the Beach*

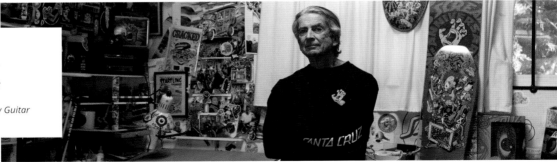

Jim Phillips is a graphic artist who is best known for his surf and skateboard art. Born in San Jose, California, he's lived most all of his life in Santa Cruz. Jim's first published work was in the spring 1962 issue of *Surfer Quarterly*; his "Woody," a pen and ink illustration, was a winner of a 1961 surf car cartoon contest held by the magazine. Soon Jim's surf art began to appear in the major surf magazines during the 60s and beyond. His earliest jobs were in local surf shops, where much of his work was applying art and designs to surfboards. In 1965/66 Jim studied fine art with a scholarship at California College of Arts and Crafts in Oakland. He became solo artist and art director for NHS Inc. during its early years in the 1970s and 80s, creating thousands of decks, t-shirts, stickers, product illustrations, and skateboard magazine ads. In 1988 he founded Phillips Studios, where he trained young skateboarding artists to create designs for NHS. Jim's art has grown even more popular recently, and NHS currently markets his work in 80 countries.

In 2016–17, *The Screaming Hand*, an NHS art exhibit tribute to Jim's art, traveled to 25 art venues worldwide, invited 50 world-class artists to join, and broke all attendance and membership records during its eight-month stay at MAH, the Santa Cruz Art and History Museum. In 2020 NHS will be presenting a similar traveling art show based on Jim's art and advertising for Santa Cruz wheels, culminating in a worldwide exhibit at the MAH in the spring of 2021.

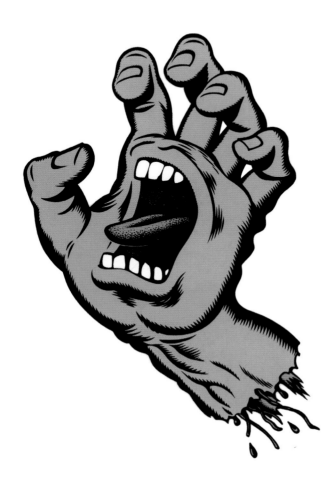

ABCDEFGHI
JKLMNOPQRS
TUVWXYZ

PHILLIPS

JIMBO PHILLIPS

Santa Cruz, USA

@jimbophillips

TRACKLIST:
Metallica - *... And Justice for All!*
Bob Marley - *Exodus*
Jimi Hendrix - *Are You Experienced?*
A Wilhelm Scream - *Career Suicide*
Mastodon - *Crack the Skye*

Phillips is a difficult name to carry in the world of board culture, but Jimbo has managed to impose a first name right in front of it. He was born and raised in the art world of Santa Cruz. His father, Jim, is a legend of the board culture and a very influential illustrator of the 1970s and 80s, notably being the creator of the famous "Screaming Hand" of the skate and surf brand Santa Cruz. Not easy to be the son of a legend. Many have broken their teeth there, but he has succeeded brilliantly! He began to follow in his father's footsteps at a very young age, creating illustrations, t-shirt designs, and advertisements in the early 90s. He also made a name for himself by working and imposing his style with top-notch customers: Toyota, Nike, Snickers, Volcom, Puma, and Bell, among others. He exhibited all over the world, took part in the Tony Hawk Wasteland game in 2005, and produced concert posters. A committed man, Jimbo also participates in charitable works and cares about the planet; for his own productions, he produces exclusively locally.

An artist who, since birth, has been at the heart of board culture in the holy city of Norternh California surfing, Jimbo is both the guarantor of a family and cultural tradition and the promise of a future that will know to perpetuate and evolve these values and graphic universes created by his father. In addition to his works for major brands, his fans and collectors will also find a whole series of unique products and works on his website. Jimbo is an artist who strives to push the boundaries of what's possible on a skateboard, t-shirt, poster, sticker, or any other surface. And he continues to do so in a flowing, eye-catching style. Keep your eyes peeled for his next graphic assaults!

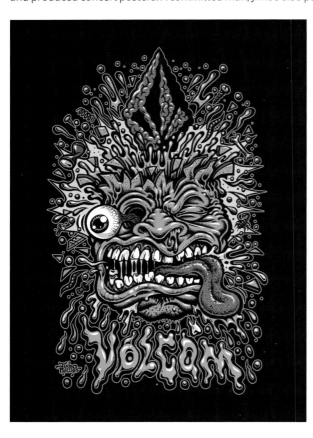

JOAN LE BRETON

Sanguinet, France

@jobretms40

TRACKLIST:

113 – *Les Princes de la Ville*
Action Bronson – *Mr Wonderful*
Paul Kalkbrenner – *Berlin Calling*
The Builders and the Butchers – *Where the Roots
All Grow*
Seasick Steve – *Man from Another Time*

Behind his "tough" look, Jo is a multifaceted Landais who enjoys artistic and sporting activities. He uses the north of the Landes as a huge playground. Navigating between the trendy seaside resort of Biscarrosse and the pretty village of Sanguinet stuck to its lake, this young 34-year-old has found his balance. But this lover of life, always surrounded by his friends, also devotes himself to all kinds of sports typical of southwestern France, such as rugby, surfing, and of course skateboarding, in which he manages to achieve feats as if he was one with his board. At a young age, he became interested in drawing and then design. The circumstances of his career quickly led him to become a professional tattoo artist, totem sculptor, and surfboard decorator. He even managed to make a living by opening his shop in Biscarosse, a stone's throw from the ocean, for seven years.

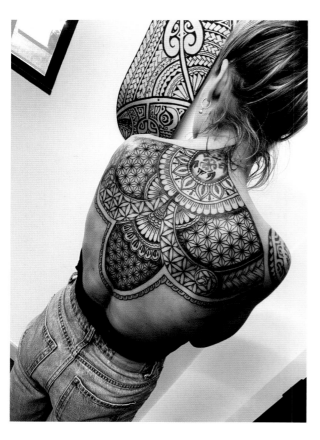

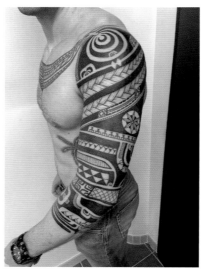

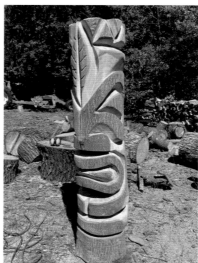

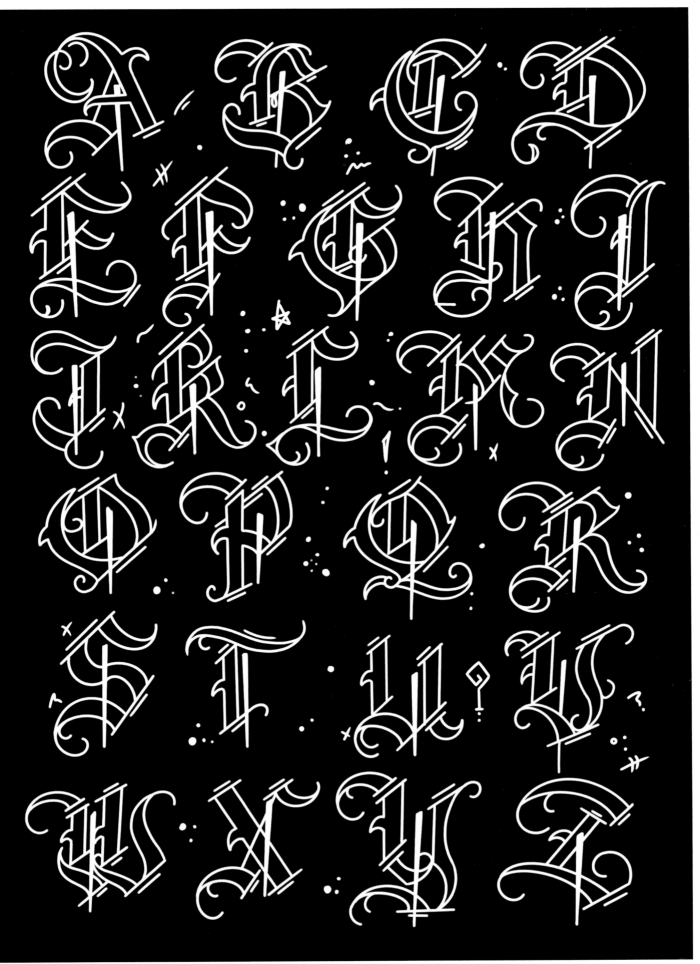

JOCELYN BOUGET

Jonquerettes, France

@jocelyn.bouget

TRACKLIST:

Trevor Rabin - *Armageddon* soundtrack
Guns N'Roses - *Use Your Illusion 2*
Renaud - *Mistral gagnant*
Jean-Jacques Goldman - *En passant*
Hans Zimmer - *Gladiator* soundtrack

Born before the 80s, Jocelyn followed a normal school journey with a slight predisposition for drawing, influenced by the classics of the time: Asterix, Dragon Ball, Waikiki, Fido Dido. He discovered comics a few years later and found that it's a blast, especially with the work of Michael Turner and his female characters: Witchblade, Fathom, etc. He is also strongly influenced by the work of Giger and Royo, which can felt in his illustrations. With a baccalaureate in applied art in his pocket, he entered the Beaux-Arts in Reims, discovered computer science, CAD, and 3D, which will began to take more and more place in his artistic expression. He created his company in parallel with his studies, worked on drawing and sculpture, and experiment a lot. Jocelyn's pieces are exhibited in France and New York. After a stint in an agency, he has refocused on his family life and his work. He is an artist, a lover of detail and beautiful lines, to follow.

JOHANNE 8

Sceaux, France

 @johanne_8

TRACKLIST:

Drive soundtrack
Jabberwocky - *Lunar Lane*
Sébastien Tellier - *Sexuality*
Amy Winehouse - *Back to Black*
Gipsy King - *Greatest Hits*

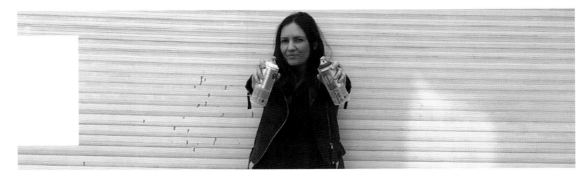

Born in Lyon in 1974, Johanne 8 is a confirmed contemporary artist. She has exhibited her paintings and sculptures since 2008 in renowned galleries, from Melbourne to Barcelona, Lausanne to Geneva, as well as in France. Johanne has also been able to take part in prestigious events, such as the Grand Palais de Lille for Lille Art-up or the Urban Art-Fair in Paris. In her studio, Johanne creates bright and colorful paintings that tell a story. Her history. Observed and chosen by big names in fashion—Paul & Joe, Karl Lagerfeld (Chanel), and Olivier Rousteing (Balmain)—and from French gastronomy, including the three-starred chef Anne-Sophie Pic, Johanne 8 continues on her path and never stops to renew.

She has just developed a new technique, in order to add relief to her creations, by drawing inspiration from the brands of sweets that she likes to put on canvases (Milky Way, Bounty, Galak, Mars). It is reminiscent of the artist who grew up in the 1980s and is fully imbued with this culture. In her paintings you will undoubtedly find references to those who have always inspired her: Basquiat, Warhol, Lichstenstein, Erro, and even Julio Le Parc. Her universe is fueled by Pulp, comics from the 1950s, and international news and major social themes. As for the number 8 next to her first name, that is the day of the birth of her son Mattia, her lucky charm.

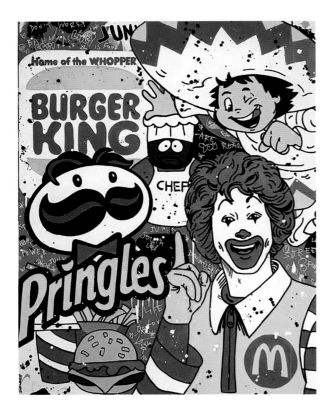

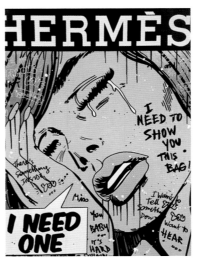

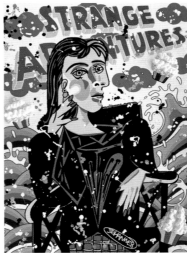

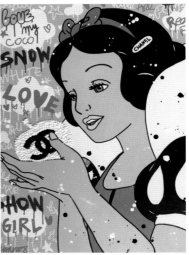

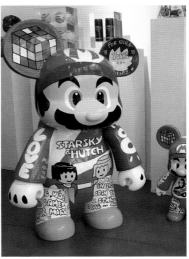

A B C D E

F G H I J K

L M N O P

Q R S T U

V W X Y Z

·:JUANITOOX·:

JUANITOOX

Moissy Cramayel, France

@juanitoox

TRACKLIST:

Snoop Dogg - *Doggy Style*
NTM - *Paris Sous les Bombes*
Wu Tang Clan - *36 Chambers*
113 Clan - *Les Princes de la Ville*
Doc Gyneco - *Première Consultation*

Ever since he was old enough to hold a pencil, JuaN has been walking around with a drawing pad in his backpack as if his life depended on it. Despite having a master's degree in karaoke, 5th DAN, country option, he became a graphic designer. And then finally he became a tattoo artist because his best mate (Tito) was in the business and he plucked him.

JuaN has a highly distinctive style in which many influences meet, from hip-hop, classic cartoons, and babes, to Latino and gang-style graphics, graffiti, and apes! Don't tell anyone but this guy should do a graphic novel!

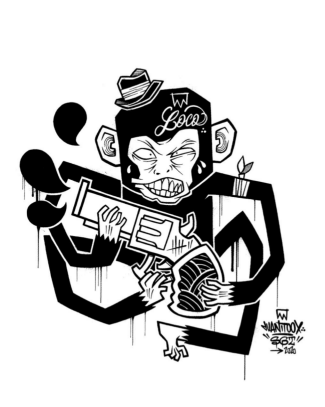

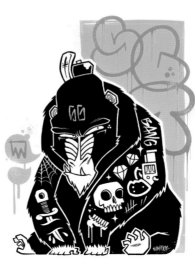

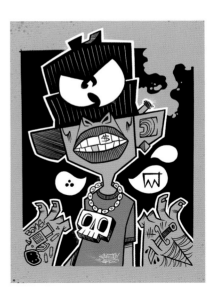

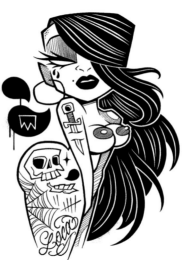

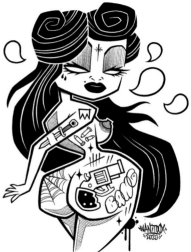

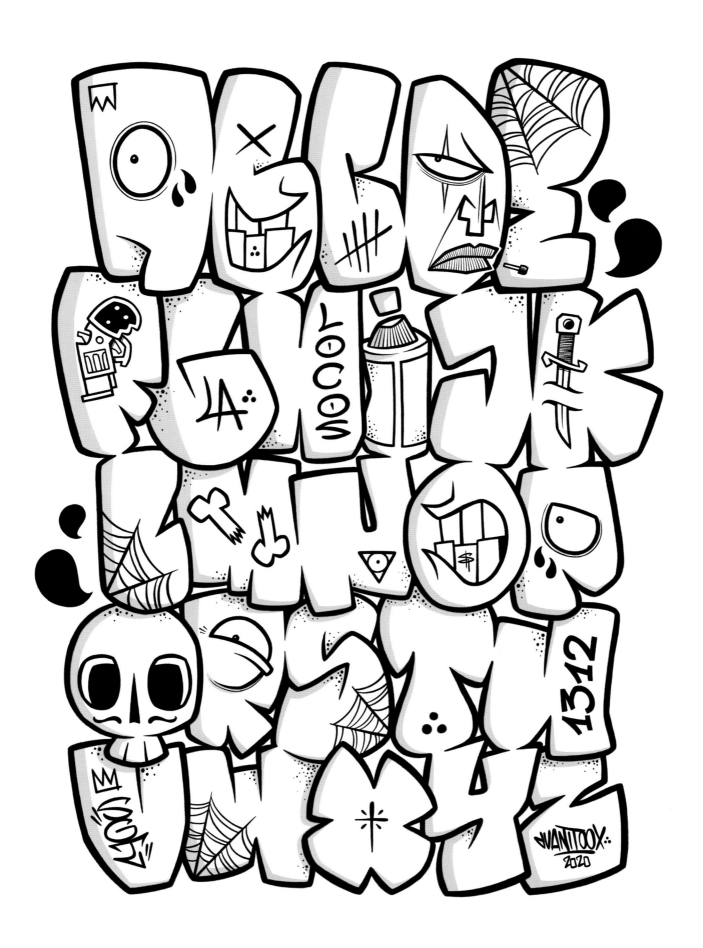

KANO

Burbank, USA

 @kanokid

TRACKLIST:

Mos Def & Talib Kweli Are Black Star
Beastie Boys - *Hello Nasty*
Gorillaz - *Demon Days*
Kaytranada - *99.9%*
Nas - *It Was Written*

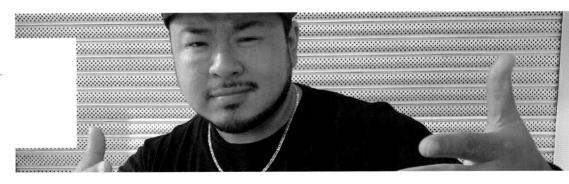

Born and raised on the streets of New York City, kaNO discovered art at a very early age. The graffiti on the walls and the cartoons on the TV set the tone for a creative childhood. He graduated from the High School of Art & Design in 1995 and went on to obtain a BFA in animation at the School of Visual Arts in 1999. From the silver screen to galleries and even onto toy shelves across the world, kaNO's style is distinctly recognizable as his own. As his creative pursuits expand, so does his ever-growing list of clients and exhibitions. In 2010, he moved out to Los Angeles, where he freelances as a character designer for notable studios such as Warner Bros. Animation, Cartoon Network, and Hasbro. When he's not making cartoons, you can find him working on paintings, commissions, and designing products through his brand kaNO kid at his art studio in Burbank, California.

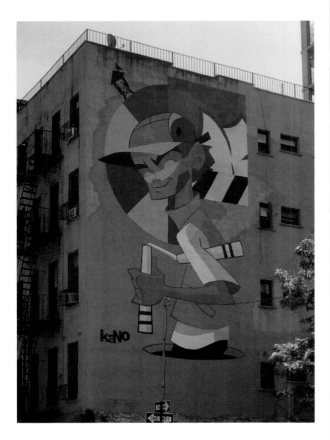

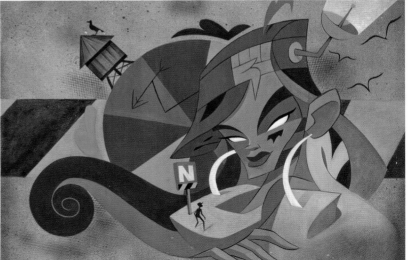

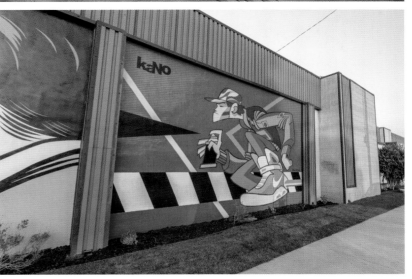

KEKLI

Villejuif, France

:camera: @kekli

TRACKLIST:
N.E.R.D - *In Search Of*
Wu Tang Clan - *36 Chambers*
Busta Flex - *Busta Flex*
Kid Cudi - *Man on the Moon*
Lil Jon & The East Side Boyz - *Crunk Juice*

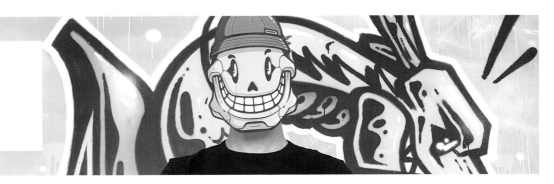

In the 90s, Kekli began painting via hip-hop culture through graffiti. Over time, a character takes an increasingly important place in his work: the Boyo, a yellow ovoid head displaying a frozen smile. He draws, stencils, glues, and paints his characters with broad smiles on the four corners of the streets of our cities, paying homage to the heroes of his childhood and to pop culture icons. These smiles scattered in the streets try to make other smiles appear, to generate a response from a passerby, to take him out of his routine if only for a few seconds. Just smile!

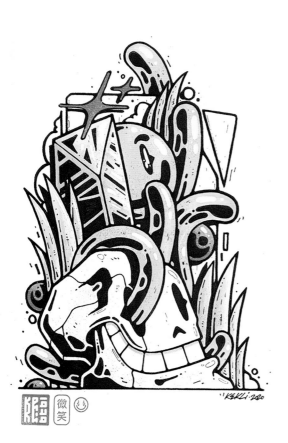

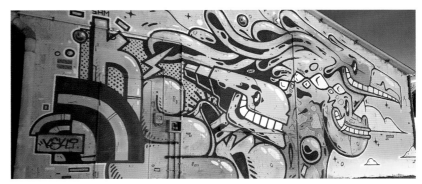

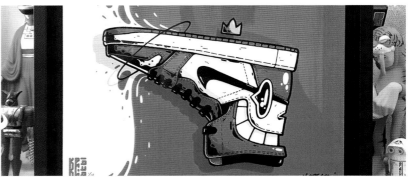

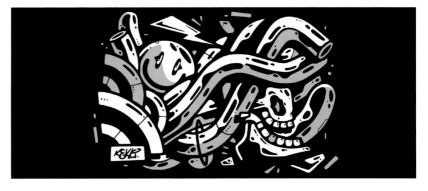

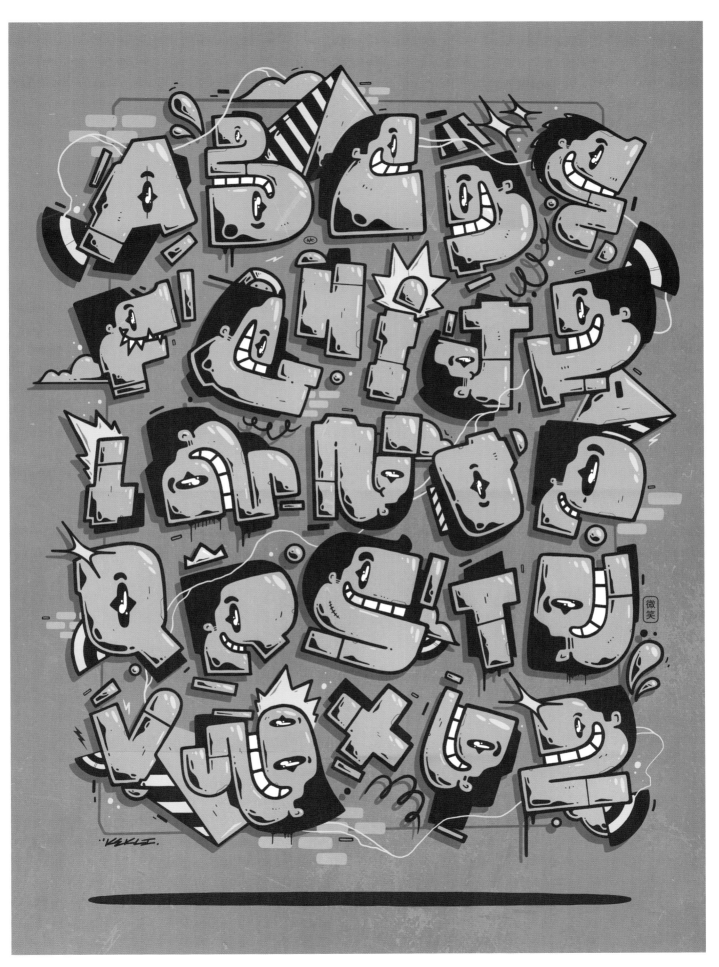

KIDBAZ

Caen, France

@kidbaz

TRACKLIST:
Chance the Rapper - *Acid Rap*
Nas - *Illmatics*
NTM - *Suprême NTM*
Mac Miller - *Best Day Ever*
Dom Kennedy - *Get Home Safely*

Son of a painter, Lorys, aka Kid Baz, began to draw during his childhood. He preferred to scribble in his notebooks instead of listening to lessons. One thing led to another and Lorys left school very quickly. The street culture interested him. He is influenced by all his forms of expression: graffiti, music, etc. He's also a big sneaker addict. His influences are diverse even though he adores cartoons, video games, and Japanese folklore. In 2011, he began his tattoo apprenticeship in a studio located in Caen, then in 2016 joined Calvanostra, the studio created by Sane2.

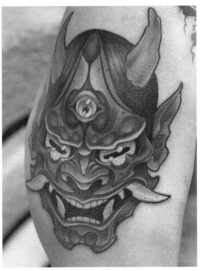

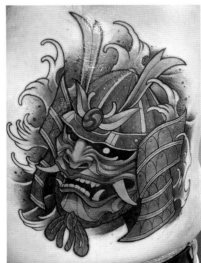

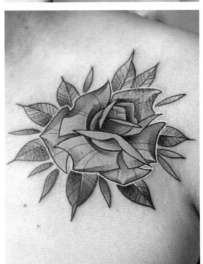

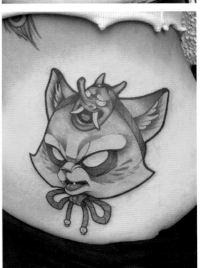

KRESO ERG

Tuscany, Italy

@kreso_erg

TRACKLIST:

Mos Def - *Umi Says*
J-Dilla & The Slum Village - *Fall in Love*
Red Hot Chili Peppers - *Scar Tissue*
Fabrizio De Andrè - *Un chimico*
DJ Gruff - *Cose che*

Creso, Kreso-Erg is an Italian graffiti writer. He started back in 2000 in Florence, his hometown. He worked alone until I started to hang out at the first rave parties, where I met other people with whom I shared the same interest (in particular Rima and the Kbteam). Since he was a child, drawing has been his thing. Traveling to the different European capitals with his family from a young age made him discover graffiti. Cinema has also made a great contribution. He can remember those 1980s movies, set in New York City, where you could see the subway cars all smashed. What a blast!

For Creso, writing has always been a passion to be nurtured and a priority over many aspects of ordinary life. It can drive him into a sort of ataraxia state that makes him feel complete and needless. In some cases it becomes a sort of addiction too (the adrenaline helps), and it is something hard to explain but understandable I guess, since it is a strong common component of every creative process. That's why he loves everything about writing: the smell of the ink, the flow of a nib on a surface, the sound of the same nib on a glass or iron door. Writing with sprays is fun too. The combination of tricks is extensive, the flare variations and the strokes of the different caps, and the personal wrist movement can be a distinctive mark.

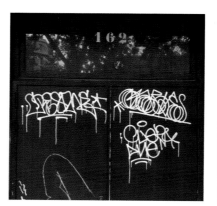

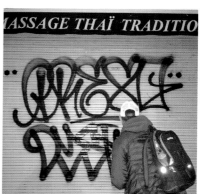

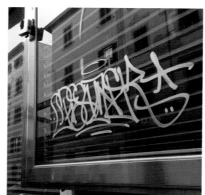

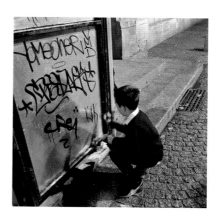

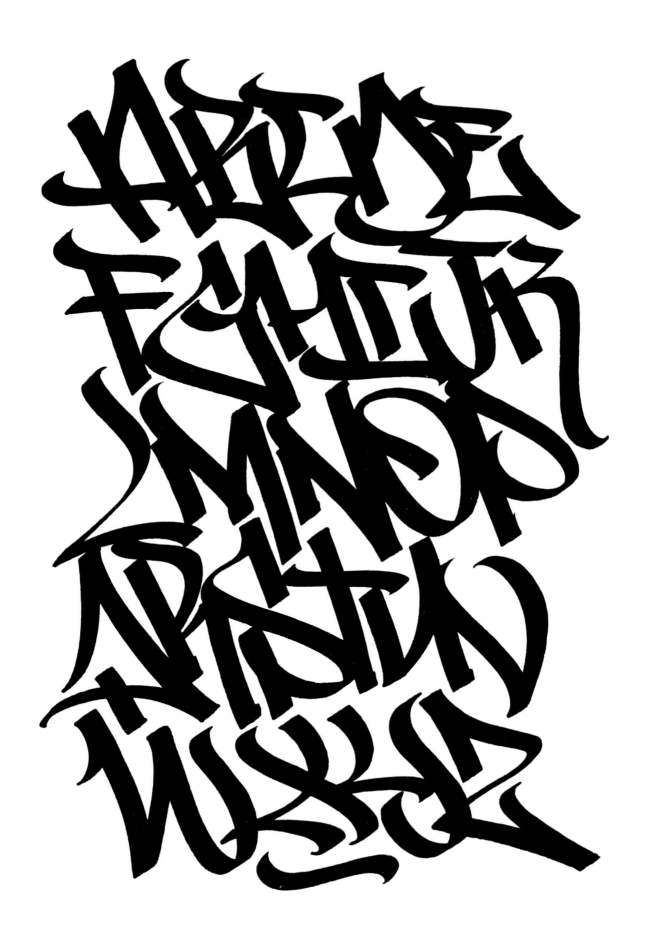

KUPS

Caen, France

@kups.tattoo

Kups is an artist from the graffiti culture. He left school at age 16 and roamed the streets, seeing there a school less academic and less controlled. From his hometown of Caen, via Las Vegas, Washington, Dresden, London, Berlin, or more recently New Caledonia, where he spent many years before returning to Caen, the streets were his first source of inspiration. At 17 he turned to tattooing, applying techniques he developed in his street art experience. One of his famous signature pieces is his famous "kups skull," which he did on all existing supports. Used to the large size the streets offer, Kups uses oils and aerosols on canvas without limiting himself to the size of his works. "At the worst, what can happen?" is the expression that transcends each of his canvases. Obsessions, ossuaries, the street, and painting his contemporaries are his main source of inspiration. Soaking up the grey atmosphere of his city, he uses simplicity to show the essential spark of his subjects; his friends inspired him to capture the unique traits that defined them, and this remains the essence of his artistic approach. His work combines neoclassical portraiture with the graphic approach of street art, creating a whole whose message's driving force remains the expression of life, provoking deep emotions, even uneasiness.

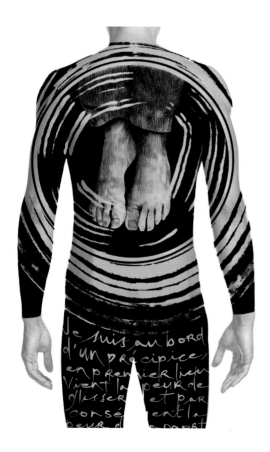

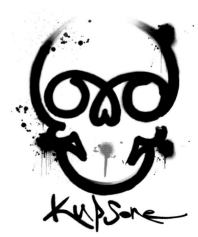

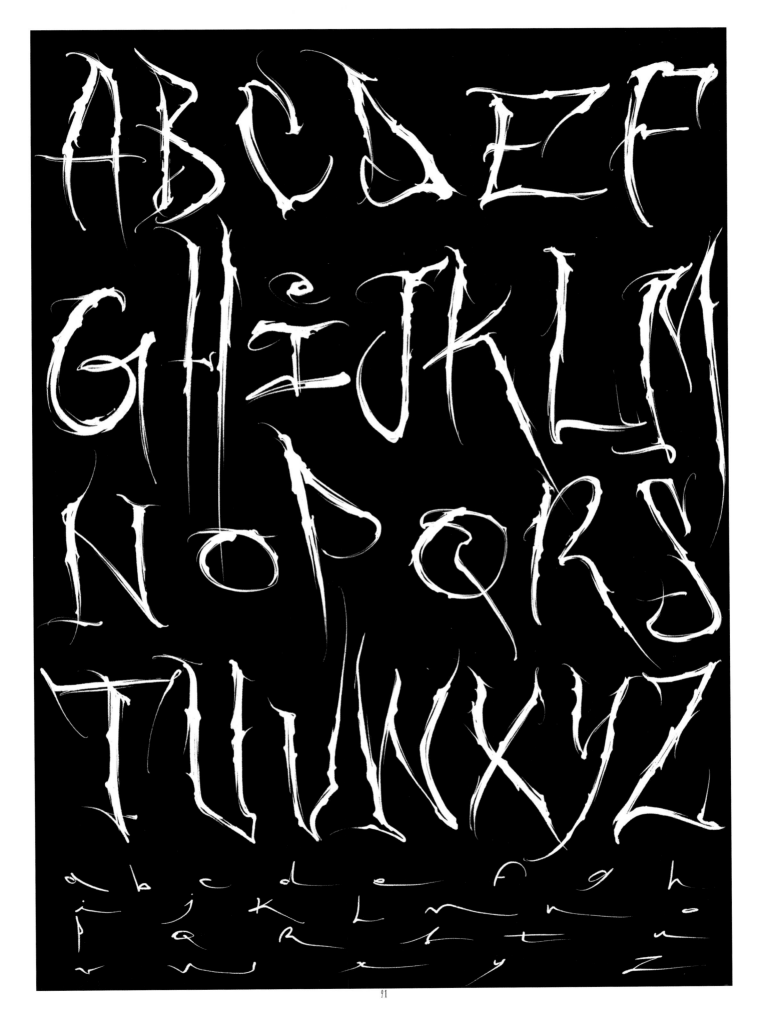

LADY K

Paris, France

@lady.k_156

TRACKLIST:
Elvana Gjata - *A m'don*
браво - *ветер знать*
Znam - *Ceca*
Fake - *Another Brick*
Pusto Ostro - *Marta Savic*

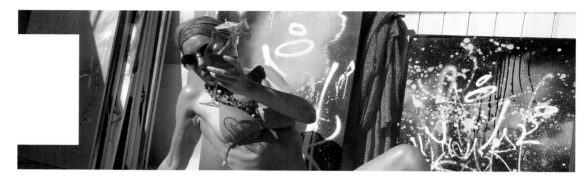

Lady K's main interest is lettering. She's always looking to create it on a maximum of supports, in which the sets and characters are at its service to enlighten them. However, she refuses to distort her activity as a writer by making only canvases: Lady K wants to preserve what makes up the essence of the writer, namely, sketch and walls. She's looking for a link between her external work and her studio production. Her canvases are constructed in such a way as to retranscribe the energy circulating in the world. It's our emotions that configure our reason, when the columns of smoke rise in the sky or it is covered with stars. This molecular cocktail inspired by the environment creates hate, love, revolt, friendship, fear in the heart of an organization based on a Platonic pyramidal system. The tags are part of the anthropocentric path cleared by the Renaissance. They carry within a hedonistic perspective in which everyone can find their place in the world. They also come to disturb an unjust current order that configures our unstable future: from a political, economic, ecological, sociological point of view. . . . This is all that Lady K captures in her paintings, which become a fragment of the world she steals.

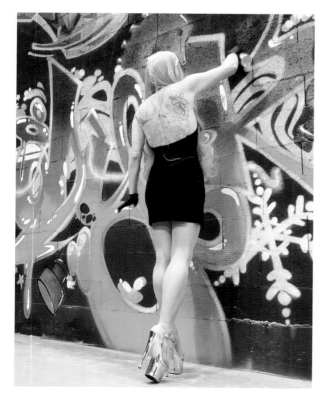

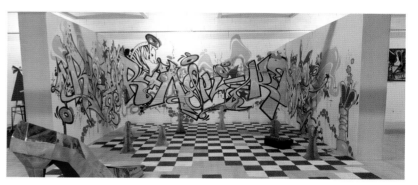

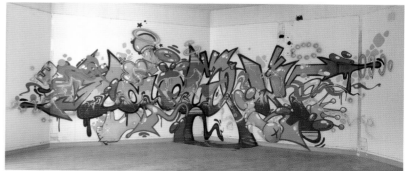

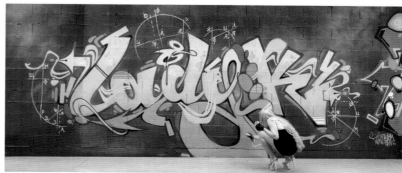

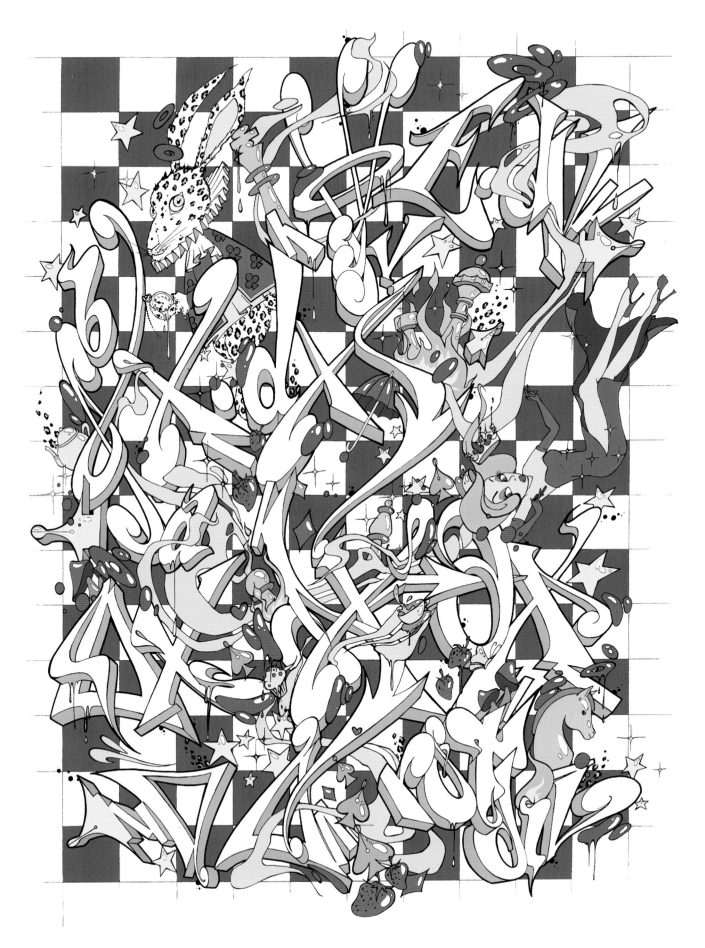

LAUREN WEST

Philadelphia, USA

 @laurencatwest

TRACKLIST:

Funkadelic - *Maggot Brain*
The Jam - *All Mod Cons*
Wire - *Pink Flag*
Yo La Tengo - *Electr-o-pura*
Sun Ra - *In the Orbit of Ra*

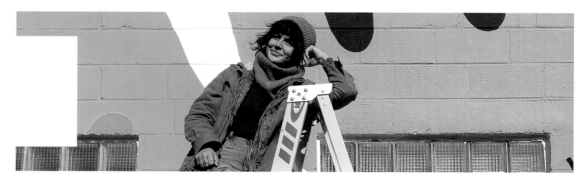

Lauren West is an illustrator, muralist, and designer based in Philadelphia. Her work explores humor, nature, and everyday city life with a focus on simple forms, bright color, and dynamic spaces. Her combination of humor and simplicity pushes her work into a world between strange and playful, but never serious. As a designer and art director, she has worked in design agencies full-time and as a freelance consultant since 2011. Her client work spans the worlds of higher education, small business, consumer brands, professional sports, and food and beverage through branding, marketing, and advertising design. Yes, it doesn't make sense that someone who laughs at her computer the entire time she's working on something because it brings her that much joy can also make serious work for clients. But it's true. She can prove it. As a muralist, Lauren started painting walls in 2015 as an apprentice for a project refurbishing faded business signs in the city. From there she took on bigger projects of her own and eventually painted her first large outdoor mural in the summer of 2017. Her murals can be seen throughout Philadelphia and New Jersey. Lauren paints independently and is also an artist with Mural Arts Philadelphia. Before working as a full-time artist, she worked in the bicycle industry for more than ten years. Cycling still plays a major part in her everyday life, whether riding through the city or in the woods. Man, bikes are so cool.

SWEET, SWEET, PASSIONATE ART

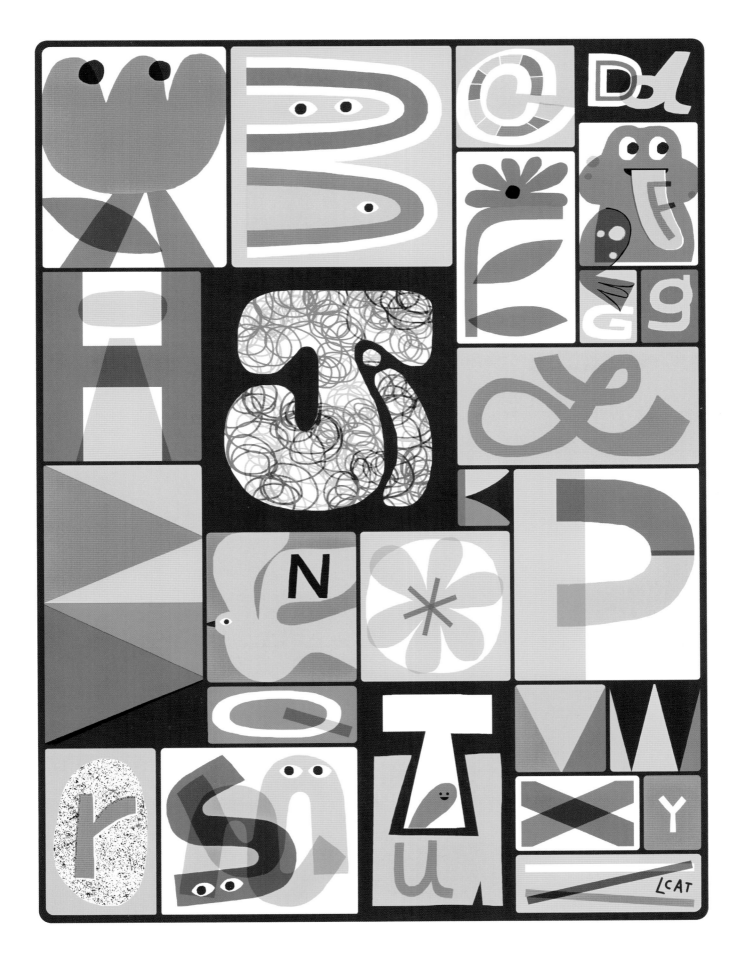

LIGHTON
Paris, France

 @lightonart

TRACKLIST:
Grems - *Algèbre2.0*
Orelsan - *La fête est finie*
50 Cent - *The Massacre*
Travis Scott - *Birds in the Trap Sing McKnight*
Pop Smoke - *Meet the Woo (Deluxe)*

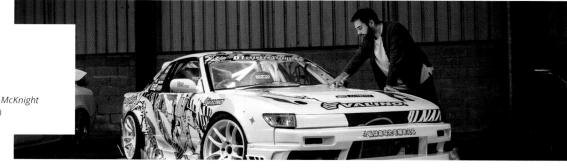

Yohan Quintar, aka Lighton, is a French artist born in 1990. He is an artist and art director based in Paris. Born in Burgundy, he started to work as a graphic designer in advertising agencies at age 16. From then on, he has never stopped working on his own identity. Yohan fell in love with pop art, and since that time he has tried to express his own vision of popular culture by illustrating the common emotions of a generation born in the 90s. To build his style, he mixed all his influences: pop art, advertising's codes, and the reflections of a boy from Gen X with a personal touch of blue. For Lighton, this blue represents the power of life, no skin color, no realistic representations, just the bright color of life. He has worked for many clients, including Red Bull, Dom Perignon, Virgin, Snapchat, Wax Taylor, Air France, and many more.

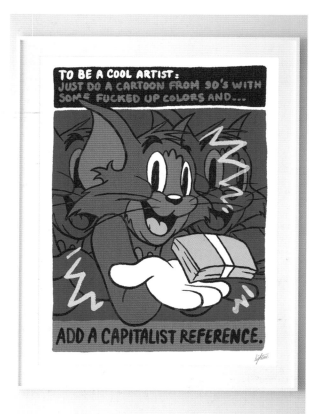

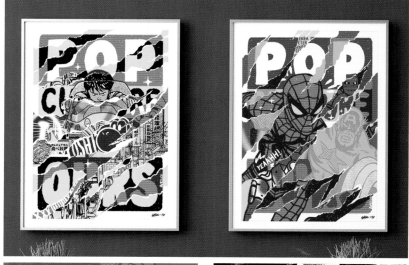

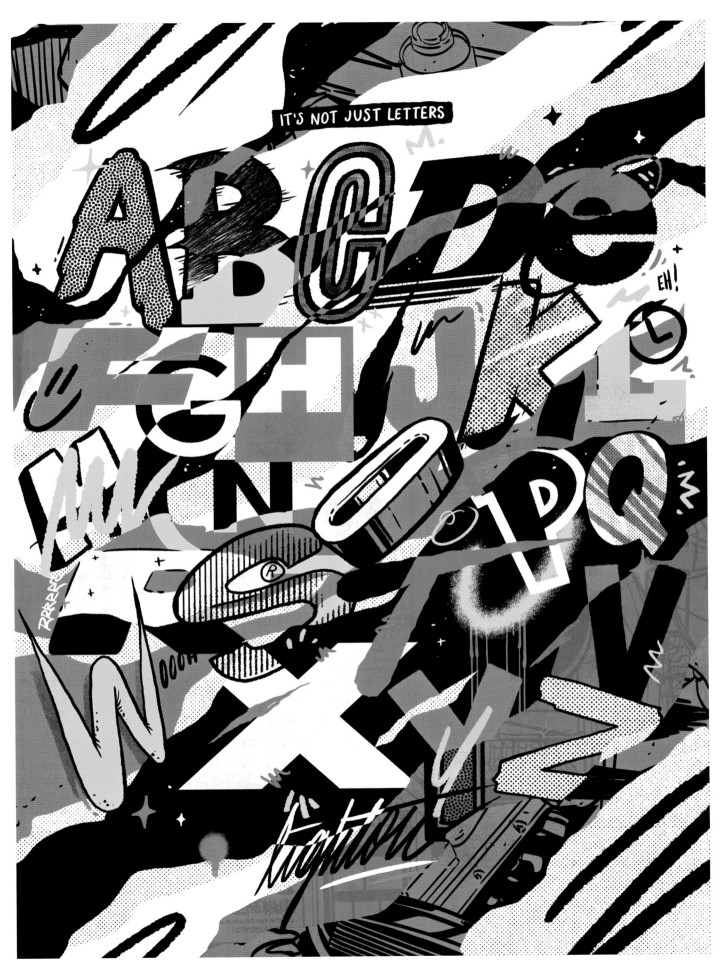

LIZA SHUMSKAYA

Kyiv, Ukraine

[icon] @kino_maniac

TRACKLIST:
Beck - *Colors*
Beastie Boys - *Intergalactic*
Kool and the Gang - *Wild & Peaceful*
Tom Mish - *What Kinda Music*
Woodkid - *S16*

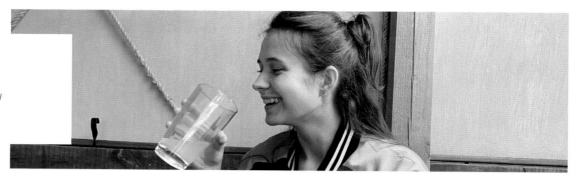

Liza, aka kino_maniac, is a full-time freelance illustrator and poster artist for the past four years. She was born and currently lives in Kyiv, Ukraine. Most of her works are focused on cinema and pop culture. Those things inspire her to create her own art. It's Liza's passion and hobby and she's lucky enough to have turned this passion into a job. Creating posters is a great way to combine all the things that she enjoy so much. It's a unique kind of art that can tell you a story without a word, conveying the mood and atmosphere, whether it's for a movie, game, TV series, or song. Her style is delicate and precise, with a suave touch. She has worked with various clients including the Scorpions, the Strokes, Paramount, Sony Pictures, Netflix, Warner Bros, PosterSpy, ARTtitude, Printed in Blood, Monsa Publications, Collective Alley, Carlotta Films, DNTNOD Ent, TCM Cinema, Вольга, and many more.

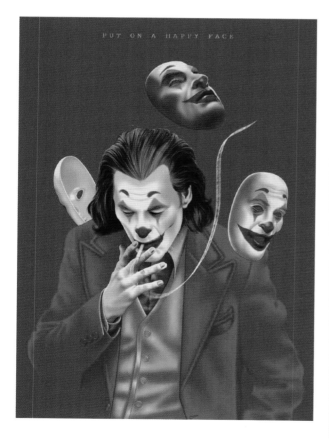

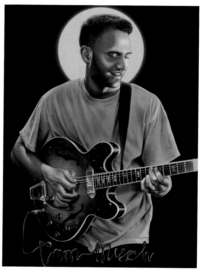

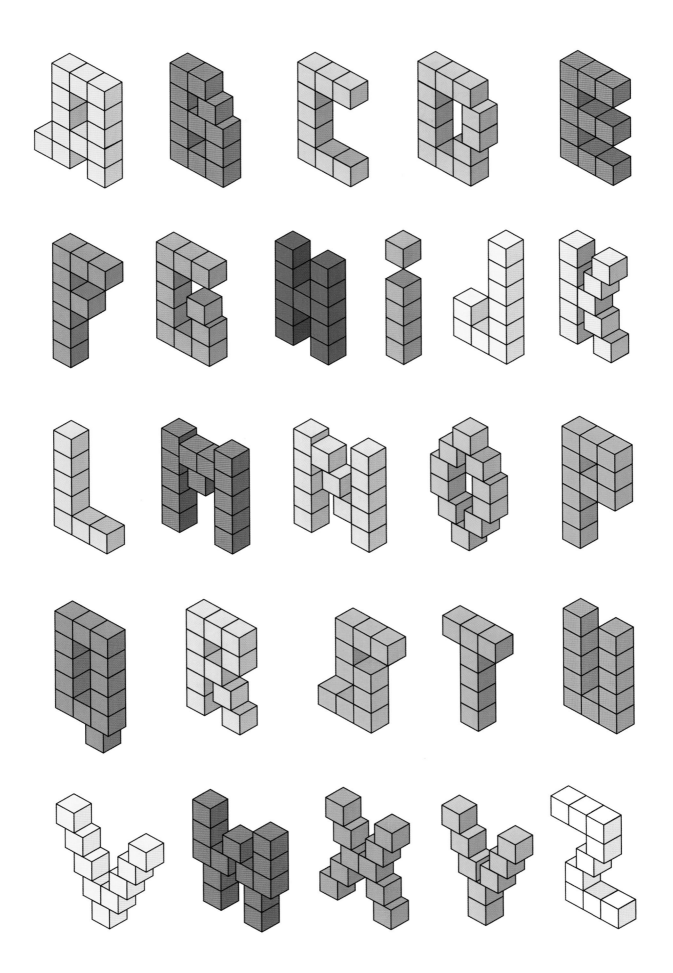

LORD URB'1

Paris, France

📷 @urb1_lord

TRACKLIST:

Mysa - *Piqure de Rap/Mortel*
Groundation - *Hebron Gate*
Immortal Technique - *Black Cargo*
Leo Ferré - *Avec le temps*
Diego El Cigala - *Dos Lagrimas*

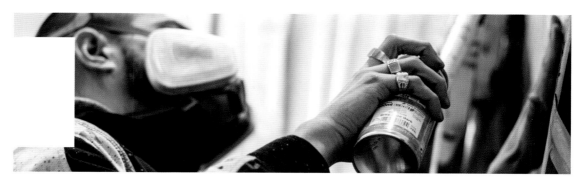

Lord Urb1 (or Urb1) is a Parisian graffiti artist from the graffiti movement of the 1990s. He has drawn since childhood and has always been passionate about lettering and what he calls direct drawing. In 2010 he moved away from traditional graffiti and toward a more abstract expression that mixes calligraphy and geometry. He deconstructs his letters and deletes the fills in order to play on the effect of transparency, thus creating more depth in his works. His taste for calligraphy is felt in his drawing, which combines style and dynamism with a stroke of the pen. Lord Urb1 was introduced to graffiti on walls, and it is only natural that he approaches new supports (canvas, vinyl, etc.) and materials; he is constantly looking for graphic evolution. Travels and meetings allow him to integrate several groups. He is involved in many cultural actions, mainly through animation street-art workshops, especially abroad.

He is now embarking on a new adventure: the art of tattooing.

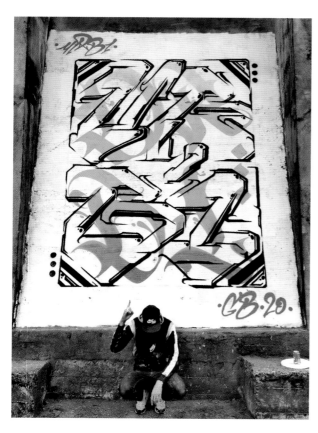

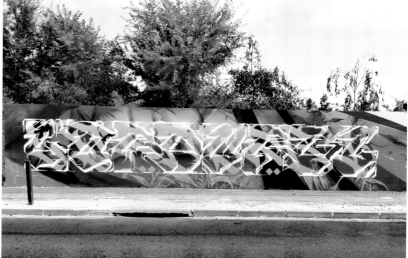

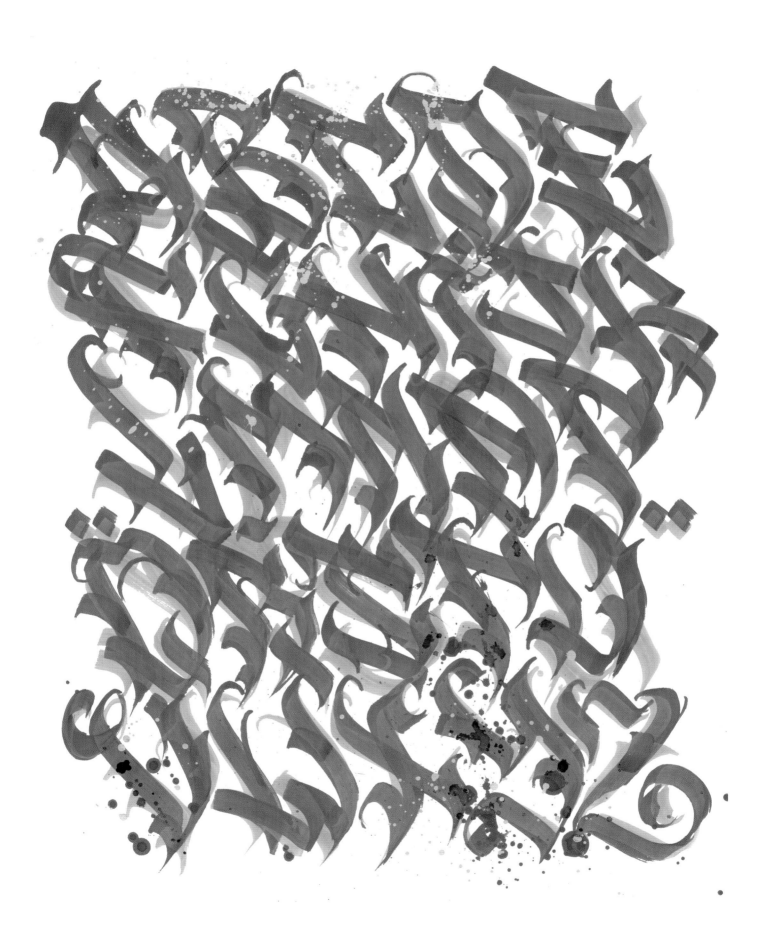

MAMBO

Apt, France

@instamambo

TRACKLIST:

Ella Fitzgerald and Louis Armstrong - *Ella & Louis*
Serge Gainsbourg / Sly & Robbie - *Aux Armes Etc...*
Curtis Mayfield - *Curtis*
Shivkumar Sharma - *Call of the Valley*
Ritmo Mundo Musical - *La Combinacion Perfecta*

Flavien 'Mambo' Demarigny was born in Chile in 1969; his father was French and his mother Hungarian. He grew up in Latin America and started his artist career in Paris in the mid-1980s. He has lived and worked in Los Angeles, California, since 2011. Mambo is a polyglot artist, capable of choosing what he needs from his language palette to express his feelings in the moment. His different series shift from semi-abstract graphic interplays of lines and spontaneous designs (Brainology) to abstract action painting (Strokes series) to minimal portraits (Humans), all using his signature red-orange color. He creates an expressive graphic universe, full of underlying meanings, combining observation, ambiguity, and humor. The core theme is humanity, and the inspiration is our brain, our mental processes, sensations, emotions, memories, inner feelings, and mechanical reactions. Human behaviors become colorful ideograms; our environment becomes a dictionary, from which he picks symbols to write his own prose: visual enigmas, combining intuition and mastery.

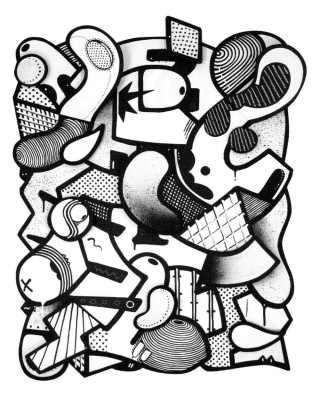

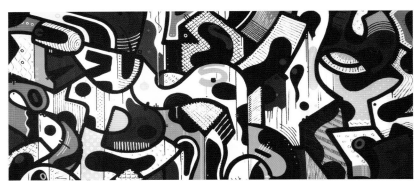

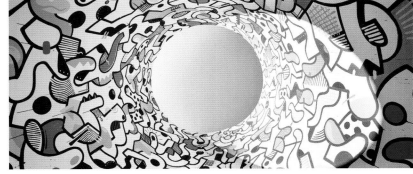

A B C D E F G
H I J K L M N
O P Q R S T U
V W X Y Z

1 2 3 4 5 6 7 8 9

→ () / : + x ~ #

mambo

MANON ORANGE

Caen, France

@manonorangedesign

TRACKLIST:
Fleetwood Mac - *Rumours*
Tame Impala - *Currents*
The girl from ipanema
Still Corner - *Strange Pleasures*
Etta James - *At Last!*

Born in 1996 in Flers, in Lower Normandy, Manon was passionate about drawing from a young age, drawing inspiration from the many trips made during her childhood. When the time came to study, Manon got a bachelor's degree specializing in applied arts, which encouraged her to refine her pencil line. This training allowed her to forge a critical look at the arts; It was then she understood that beyond its purely technical aspect, artistic creation is a true philosophy. Next she will attend the famous Brassart school in Caen, where she will have the opportunity to perfect herself and discover various artistic techniques while acquiring solid knowledge in marketing. She works as a freelance graphic designer in Caen. Her goal is to settle in Montreal; the excitement of the city inspires her. Being self-employed is an ideal combination that allows her to perfect her artistic style while ensuring that she meets the needs of her clients and supports them in their projects without ever losing sight of the objective of offering them an adequate visual identity.

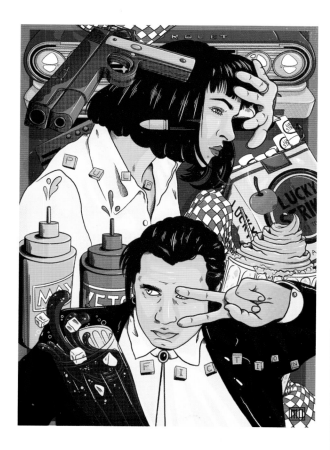

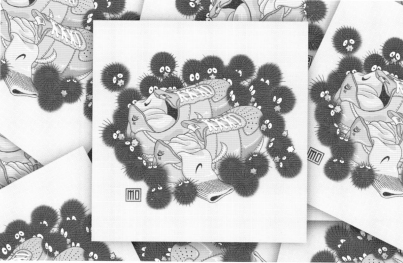

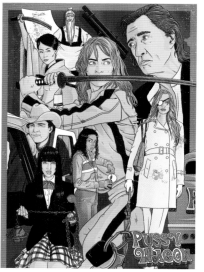

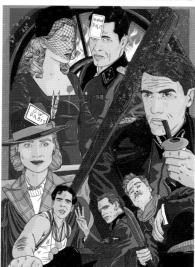

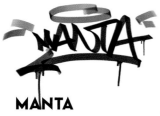

MANTA

Caen, France

📷 @goldenkara94

TRACKLIST:
NCA Crew - *Diseurs d'images*
IAM - *L'école du micro d'argent*
FLYNT - *J'éclaire ma ville*
Première Classe - *Volume 1*
Nekfeu - *Les étoiles vagabondes*

Originally from the Val de Marne (east of Paris), Manta became interested in graffiti at the end of the 1990s when he saw the graffiti near his home while going to college and on the metro line. He remembers the colorful frescoes of the P19s on the lanes, the bludgeoning of Inser (RIP), and Nebay visually slapping him hard. He tagged and did graffiti solo without really calculating what he was doing. Then in 2005, he met Adoré of the RJKs, who taught him the fundamentals of this movement. He quickly got a taste for the adrenaline rush of this practice, and focused his main actions on the walls of the various highways. Over time and meetings, he joined the NCA - RJK - DW - A2R and H2 crews. He also loves spending cool time on the grounds with his friends and his wife (Venus), who also paints and looks for abandoned and virgin places to make her mark.

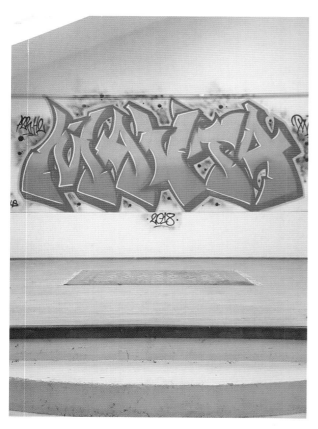

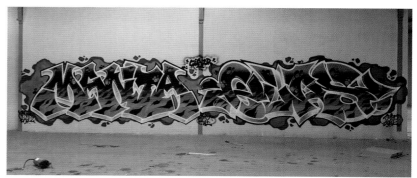

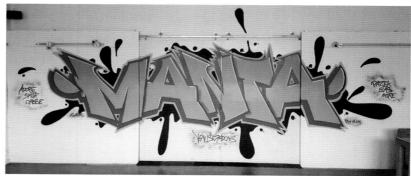

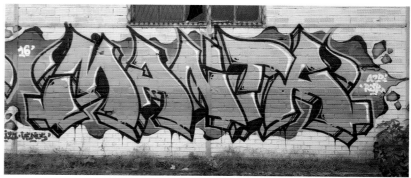

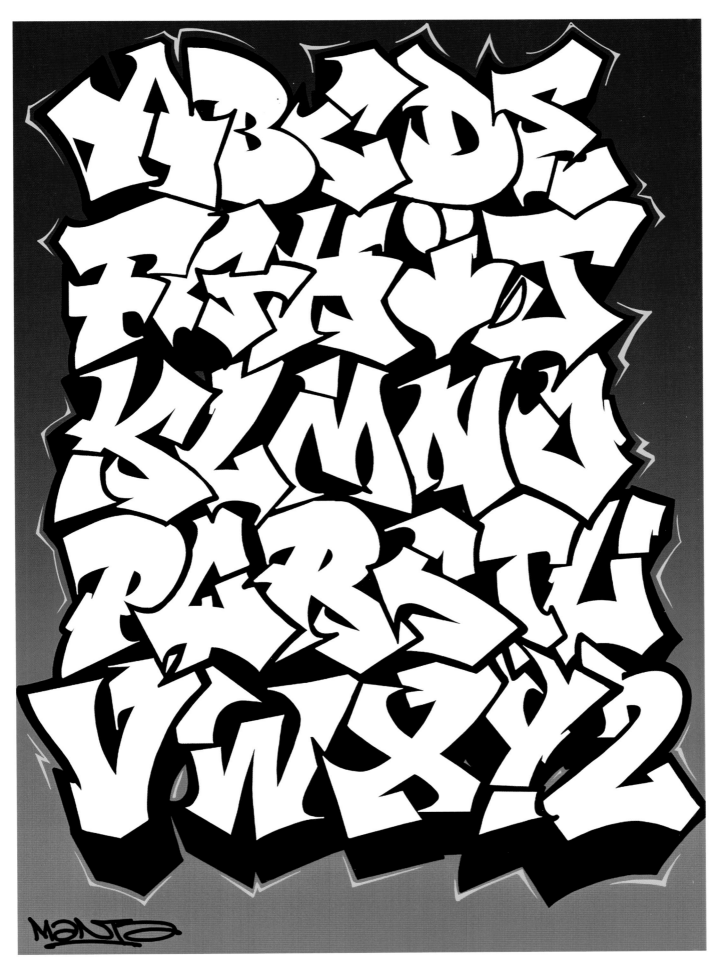

MANUEL REGALADO

Guatemala, Guatemala

@reggalado

TRACKLIST:
Kashmir - *Zitilites*
She Wants Revenge - *She Wants Revenge*
Kavinsky - *Outrun*
Massive Attack - *Mezzanine*
White Lies - *To Lose My Life*

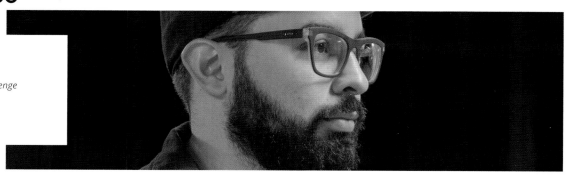

Manuel Regalado is an illustrator and graphic designer born and based in Guatemala City. He graduated in 2010 from the University of San Carlos of Guatemala with a bachelor degree in multimedia and graphic design. After graduating he worked for more than five years as project manager and art director at FOX International Channels. He also worked as a freelance illustrator for advertising companies BBDO, TBWA, Saatchi & Saatchi, and Ogilvy.

His favorite medium is digital but he uses a wide range of techniques, moving from pencil to ink, acrylics and sculpture. He's heavily inspired by movies, sci-fi, comics, mangas, anime, and old cartoon shows. His passion for art has given him the opportunity to exhibit his work in Guatemala, New York, Belgium, Argentina, and the UK.

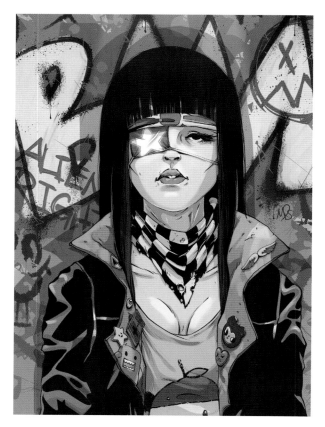

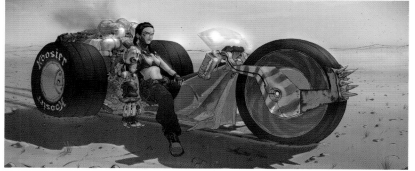

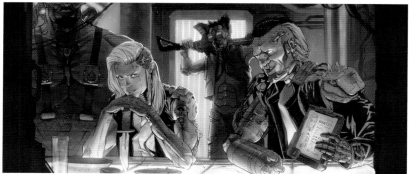

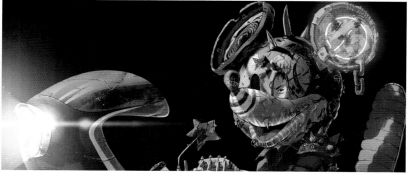

ABC ÷ D
EFGHI
> JKLM
NOPQR
STUVW
XY = Z :

MANYAK

Paris, France

 @manyak_paris

TRACKLIST:
Heltah Skeltah - *Nocturnal*
Cannibal Ox - *The Cold Vein*
Souls of Mischief - *93 'til Infinity*
Eto / Flee lord - *Roc Amerikkka*
Ghostface Killah / BadBadNotGood - *Sour Soul*

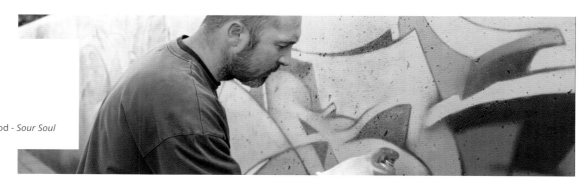

Originally from the southern suburbs of Paris and passionate about drawing, Manyak encountered graffiti in 1988 at the age of 13. First on paper and then quickly on the wall, his letterwork is classic. After two years of drawing in this direction and trying his hand at tagging, he produced his first color fresco with his group at the time.

In 1995 (the year he joined the Paris Belleville School of Architecture) he turned to 3D lettering and became one of the first and main representatives of this style in France. Even though he regularly makes characters and decor, defender of the "graffiti spirit" Manyak remains attached to the work of the letter in all its forms: tag, throw up, 2D or 3D lettering, calligraphy. At the same time, he took an interest in anamorphoses and the integration in his paintings of the architecture, materials, and atmospheres present in the places where he intervenes. The support becomes the background, staged by the work that imposes itself. The photography of the final rendering takes on its full meaning in the creative process. In recent years, his production has developed in the workshop as a continuation of his plastic and graphic work of the letter, allowing a widening of the fields that can be exploited on canvas or in sculpture. Generally, the supports and materials are varied, sometimes worn, patinated like the walls he likes. The letter is then a pretext for painting, a subject of study sometimes pushed to the point of abstraction where structure, texture, and dynamism mingle.

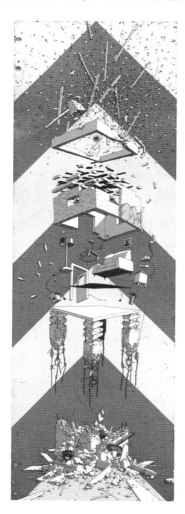

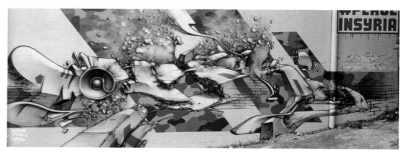

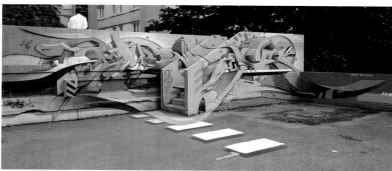

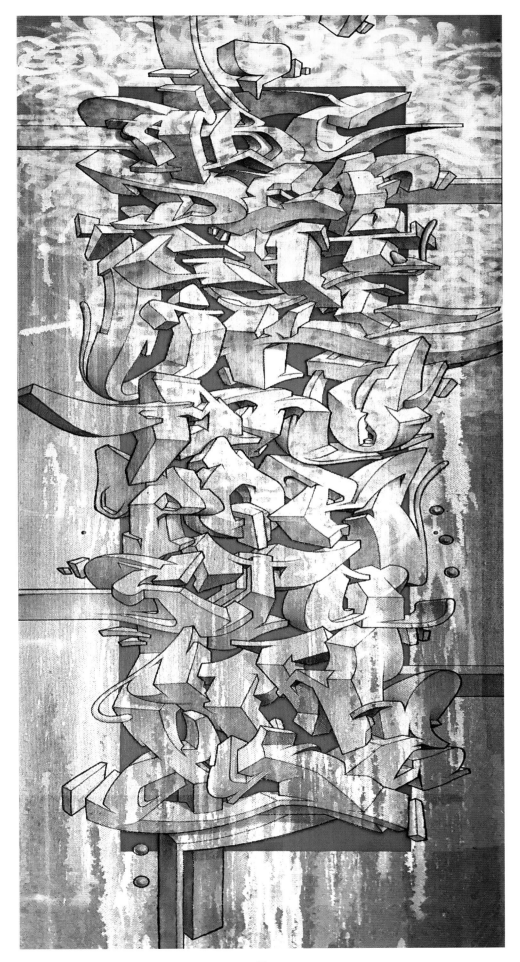

MARCOS CABRERA

Barcelona, Spain

@marcos_cabrera

TRACKLIST:
Guns and Roses - *Appetite for Destruction*
Soundgarden - *Superunknown*
Nine Inch Nails - *Fixed*
Misfits - *Walk among Us*
Motorhead - *Ace of Spades*

Marcos Cabrera is an illustrator, graphic designer, and tattoo artist based in Barcelona. He was born and raised in Santa Cruz de Tenerife (Canary Islands) and graduated there with a degree in fine arts in 2001. Afterward, he worked in several advertising agencies as a graphic designer and illustrator. In 2004, the call of the creative community, as he likes to say, drove him to Barcelona to take courses at the prestigious Massana Permanent Art Academy.

He is strongly influenced by the culture of skateboarding and surfing, and by the metal, punk rock, and hardcore subcultures (Jim and Jimbo Phillips, Courtland Johnson, Pushead, Ed 'Daddy' Roth). He is also inspired by science fiction and horror. His production is quite large: posters, art reproductions, merchandising, record covers, skateboards, textiles . . . His' illustrations fascinate with their array of monsters, zombies, and demon-vomit howling skulls eating the brain of an unsuspecting victim. They ooze the frightening horror of the fever of childhood nightmares. Marcos works all over the world, and his client list would make anyone green with envy: The Kooples, Desigual, Last Tour International, Century Media, Nuclear Blast, Vans, EMI Spain, House of Marley, *Vice* magazine, G-Shock, Resurrection Fest, Converse, Boss Gear, IronFist, Long Island Longboards, Jart Skateboards, and *Total Guitar* magazine.

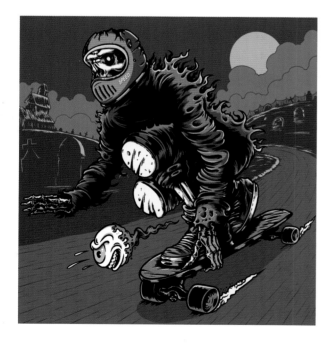
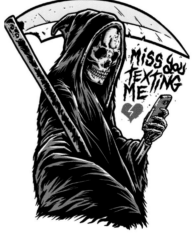
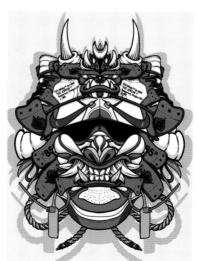

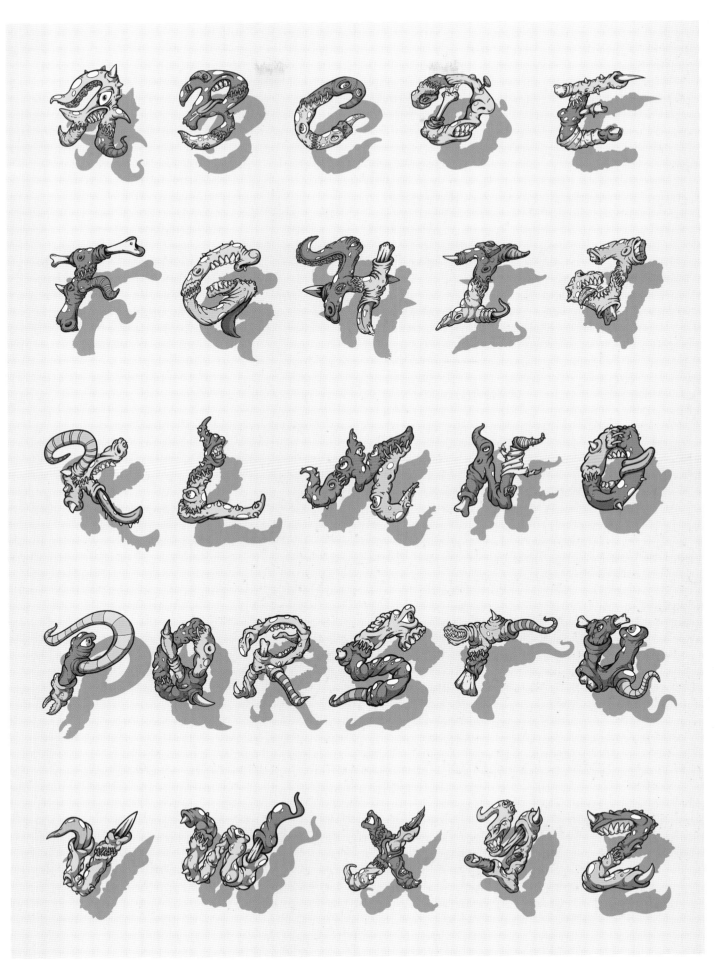

MARY FRANCOIS

Paris, France

maryfrancois_illustrations

TRACKLIST:

Dillon - *This Silence Kills*
The Neighbourhood - *I Love You*
Purple Disco Machine - *Hypnotized*
Jabberwocky - *Lunar Lane*
Daughter - *The Wild Youth EP*

Mary François is a freelance illustrator in Paris. From an early age, she has been passionate about art and is particularly interested in the aesthetics of graffiti, tattooing, and urban art; she is also a big fan of comics and cartoons. These influences, inspired by her childhood, are now found in her illustrated posters, which mix "cartoon" characters, typographies, and ornaments, entirely made by hand. She works exclusively in black and white, contrasting and graphic, and her production is striking and funny, fresh and recreational. Mary works equally well with clothing brands, restaurants, and shops as well as with individuals. For the past two years, she has embarked on the customization of skateboard decks, which she paints by hand and in colors, on themes such as pop culture and video games, personalized at the customer's request.

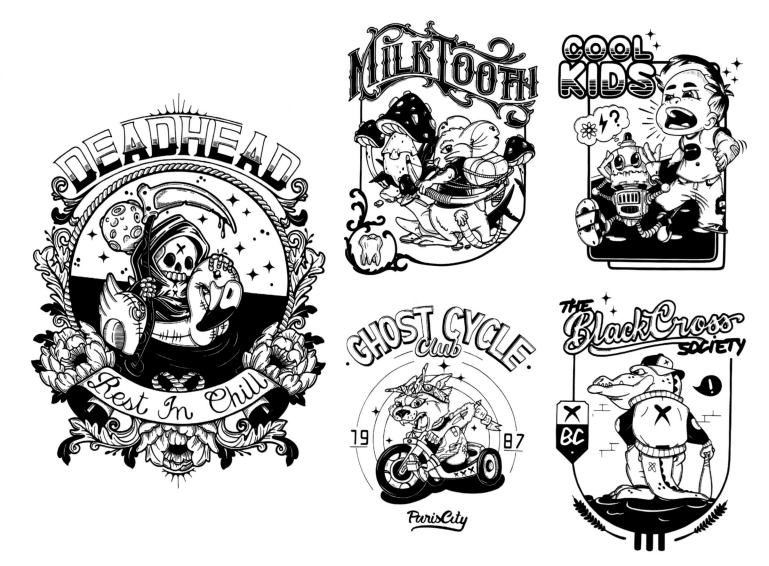

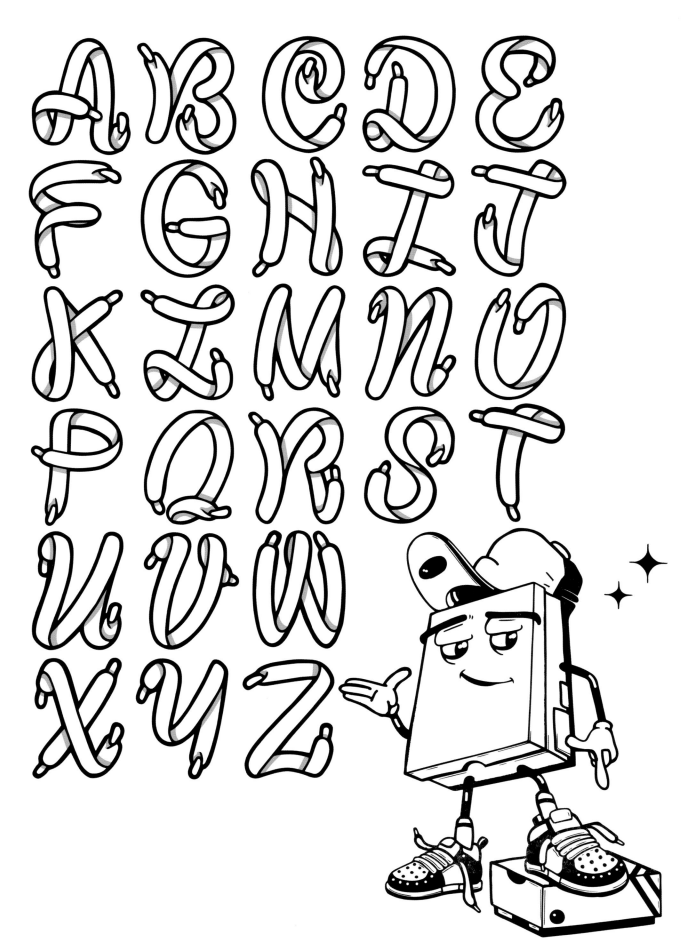

MARYNN LETEMPLIER

Biarritz, France

marynn_letemplier

TRACKLIST:

PJ Harvey - *is this Desire ?*
The Smiths - *The Queen is Dead*
Slowdive - *Souvlaki*
Warpaint - *Warpaint*
Ty Segall - *Melted*

Marynn's style is influenced by the rollercoaster of love and life. She likes to play with symbolism, imagining stories articulated with feminity and poetry, sometimes in her hyperrealistic style in graphite or oil painting, sometimes with photography or typography. She likes to explore different styles and techniques, keeping her curiosty awake to navigate her dreamy world. From a first love guided by graphite, Marynn is known by her works in a hyper-realistic style, featuring an imagination populated by women and emotions, one foot in melancholy, the other in finesse, navigating a universe where the crack is aestheticized and the fragments make a whole. She learned calligraphy from her grandmother, in particular Gothic lettering, with its beveled feathers. As a tribute, she took up the pen again years later and breathed new life into the Gothic alphabet. From this variation, she used the medium of tattooing to ink poems on people's skin.

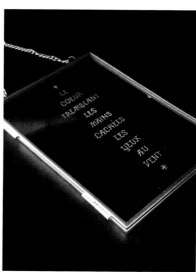

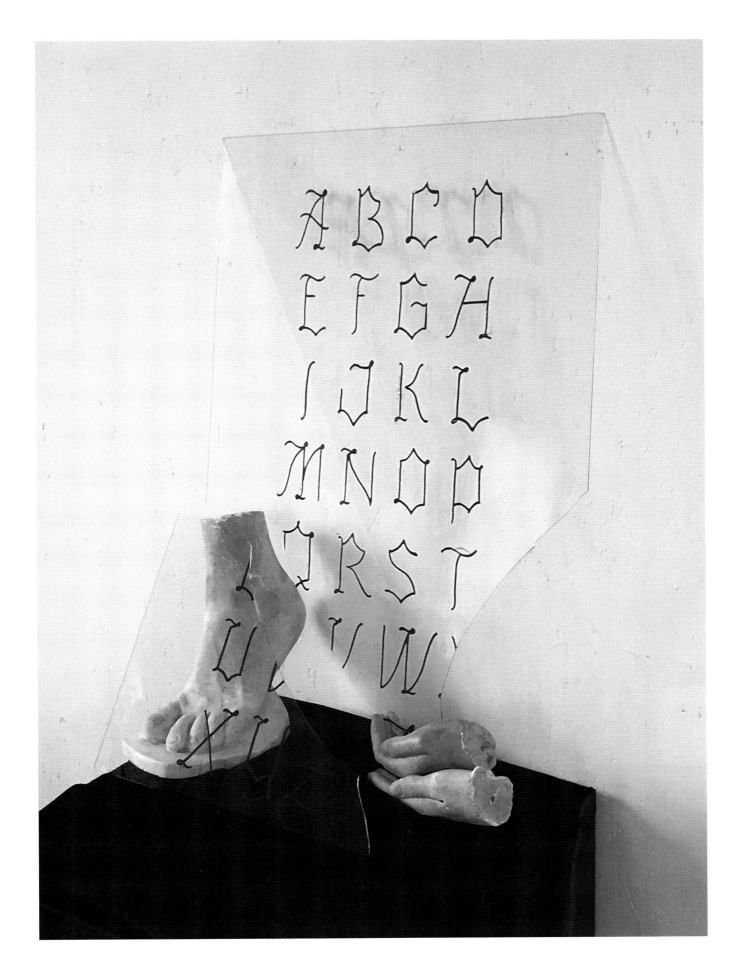

MATEUSZ WOLSKI

Pajęczyna, Poland

@wlk_calli

TRACKLIST:
Guzior- *Pleśń*
Lil Kim- *Hard Core*
Da Vosk Docta
Słoń – *Redrum*
Taco Hemingway – *Europa*

Mateusz Wolski, aka WLK, was born in 1988 in Jaworzno. He is a graduate of the Faculty of Graphics and IT of Slaska Wyzsza Szkola Informatyczno-Medyczna. He planned and prepared his master's dissertation under the direction and supervision of the famous Polish graphic artist, painter, woodcutter, and designer Roman Kalarus. Mateusz has been practicing calligraphy for over 11 years. He works as a tattooer in Pajęczyna studio in Cracow. He also design logotypes and apparel, and he spends a lot of time painting. His main inspirations are works by such renowned artists as Roman Cieślewicz, Franciszek Starowieyski, Adam Romuald Kłodecki, Pokras Lampas, Big Meas, and Niels Shoe Meulman. He is also interested in poster art, graphic design, street art, graffiti, skateboarding, and tattoos.

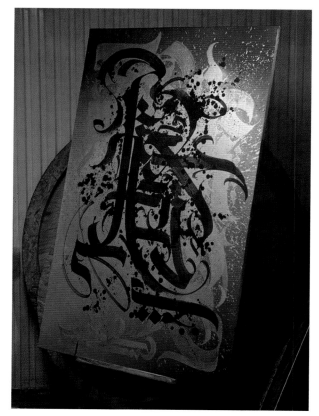

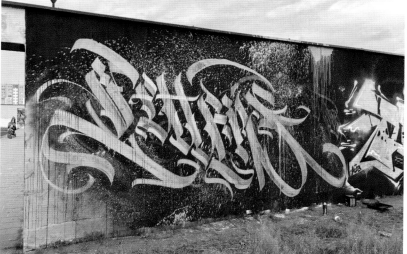

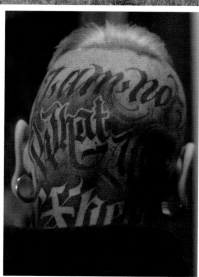

a b c d e
f g h i j k
l m n o p
q r s t u
v w x y
z

MATT HEATH

Sydney, Australia

@mattheathart

TRACKLIST:
Phoebe Bridgers - *Stranger in the Alps*
Bon Iver - *22, A Million*
Def Leppard - *Hysteria*
Propagandhi - *Supporting Caste*
Alkaline Trio - *Agony & Irony*

Matt is a skull sketching pen addict, illustrator, and concept artist working in the advertising, film, and games industries. Inspired from an early age by *Star Wars* films and 2000AD comics, his waking hours are consumed with design and art projects. With ARTtitude, Matt has worked on projects for Konami, Nintendo, World of Warcraft, and Wargaming. His first foray into feature films was the sci-fi drama *Terminus*, released in 2016; that same year he published a tutorial in *Digital Painting Techniques* volume 8 by 3DTotal. He continues to teach concept-art workshops and develops online tutorials. Matt also creates art digitally, loves his Wacom devices, and has a stack of Photoshop brushes you definitely need to check out. He lives in sunny Sydney, Australia, with his family and spends way too much time drawing skulls on Instagram.

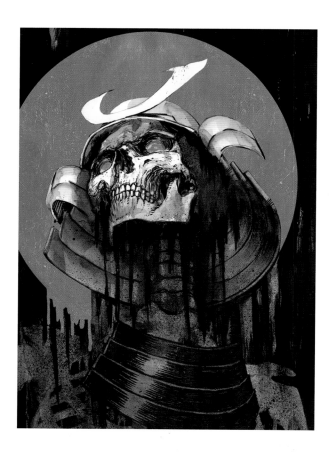

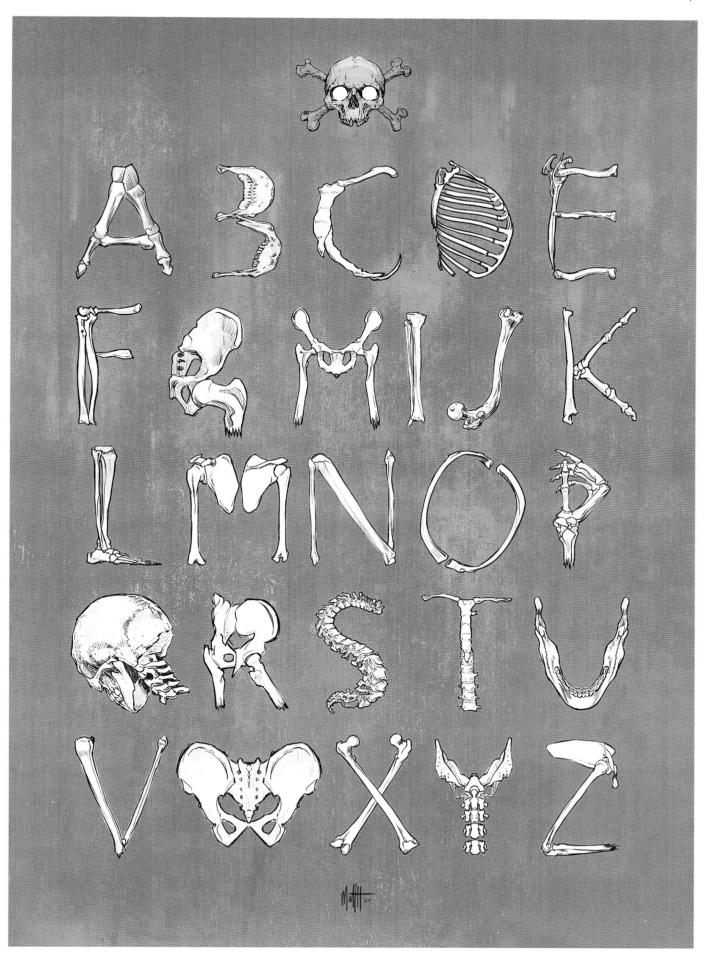

MATTHIEU DAGORN

Paris, France

@matthieudagorn

Matthieu Dagorn earned a diploma in plastic arts (DNAP) at the Beaux-Arts school of Quimper, and in 2008 he met the Parisian collective 9th Concept. What distinguishes him above all is the highly particular way that he inscribes his art in the postmodernist movement, which favors geometric and organic currents. At the center of all of his abstract and figurative constructions, he uses a structure of ribbons with voluptuous and elegant qualities. These ribbons are reminiscent of a DNA structure and therefore have an organic constituent, such as two antiparallel strands wrapped around each other to form the famous double helix. By appropriating the patterns of geometric or organic abstraction, Matthieu expresses personal content that is also revealing of the current creation. He joins the movement of contemporary artists who do not want to renounce the visible world while taking care not to completely reject abstraction, which he considers a modernist tool. He creates frescoes with volume, made of recycled materials, taking on a new dimension. The click is there; rather than staying flat, Matthieu wants to invest the space and plunge the viewer into his universe. While keeping his artistic line, Matthieu seeks suitable materials to transcribe all the spirit of his paintings in volume. He plays with wood, plastic, and metal. The mask is predominant in the work of Matthew, to protect him from the enemy, a kind of anthropology of the mind, to find the lost beliefs, the natural energies that surround, the forces diffused by nature and animals.

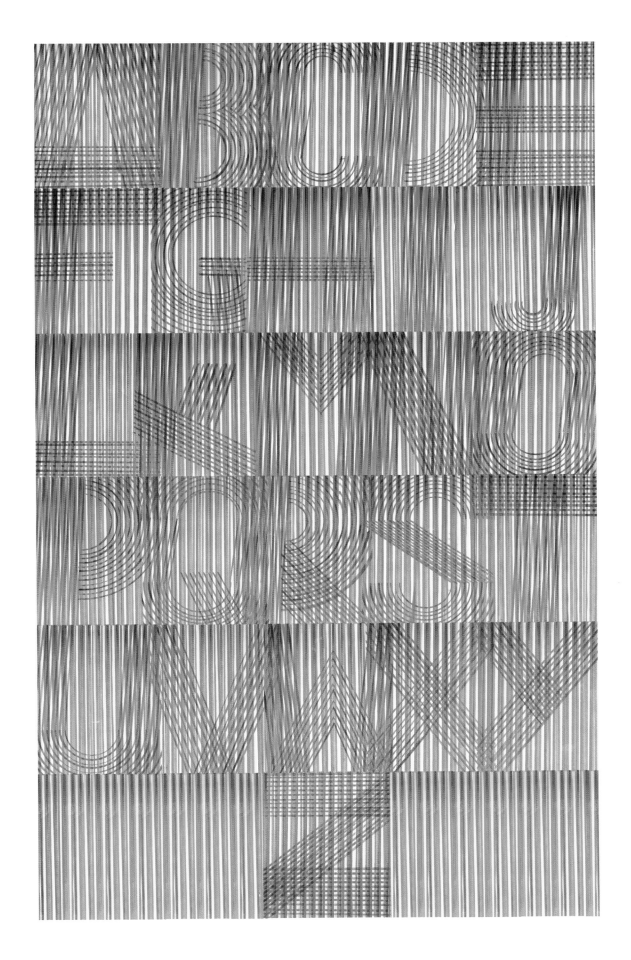

MAVIOU DEGOUB

Alfortville, France

@maviou_degoub

Maviou Degoub, also known as Blarf in his early days of illustration, was born in the Parisian suburbs. He developed a taste for graphic art in a school for visual communication. In 2006 he became a photographer for the duo Mamzelle & Maviou. The two accomplices covered the Parisian soirées and took fashion photos for *Street Tease* magazine. His first passion for illustration dates back to his sticker days when he used to "eat Crayolas," as he says. At one point he set his sketches aside to concentrate on photography and realized quickly that he couldn't live with one without the other. His illustrations even took a central place in his skills, time, and motivation. His main talent was here. Influenced by Mcbess, Mike Giant, Serre, Alex Ross, Dran, and many others, his style is unique: a mix of black humor, glamour, trash, and pop culture. He worked for many clients in the fashion and music industries before starting a new chapter with tattoo. Under the guidance of Yome, he's now a full resident at Ravenink Tattoo Club in Paris. Tattoo machines have replaced the crayolas, but the spirit and his dark humor remain the same.

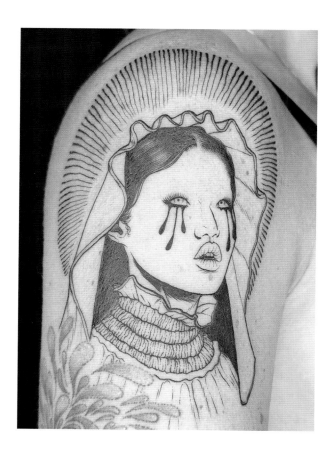

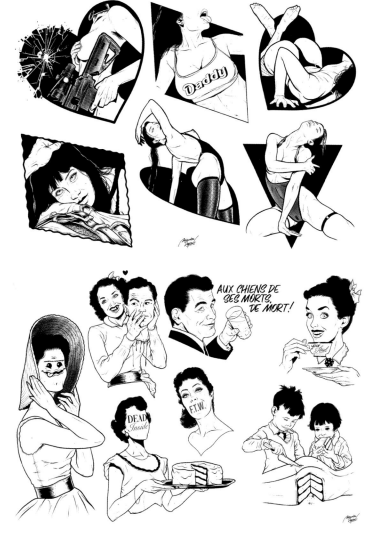

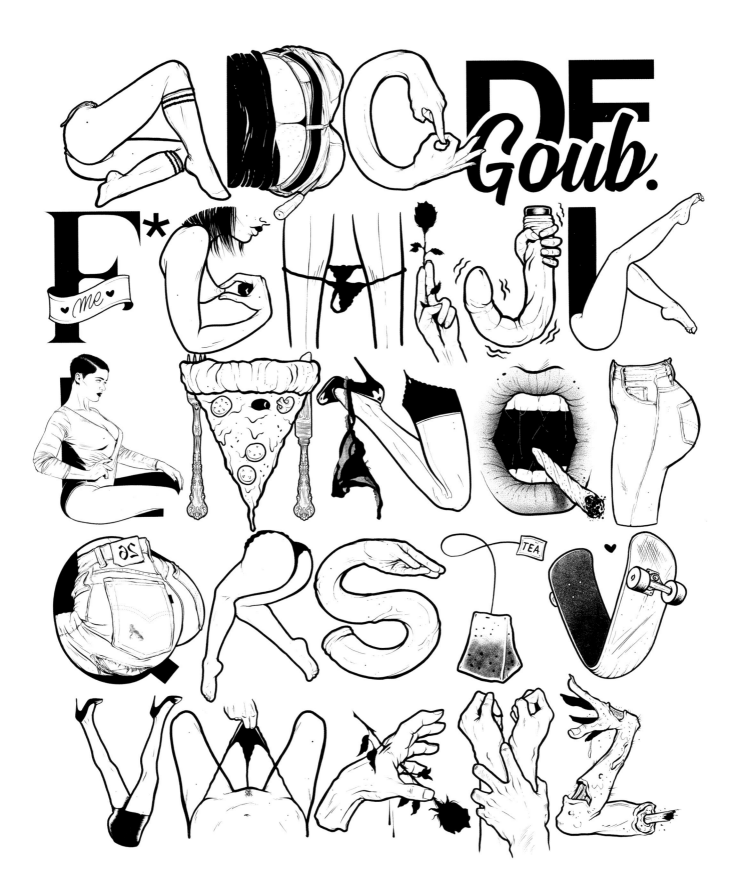

MICHAEL CHERNOZEM

Minsk, Belarus

@chernozzem

TRACKLIST:

Kalya Scintilla - *Woodland Womp*
Смоки М - *Время тигра*
Pearly Goats - *Death & Reckoning*
Sigil - *Symbiont Simian*
Onyx - *Shut 'Em Down*

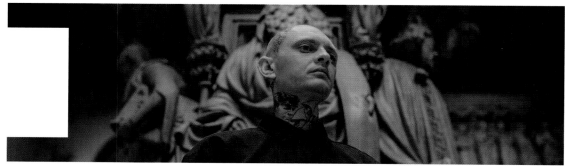

Michael Chernozem was born in a small town called Stary Oskol, in the south of Russia. He's an avant-garde underground tattoo artist-couturier and has been tattooing for four years. Michael thinks tattoo is close to fashion; he's really interested in creating truly unique designs of "human" costumes. Here is the uncharted field for self-expression and growth. He's now living in Minsk, Belarus. Michael really loves this city and the wonderful people from here. His creative journey began when he was a child, when his mother and grandfather (a People's Artist of the USSR) were painting. But his personal growth and vision were influenced by 90s hip-hop culture, especially graffiti and breakdance. He does not have an art education but has develped special skills from self-education, from his people, and from friends who have degrees in art. They always share answers to questions he's concerned about. Art is a dialogue for Michael, with himself and a spectator, through which one can visually convey one's inner and outer experiences connected to one's personal life experiences. He makes no plans for the future, but lives freely and does as he feels. Spontaneity, experimentation, and development are his lifelong challenges.

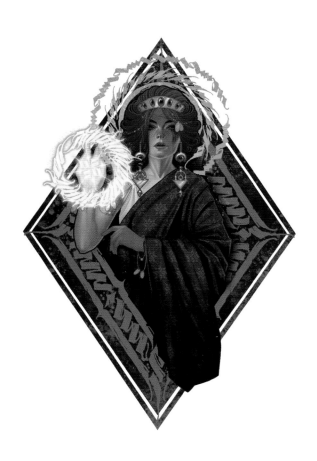

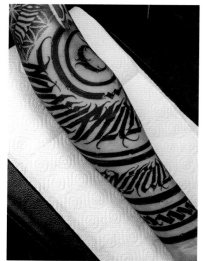

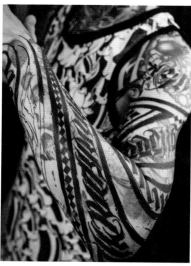

Aa Bb Cc Dd Ee

Ff Gg Hh Ii Jj

Kk Ll Mm Nn

Oo Pp Qq Rr

Ss Tt Uu Vv

Ww Xx Yy

Zz

MIKE DYTRI

Los Angeles, USA

 @ludwigvantheman

TRACKLIST:

Miles Davis - *Bitches Brew*
Prince - *Controversy*
Jane's Addiction - *Nothing's Shocking*
Bob Marley - *Legend*
Led Zeppelin - *Physical Graffiti*

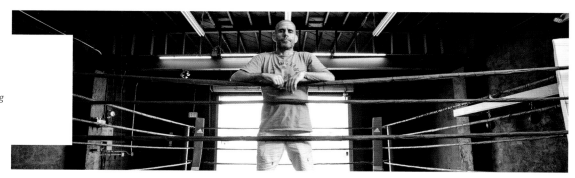

When it comes to lifestyle and fashion in the jiu-jitsu world, Mike Dytri is the man to follow. He is former creative director of Storm Kimonos and Adidas Combat Sports, founder of Sub Freakie, a company he sold to a subsidiary of LVMH in 2003, and creator of his own brand Ludwig Van, which did collabs with Vans and was sold in fashion stores around the globe including Colette in Paris. Also the man and the mind behind Vanguard Kimono, Mike is a true thinker and creative. He pushes boundaries, mixing sport and haute couture with denim made in the USA. Thanks to his background rooted in street culture, he was one of the first to see and understand the bridges between BJJ, art, culture, and lifestyle. The man who started his martial arts journey with Kyokushin karate, judo, and kendo wanted to imitate Bruce Lee, like most of the kids in the 70s He even watched *Enter the Dragon* every day from fifth to seventh grades. After a long journey into martial arts, which led him to Japan (and two amateur Shoot fights), Mike ended up becoming a black belt under Chris Haueter, one of the famous BJJ Dirty Dozen.

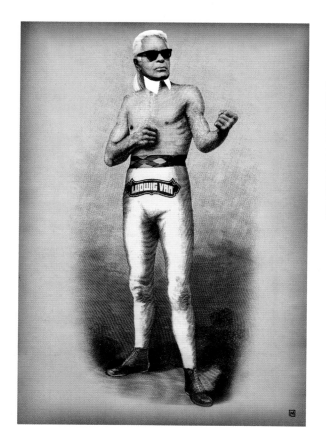

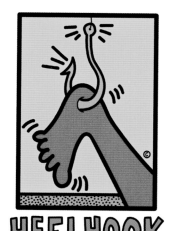

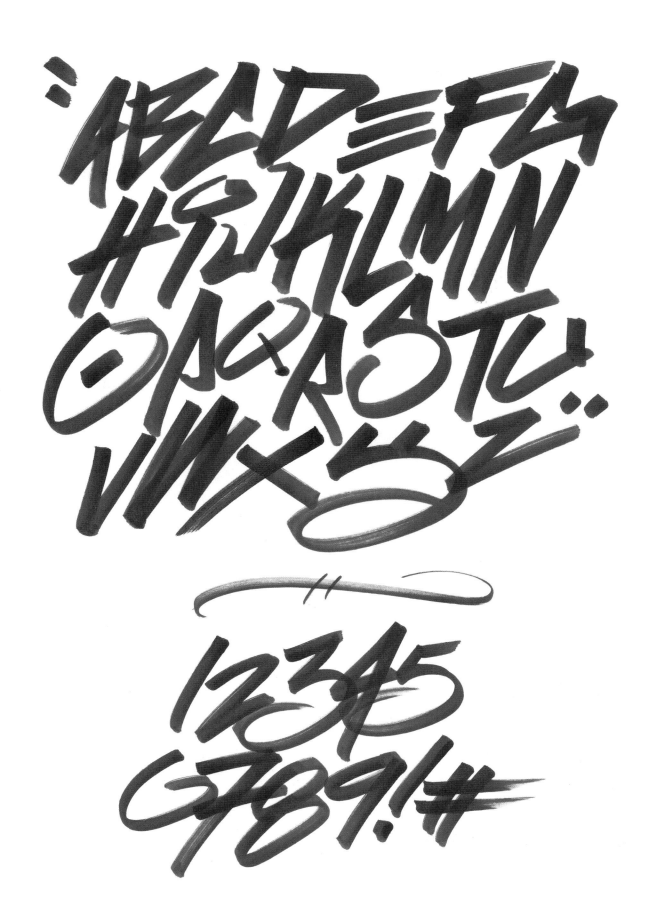

MIKE WATT

Sydney, Australia

@mike__watt

TRACKLIST:
Eric B & Rakim - *Paid in Full*
De La Soul - *De La Soul is Dead*
Gangstar - *Moment of Truth*
Outkast - *Southernplayalisticacadilacmuzik*
Pharcyde - *Bizarre Ride II the Pharcyde*

Mike Watt is an Australian artist based in Sydney who uses a variety of mediums and methods to make his work, which usually consists of his distinctively gnarly characters. Mike has jumped around in the creative world, doing every type of job he could possibly do: painting large-scale commercial murals, designing, illustrating, working in advertising, teaching, and occasionally selling a dodgy drawing or two to fund his biro habit and keep the lights on. He draws inspiration from people he sees in the street and is fascinated with weird details and quirks, which he incorporates into his work. He's been painting walls since 2000 and has been drawing for much longer.

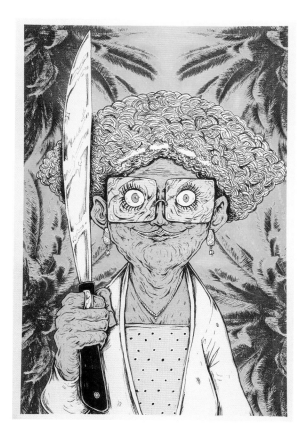

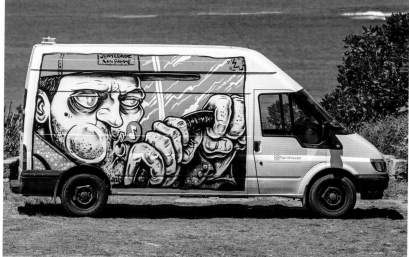

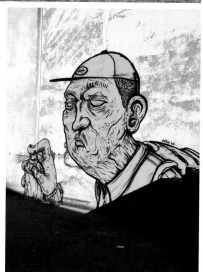

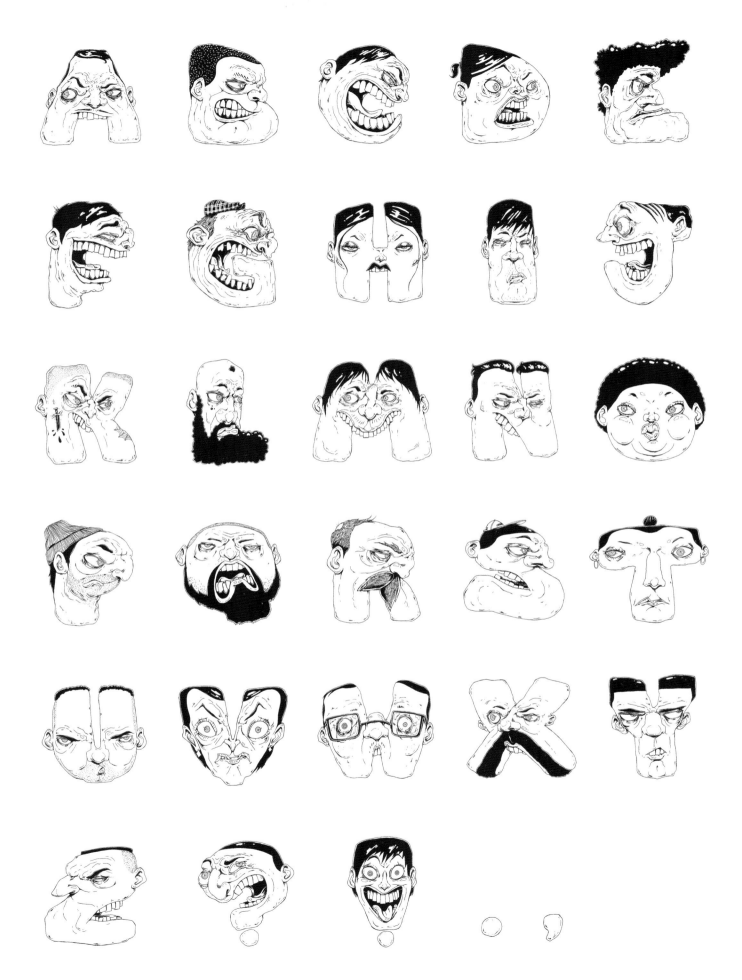

MNK CREW

Montreal, Canada

⊙ @mnkcrew

TRACKLIST:

The Blaze - *DANCEHALL*
Quantic - *1000 Watts*
Slowthai - *Feel Away*
Romeo Elvis - *Chocolat*
Action Bronson - *Well Done*

Noam, founder of the MNK collective, hails from Pont Saint Esprit, France. He decided to enter art school in 2007. After graduation, he made the decision to embark on a solo adventure for several years. A few sales of logos and business cards later, he took the initiative to build his universe in parallel. He draws his inspiration from all forms of urban culture and has a strange affection for monkeys. Like his mentors, he sketched, scanned, redrew, retouched in Photoshop, and brought MNK to life, working on as many supports as possible: posters, flyers, t-shirt, skateboards, and fake video game packaging. His greatest pride is to be able to work and have fun at the same time. Noam is the graphic answer to Jimmy Neutron, with a light touch of Guy Ritchie. His posters have been seen in several countries—the monkey likes to travel! After a few years in the ARTtitude collective Noam chose a new challenge and went to Canada to start a compositing career at MPC, then Atomic Fiction, and now at Method Studios.

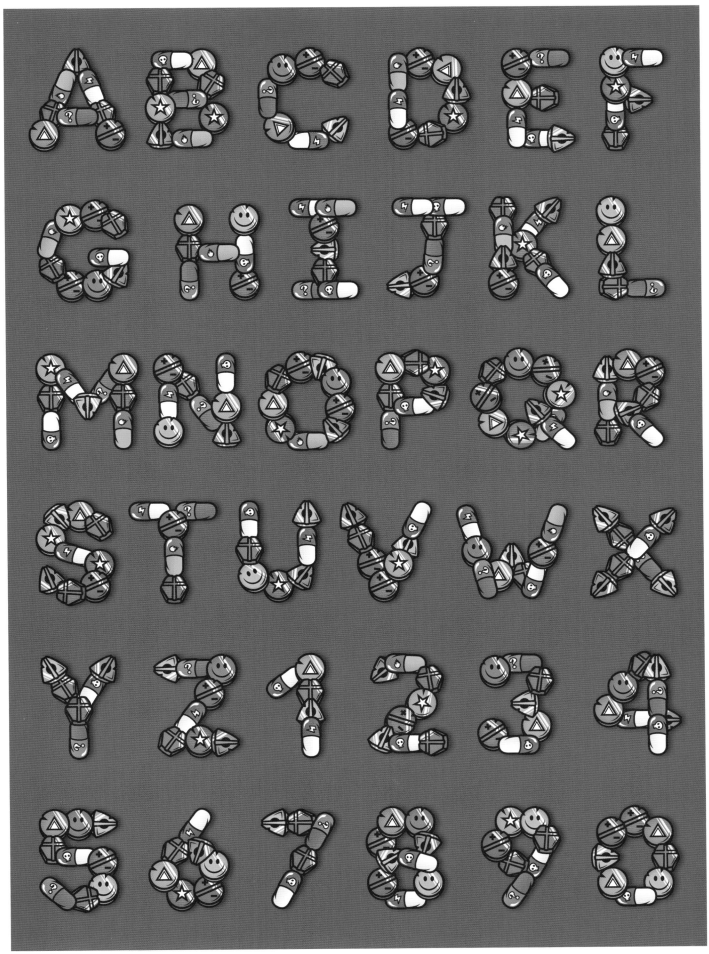

MOWGLYPH

Caen, France

@mowglyph_ic

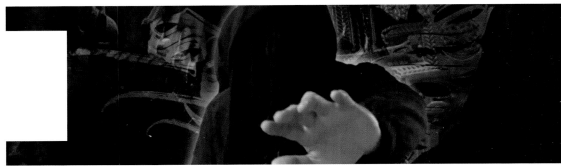

Born in 1990, much more interested in drawing than school, he has always aspired to exercise a manual and creative profession. His older brother was educated in Paris, he discovered graffiti, walls, and flops in the metro lines of the French capital at an early age. He enters the graffiti matrix at 13. . . . Already touched by the hip-hop movement with his first album (*Sector*), graffiti and its surroundings become his main focus. He quickly becomes an addict, looking for graffiti all over the early internet, in magazines, and via pirated videos. In short, all this leads him to practice. He then met graffiti artists from his city and joined a small crew. Unfortunately it didn't last long because his friends had a few issues with the law. From this point on, he filled his books, worked on letters, engraved on the walls of disaffected premises, ventured into wasteland, and polished his 'apprenticeship' . . .

Not really comfortable with sprays but more confident with one marker, he discovered the Hand style. Passionate about letters he abandoned graffiti for a while to tame calligraphy, to learn more about history and ancient practices of Scripture. And then, one day, tattoo enters his life! It's a passion that became a day job, and he is always proud of being able to realize his lettering on the living medium that is the skin.

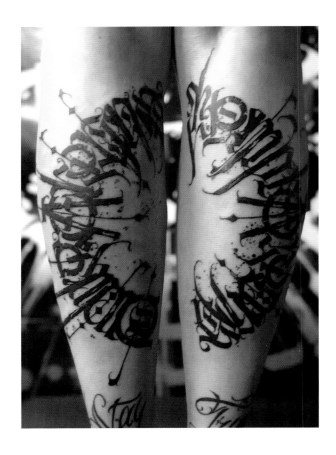

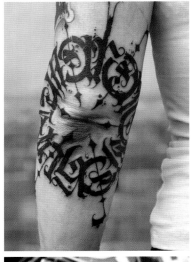

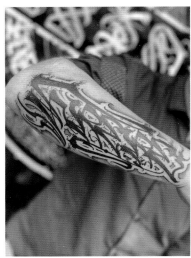

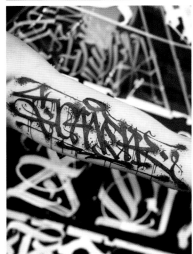

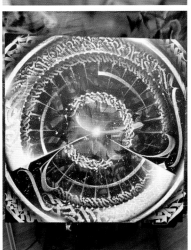

MYRIAM CATRIN

Wellington, New Zealand

@myriamcatrin

TRACKLIST:

Alter Bridge - *Fortress*
Pixies - *Trompe le Monde*
Foo Fighters - *Echoes, Silence, Patience & Grace*
Nine Inch Nails - *The Fragile*
Smashing Pumpkins - *The End Is the Beginning Is the End*

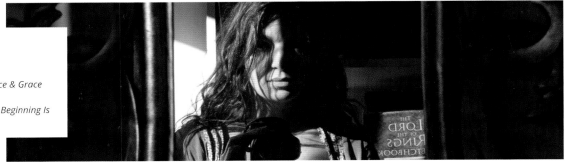

Myriam Catrin has been a concept and VFX artist for 25 years, working on more than 45 movies including *Avatar*, *Tintin*, *Prometheus*, *Man of Steel*, *Planet of the Apes*, *Wolverine* . . . She also worked on too many commercials and a few series. Among them she led the team of the textures for Smaug the Dragon in *The Hobbit* and was honored with the VES Award for Outstanding Animated Character in a Live Action Feature Motion Picture in 2014. During this project she gained her "Lady Dragon" nickname. The dragons have been her muse since an early age, and she has crafted many concepts, designs, illustrations, and stories to celebrate the most fascinating mythological creature. Being part of the collective, her first comic book, *Passages: Book I*, was published in May 2018 by ARTtitude. It is the first book of a saga-trilogy featuring, well, dragons. Stay tuned for umcoming chapters of this fantastic adventure.

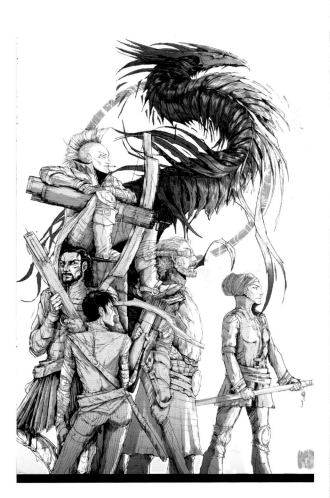

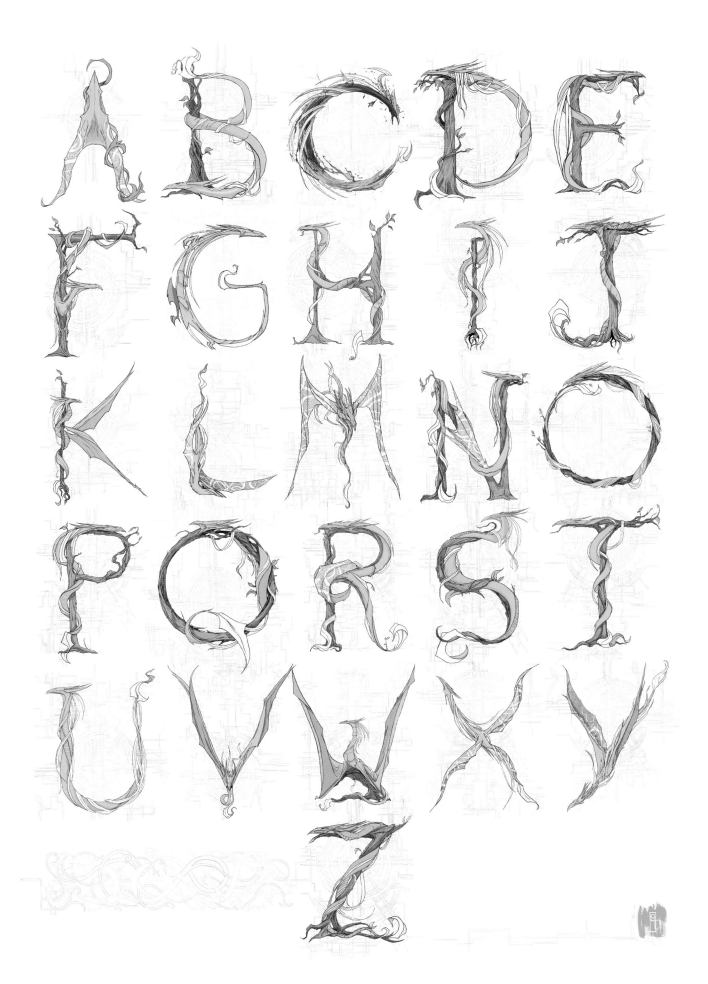

NED

Paris, France

 @ned9eme

Born in 1971, Stéphane Nedellec, alias NED, lives and works in Paris. He trained in graphic arts before founding, with Stéphane Carricondo and Jerk45, the 9th Concept in in 1990. One of the most famous French collectives, it now brings together around ten artists from various backgrounds. Ned plays with a multiplicity of influences. His Celtic origins have forged his line, which is constantly evolving. Interwoven patterns abound, complete with volutes, spirals, and complex labyrinths. Today, Ned aspires to more abstract work, combining heraldry and energetic geometry. His guideline, the essence of his trait, is a tribal line, linked to its Breton origins and Celtic art. With time and through his travels, this line has transformed to channel all kinds of forms, thus joining the fundamentals of the universal line. His compositions are unconsciously integrated into a network of regulating lines. He necessarily knows these geometric plans, these codes of divine proportion, the esoteric symbolism that are the subject of a permanent quest in his work. Raising telluric forces from the bowels of the earth through modern pentacles, he transforms his dark side into coats of arms of light. He frees himself from an old, gnarled, and complex evil in order to fly to a saving freedom.

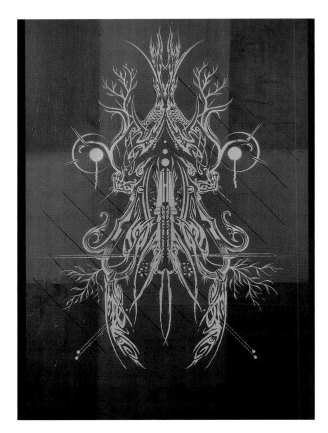

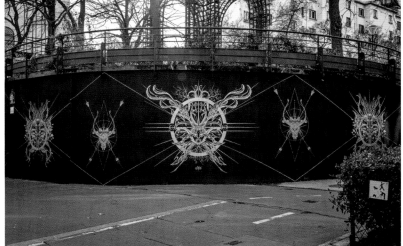

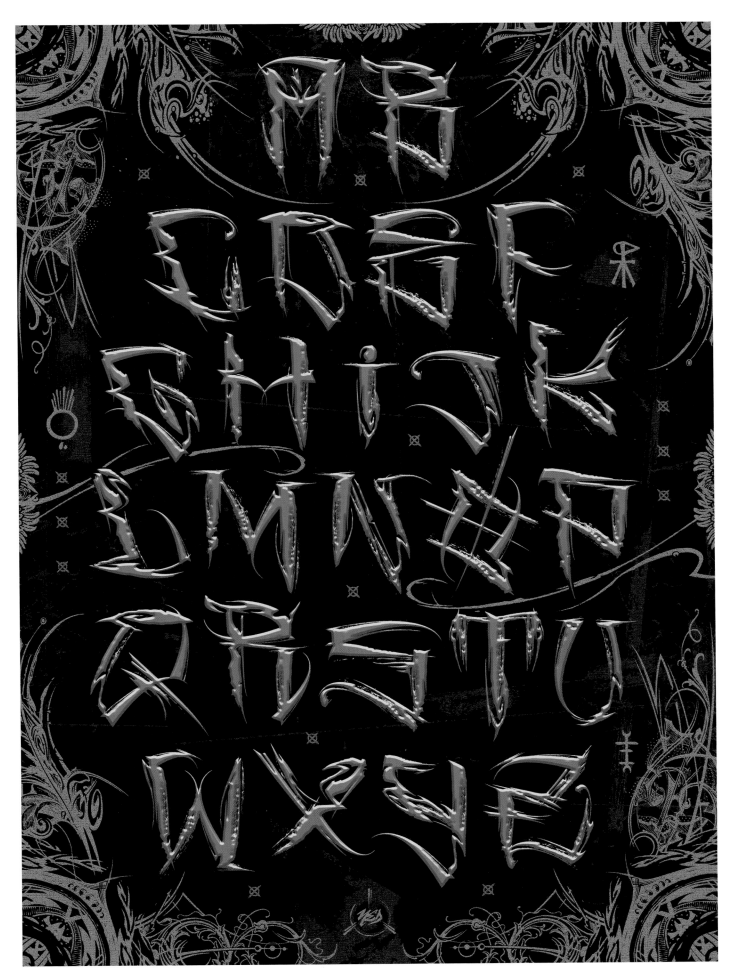

ODEA

Valenciennes, France

📷 @odea.france

TRACKLIST:

Saké Zaka - *Pièce d'orfèvre*
Sofiane Pamart - *Planét*
Scylla - *Pleine lune 2*
Nekfeu - *Les étoiles vagabonde*
Ninho - *Destin*

ODEA, which stands for Original DEwaele Arthur, was born in 1992 in northern France. He discovered his first graffiti magazines via his cousin, who was already operating in the industry. The creativity and messages passed on by this means of expression attracted him. Not very attentive or interested in conventional schooling, he enrolled in the Signs and Decor Painter program at the Le Corbusier high school in Tourcoing. He quickly realized that with the arrival of digital solutions, this profession was no longer relevant. He then learned graffiti and painting more generally in a self-taught way. Following a sabbatical year rich in experiences (mainly room decorations for individuals, jobs for friends, and graffiti of all kinds) he returned to the high school for a Brevet des Métiers d'Arts degree with a graphic designer and decorator focus. At this point his idea is to develop his technique without dwelling too much on his creativity. Many reproductions follow in order to master his craft and become more professional. Very quickly he put aside the aerosols to make room for brushes and acrylic paints, which is where he still finds pleasure today. In 2016 he grew closer to his godfather, a motorcycle painter, in Montpellier to learn from his experience and know-how. They worked together for four years, during which he discovered the pleasure of working on the customization of motorcycles. He then returned to exhibitions. Today ODEA is an independent artist who develops his style and his creativity by orienting himself as much on the fantastic as on realism while paying particular attention to the portrait and its emotions without being limited to the supports and their sizes.

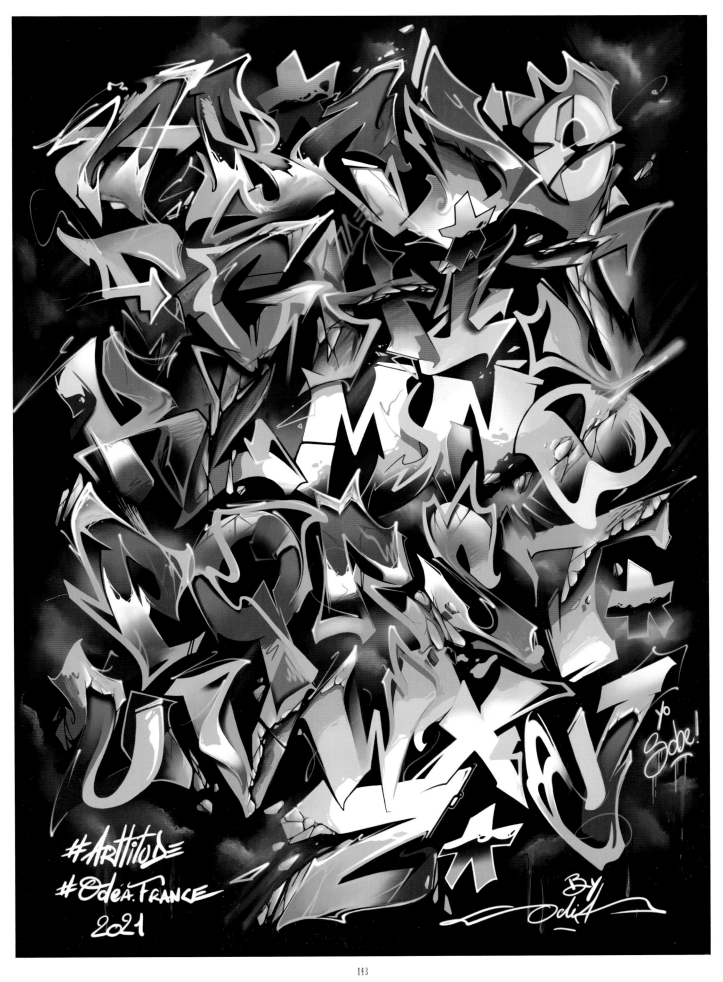

#Arttitude
#Odea.France
2021

Yo Sobe!

BY Odia

143

Olivia de Bona

OLIVIA DE BONA
Paris, France

@olivia_de_bona

TRACKLIST:
Flavien Berger - *Leviathan*
Dark Side - *Psychic*
Stravinsky- *Le sacre du printemps*
Philip Glass - *Glassworks*
Jeanne Moreau - *L'album collection*

For more than 15 years, Olivia de Bona has crafted a poetic lexicon made up of images that combine her personal imagination with collective imagery, which she declines according to the supports and materials that her creative curiosity makes her encounter. A graduate in applied arts and animation in 2005, she quickly shed digital media to satisfy her interest in artisanal know-how; she never ceases to enrich her technical palette to better express her art. Unable to dissociate the work from its medium, she sees each achievement as a whole, and it is often a technical curiosity that inspires a new project. If her technical mastery sublimates her figurative universe, it is in the thematic recurrence and the serial presentation that she attaches more strongly to the narrative aspect of her work, thus touching the tale and the respondent. Nature, animals, dreams, nudes, women, and hair are all leitmotifs that allow her to structure her artistic mythology and to lose herself in the representation of the material that is so dear to her. Thus, each of her creations is approached in two stages: first comes the emotion aroused by the dreamlike nature of her compositions, followed by the analysis of the complexity of the details resulting from her monomania with the line.

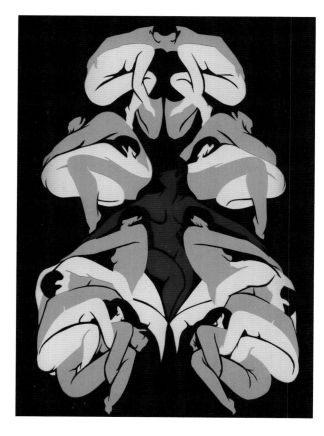

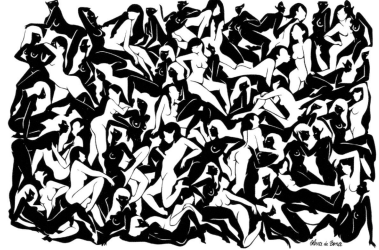

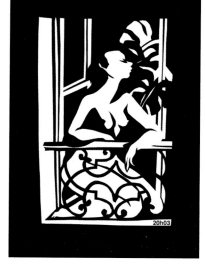

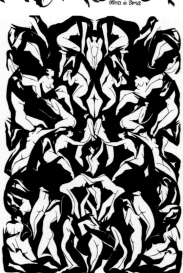

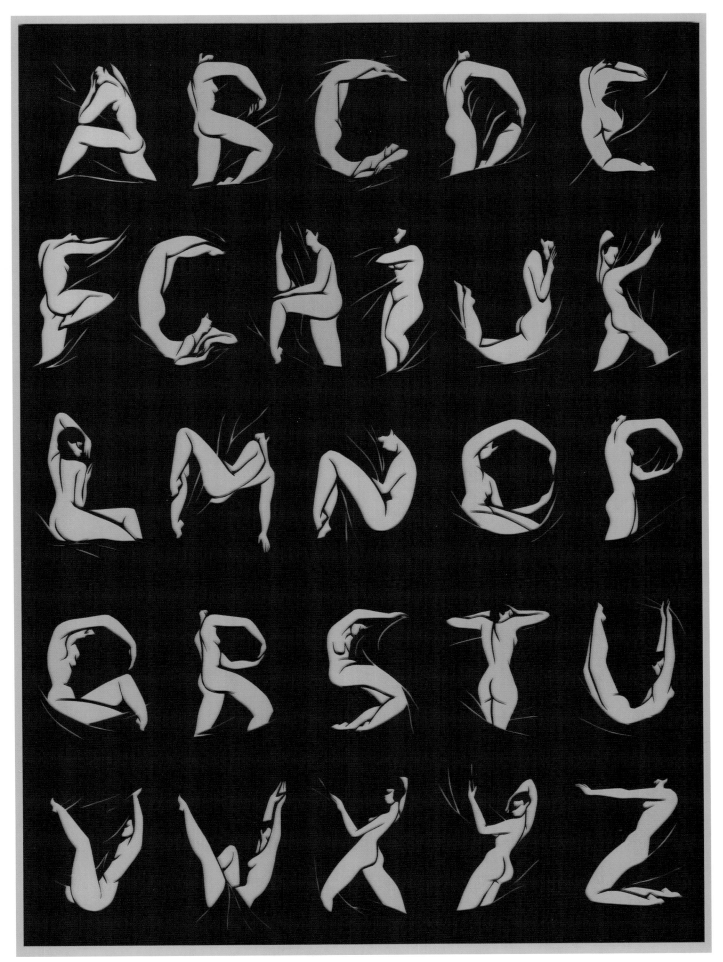

OLIVIER MAKO MICHAILESCO

Paris, France

:camera: @olivier_mako_michailesco

TRACKLIST:

The Doors – *Best Of*
Led Zeppelin – *The Song Remains the Same*
Jimi Hendrix – *Are You Experienced*
Bob Marley – *Best Of*
The Gladiators OST

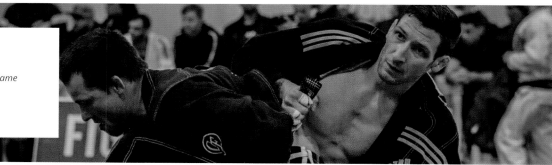

Those who know Olivier know him as the founder of the MK team, one of the biggest French teams in Brazilian jiu-jitsu. He started with judo at the age of 8, then Sanda, Thai boxing, kickboxing, French boxing, and wrestling before discovering BJJ. His pedigree is also impressive: third-degree black belt in Brazilian jiu-jitsu and second *dan* in judo. He is French champion of Judo Ne Waza and three times European BJJ champion in Lisbon in 2016, 2017, and 2018. But few people know the artist who prevailed before . . . Around age 6 or 7 he was already reproducing logos and at 12 it was graffiti that arrived in his life; at around 16 he attacked his first metro line and portions of the highway, following a few local crews in his area. He continued until jiu-jitsu came into his life. Olivier was one of the first French artists to take a serious interest in calligraffiti, the art form that combines calligraphy, typography, and graffiti, making a word or group of words into a visual composition. One thing is certain, we find in this technique the precision and the spirit of detail that we also find in his jiu-jitsu technique: 'the handcuffs.'

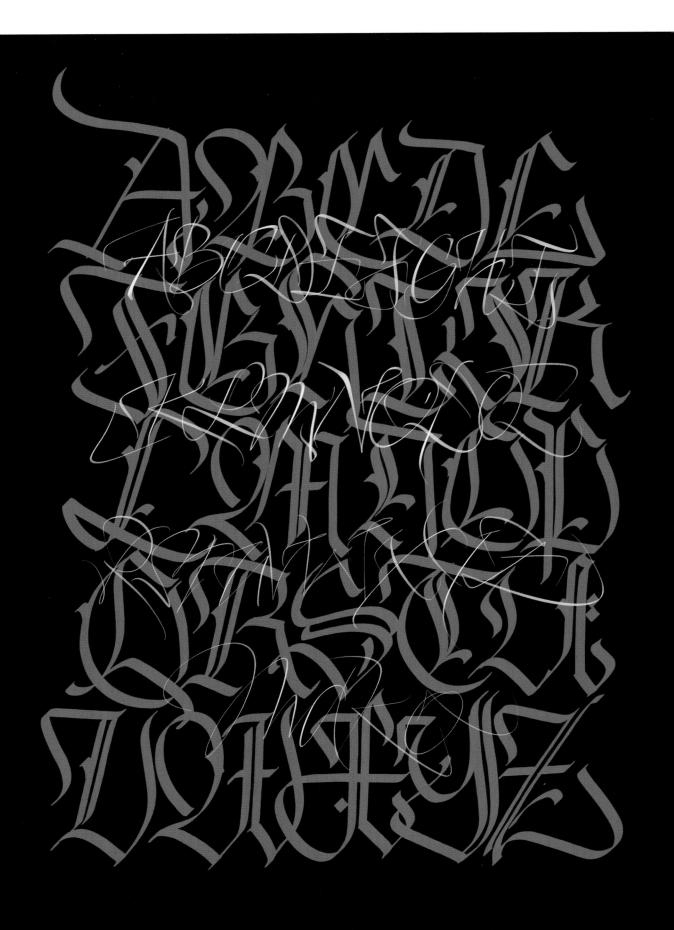

PARTONE

New York, USA

@partonetds

TRACKLIST:

The Ojays - *Back Stabbers*
Main Ingredient - *Euphraties River*
James Brown - *Sex Machine*
Jimmy Bohorn - *Ease Ur Mind*
Brick - *Disco dazz*

Part One (Enrique Torres) has a reputation of being one of the early graffiti-style writing pioneers who created some of the most brilliant artworks on New York City's subway trains. He is a veteran of the golden years of NYC subway painting and is considered a style master in the graffiti world, specializing in his own brand of lettering which he started to develop in 1974. From 1974 to 1985 he was one of the most accomplished artists on the New York City subway trains. In 1985 he took a brief hiatus from painting only to return in 1990 as a leading figure in the reemergence of wild-style pieces in murals in Harlem. His art has been featured in the classic film *Style Wars* as well as Martha Cooper's critically acclaimed *Hip Hop Files*. Most recently he has appeared in *Burning New York*, *New York City Black Book Masters*, and *Graffiti Planet*. His biography, *Part One: The Death Squad*, chronicles his art spanning more than 30 years. Part One is active today painting both on canvas and on walls around the world. He was most recently a featured artist at *Born in the Streets* at the Fondation Cartier in Paris.

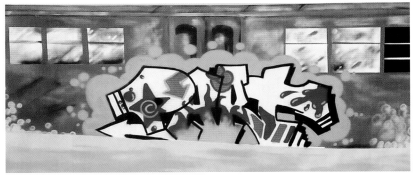

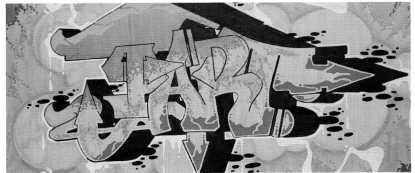

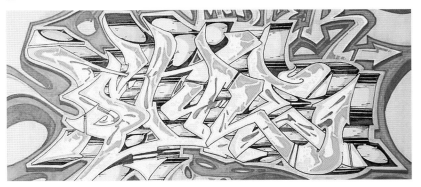

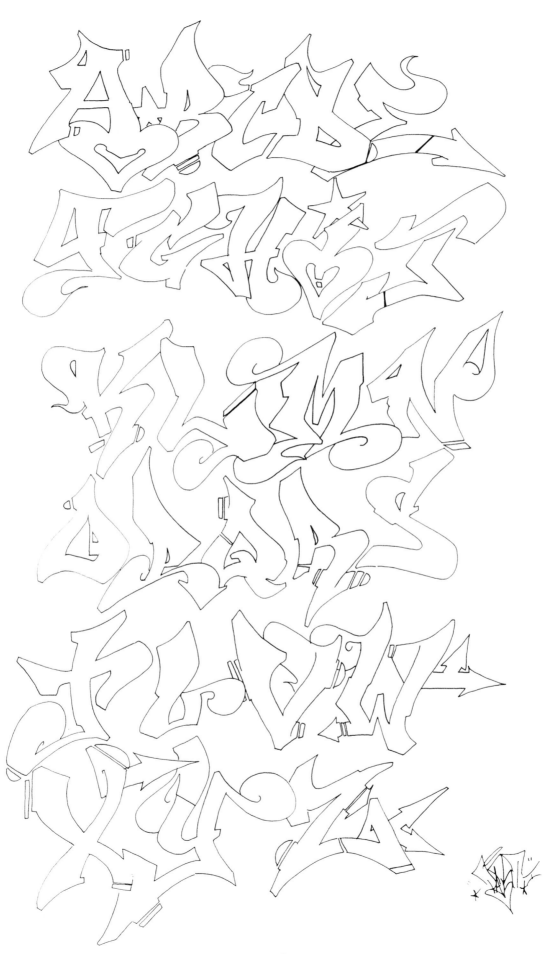

PIERRE TARDIF

Grondines, Canada

@pierretardiflettreur

TRACKLIST:
Slayer - *Show No Mercy*
Iron Maiden - *Piece of Mind*
Francis Cabrel - *Public*
Dwight Yoakam - *Guitars, Cadillac, Etc...*
Yanni - *Live at the Acropolis*

Pierre Tardif has been hand lettering for over 25 years. Since the opening of his sign shop in 1988, all of his work has been hand painted and still is today. The bulk of his work is the creation and production of vintage lettering and signage. In general, his customers consist of businesses with historical interests, car collectors, custom car owners, museums, and movie productions. His ability to precisely re-create the environment of times gone by has gained him international recognition. His work has been featured in sign magazines, TV productions, and advertisements for One Shot Paint. Pierre has found great inspiration from his huge vintage-sign book collection and by rubbing elbows with some of the best veteran sign artists in the industry. A highly skilled artist who is driven by passion, he has spent years practicing and perfecting his art of traditional sign painting. His services now consist of consulting, designing, and sign painting.

PIERROKED

Paris, France

 @pierroked

TRACKLIST:

Lunatic - *Mauvais Oeil*
Flynt - *J'éclaire ma ville*
Renaud - *Amoureux de Paname*
Bobby Lapointe - *Comprend Qui Peut*
Mobb Deep - *The Infamous*

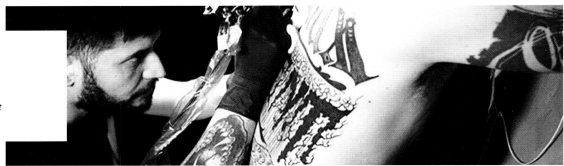

Born in the Parisian suburbs, Pierre quickly became interested in hip-hop culture and discovered graffiti. After earning a baccalaureate in graphic communication, he continued his studies and began to push lettering. He truly discovered Paris, the signs of old shops, the jobs of letterers and sign painters . . . He also revolves around tattooing, a fascinating art, which makes it possible to truly work on drawing. Tired of working behind a computer, he decided to quit his job as an artistic director and, in 2013, tries the adventure of a Parisian tattoo parlor, the most famous one: Tin-Tin Tattoos. There he developed his highly personal style: the composition of letters, always drawn by hand. Plays of letters, blocks, and contrasts. He has developed an ornamental style, inspired by different artistic trends. Since that time, Pierroked navigates among different tattoo shops and also works for brands and individuals.

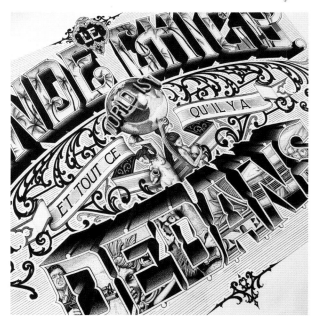

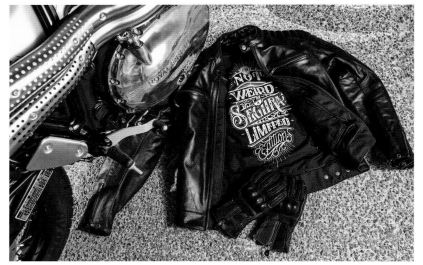

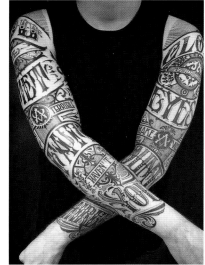

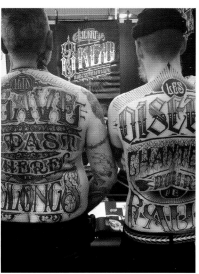

PLAQUE

Cologne, Germany

📷 @plaqueone

The street artist Martin Liebschner, known as Plaque One, was born and raised in Dresden in 1980 and is currently based in Cologne. He can look back on a career of more than 25 years as a graffiti and street artist. His works impress with their clear shapes, colors, and contrasts and create a balancing act between tradition and modernity in European graffiti culture. His main focus is on the abstract form of calligraphy, and his works are difficult to categorize into formats such as canvas or frames. Large-format productions in free space correspond to his ideal of artistic freedom. In cooperation with well-known companies in the industry and a strongly networked cultural scene, he has created complex projects in Germany, Luxembourg, Belgium, the Netherlands, France, and Switzerland. Thanks to his social skills and his sense of communication, he is involved in well-thought-out theoretical/practical workshops for children and young people as well as in innovative team-building campaigns for leading companies. And of course, all kinds of commissioned work indoors and outdoors are part of his repertoire. He is the happy father of three children and has in-depth knowledge of project management and corporate governance. At the beginning of the 2020s, he made contact with contemporary art galleries in order to make his works, such as photographs and originals in acrylic, accessible to a wider audience. Due to the transience of graffiti in public spaces, he sees this as an opportunity to implement longevity and sustainability in the graffiti subculture.

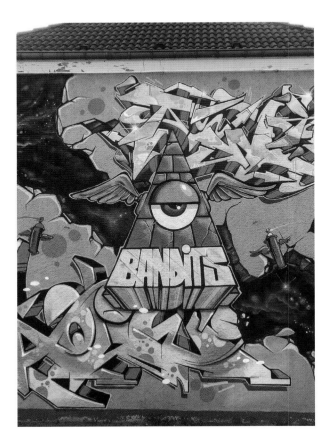

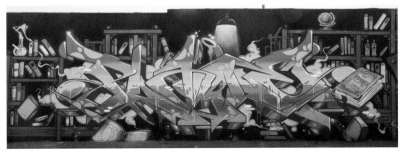

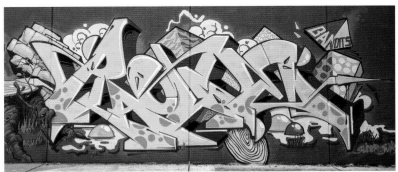

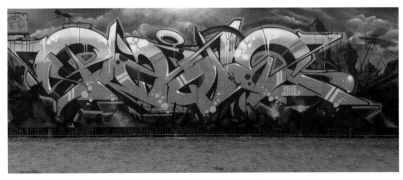

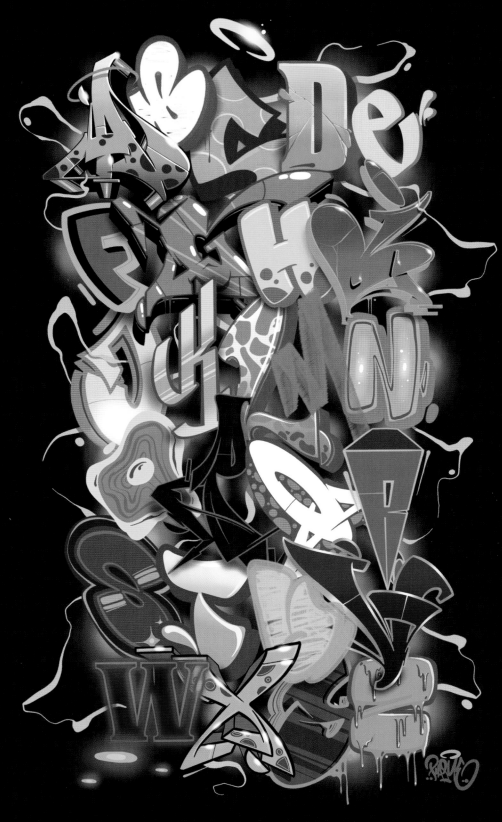

POCKETSKI

Los Angeles, USA

 @pocketski

TRACKLIST:
Bad Balance - *Город джунглей*
DMX - *The Great Depression*
Ray Charles - *Hallelujah I Love Her So*
Грот - *Братья по умолчанию*
Скриптонит - *Уроборос: Улица 36*

A calligraphy and tattoo artist from Siberia now based in Los Angeles, Alex, aka Pocketski, was born and raised in the black and gray landscapes of the Russian provinces. He has started doing graffiti and tagging in middle school. He got involved with calligraphy at the end of 2009, when basic tagging style became boring; he then decided to develop his handstyle. Writing on a body is more challenging than a flat wall or canvas. Pocketski will search for that spot where anatomic lines and composition of calligraphy meet in harmony and balance. He pushes the boundaries to deliver completely unique tattoos to his customers. During the past year, he has achieved significant results. In the beginning of 2020, he took a part in the Golden State Tattoo Expo contest with the biggest calligraphy tattoo ever: he covered half of the model's body with only three words.

At the moment he continues his path in tattoo culture, is working on a few paintings, and plans to drop his own merch line soon. Stay tuned!

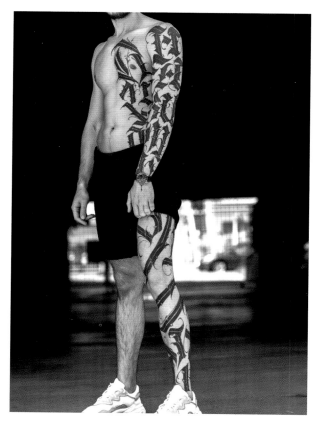

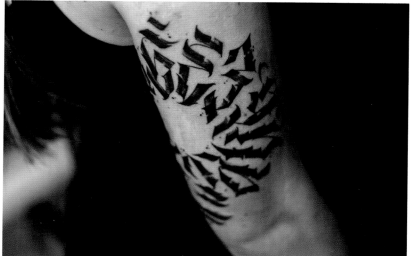

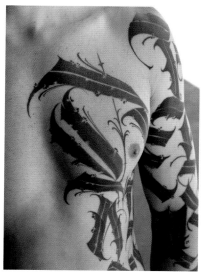

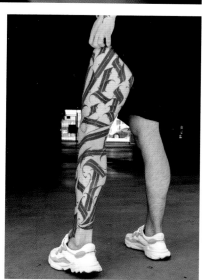

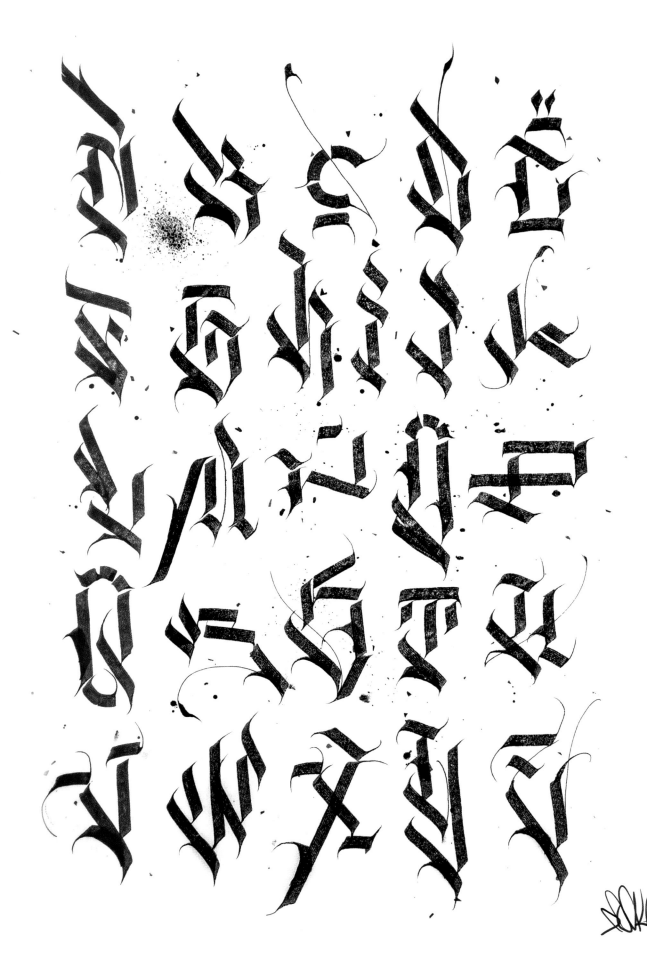

ROB ADER

New York, USA

@robadernyc

TRACKLIST:

Jay Z - *Reasonable doubt*
Nas - *Illmatic*
Roy Ayers - *Studio Album*
Biggie - *Ready to Die*
Melissa Morgan

Native New Yorker, born and raised in Brooklyn, Rob Ader started writing in the early 1990s. He has been active in the New York city bombing scene throughout the Mayor Dinkins and Mayor Giuliani era. His first gallery break was in 1998 for a group show at Martinez Gallery. His first television appearance was BBC International. After the exhibition, he was featured in the arts section for a cover story in the *New York Times*. Rob comes from an art background and spent his earlier years drawing and painting. He attended school for fine arts and illustration studies in traditional methods. From an early age he has always had a love for colors and letters, the motion of shapes moving on roaring trains through the city when he was too young to read. Growing up in the heart of Brooklyn, it's not a coincidence he became immersed in the subculture of graffiti. He coined the name Ader from the 1980s British comedy *Blackadder*. He became known throughout the scene for scrawling his signature on countless sites throughout NYC. He went on to receive accolades from his peers during the 90s. By 1998 he was a participant in a historic group show *Old School Meets New School*, held at Martinez Gallery in Chelsea. Immediately after the success of the show, he became fully immersed in his art. His main focus now is to use those skills to give back to the community.

ROBERT GAUGHRAN

Housatonic, USA

@robgaughran

TRACKLIST:

Mastodon - *Leviathan*
Samhain - *November Coming Fire*
Wu-Tang Clan - *36 Chambers*
Day of the Dead Soundtrack
Primus - *They Can't All Be Zingers*

Rob was born and raised in Brooklyn, New York, and then moved as a teenager to the rural mountains of western Massachusetts, where he lives as a family man and draws while not working as a firefighter. As a child growing up in the late 80s, Rob had a healthy dose of bad action movies, slasher horror flicks, Saturday morning cartoons, and the comics craze of the 90s. He watched anime back when it was still a dirty little secret among American nerds. Rob's main influences come from classic American genre comics starting as early as the 50s up through the ultra-violent black-and-white comics of the 80s. Some of his favorite artists include Jack Davis, Frank Frazetta, Harvey Kurtzman, Frank Miller, Wally Wood, Simon Bisley, Steve Bissette, Bernie Wrightson, Richard Corben, Charles Burns, Jack Kirby, and Steve Ditko. These days he enjoys diving into his favorite subject of horror, reading classic literature, and watching new and old gritty, violent, and/or low-brow comedy movies. Rob most of all enjoys time with his family doing family stuff and enjoying Brazilian jiu-jitsu.

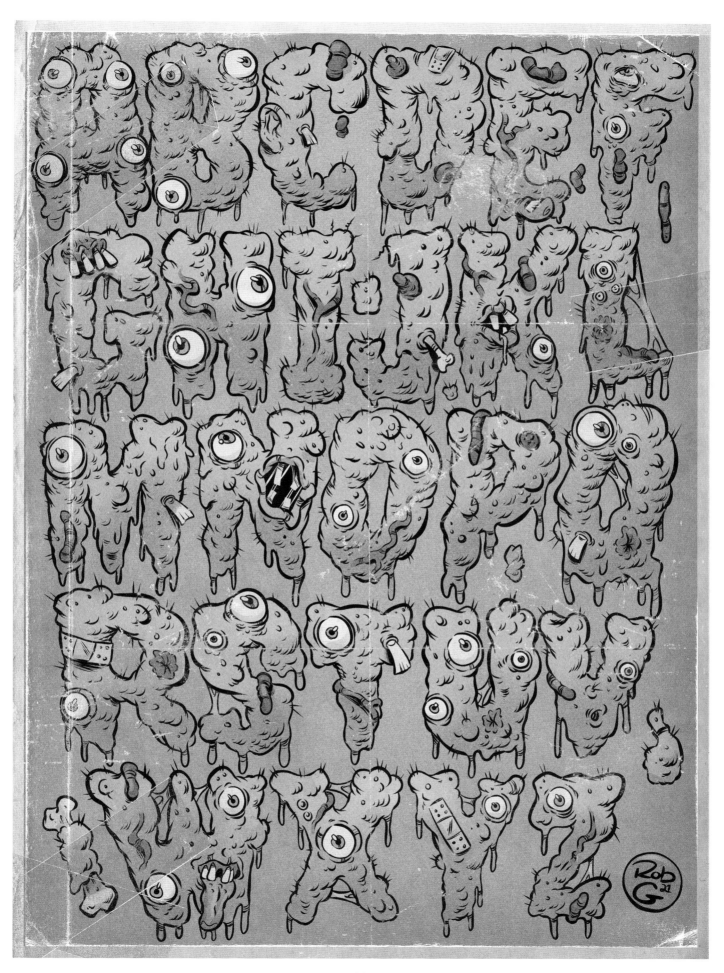

ROMAIN FROQUET

Paris, France

@romainfroquet

TRACKLIST:

Gil Scott-Heron - *Pieces of a Man*
Country Joe McDonald - *Natural Imperfections*
Ramsey Lewis - *Country Meets the Blues*
Alice Coltrane - *Ptah the El Daoud*
Outkast - *ATLiens*

Self-taught artist Romain Froquet first dipped his toe into the creative sphere in the late 90s. His talent expresses itself through his practice, based on the repetition of line and completed with the development of his own pictorial language. He draws on tribal art and the urban world as inspiration. His protean art opens the door to all manner of experimentation; he explores numerous media, drawing with Chinese ink on paper, working with material and color on canvas in the workshop, and exploring depth of movement when working in situ. His principal preoccupation is the search for balance in gesture. His artistic career has developed through his personal and collective exhibitions, in France and overseas: *Lignées* (2020, Pavillon Carré de Baudouin, Paris), *Même à sec la rivière garde son nom* (2019, Galerie Joël Knafo, Paris), *Scope* (2019, Askeri Gallery, Miami), *Légendes Urbaines* (2018, Base sous-marine, Bordeaux), *The Nature of Magnetism* (2018, Askeri Gallery, Moscow), and *Gesture and Line* (2015, Yvonamor Palix Gallery, Houston). Romain has also had the opportunity to create pictorial works in situ: Murs Murs Festival (2019, Decazeville, France), Conquête Urbaine (2019, Musée des Beaux-Arts de Calais, France), Marseille Street Art Show (2018, France), Crossroads (2017, Wynwood, US), Art 42 (2016, Musée d'Art Urbain, Paris), and Radiographik (2016, Maison de la Radio, Paris).

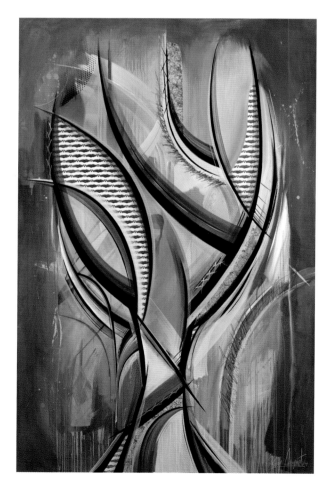

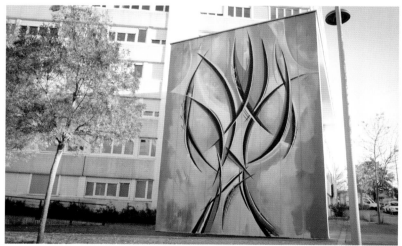

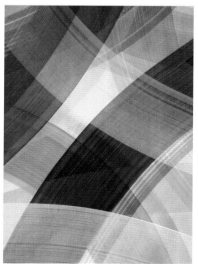

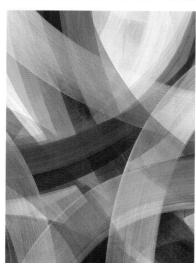

ROMAIN APSARA

Nantes, France

@romainapsaratatouage

TRACKLIST:

Gojira - *Magma*
DevilDriver - *Dealing with Demons*
Orelsan - *Le chant des sirènes*
Stupeflip - *The Hypnoflip Invasion*
Vitalic - *Ok Cowboy*

Self-taught in drawing, Romain learned his skills as an apprentice tattoo artist in Saint-Nazaire. At the end of 2009, he headed for Toulouse, where he was lucky enough to be able to join the Henrik Tattoo boutique. This collaboration allowed him to progress enormously and to better define his style and projects. The exchange, the drawing, the interpretation of what each client expects, this is the basis of the realization of a project. There are many areas in which we must constantly improve and Romain works in this direction to advance in his profession. This development also involves meetings and travels. It is important for him to come to a convention or as a guest to interact with other tattoo artists. With four years of experience in Toulouse, he went back to his roots in September 2013 in Nantes, where he opened my first Tattoo Shop: APSARA TATOUAGE. After moving to a larger location, Romain and his partners decided to develop a coworking space in which they can work as a team, each of them sharing experiences and know-how in order to move forward and keep their art factory alive. In October 2020 Romain decided with his wife to start the Sōzō Paper & Co adventure by launching an online store. It is the story of a duo, of an idea, of several ideas, of a language with four hands, of a look. A creative look, creations inspired by two worlds: graphics and tattooing. A common passion for Japanese imagery brought to light in the form of illustrations on paper. A nascent project that will evolve according to the media, the public's feedback, our meetings.

Kitsune

RONAY DIT ALOHA

Toulouse, France
📷 @alohaoriginal

TRACKLIST:
Childish Gambino - *3.15.20*
20Syl - *36 Beats & Type*
Jay Z & Roots - *Unplugged*
Medine - *Venom*
Erykah Badu - *But You Caint Use My Phone*

Self-taught, Ronay found his original expression long before the 2000s without even knowing that it had a name. Where most people barely glance, he discovers graffiti, an avant-garde peculiar to his time. His journey takes root in the concrete of 92 in Ile-de-France. Subsequently he developed a taste for graphic arts, which leads him to photography and video. And it is through these different languages that he is able to express his ideas. The first language he used being graffiti, he keeps it; it allows him to remember where he came from. His second language, the one he presents more fully, is more figurative. However he uses the tools and some writing techniques in a more post-graffiti way. He approaches his figures on paper in acrylic with a dominant black and white that he sticks on the canvas. He merges everything with different techniques, by tearing and treating the paper, creating here texture, there transparency, which enriches the visual dimension. Today he is committed to sharing more of his new studies and narrative reflections, always addressing the figurative but also abstraction. Basically, he is and remains a multidisciplinary artist, a jack-of-all-trades, an idealist for whom the horizon is constantly expanding . . .

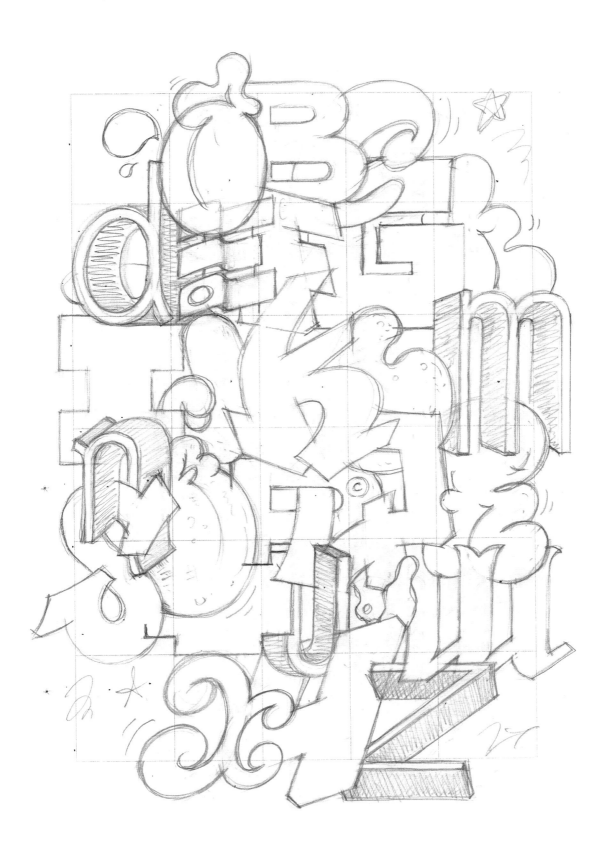

ROTA

Naples, Italy

 @rotawb_vmd

TRACKLIST:
Michael Jackson - *Off the Wall*
Neffa - *107 Elemento*
Smoove & Tutrel - *Eccentric Audio*
Daft Punk - *R.A.M.*
Fusik - *Hot Skillet*

Luigi "Rotas" Russo is a Bboy and graffiti artist from Naples, where he was born and grew up in the city's eastern outskirts. He began painting at the end of 1999 and beginning of 2000 in the Neapolitan hinterland; he joined the TCK Collective, a crew that practices the disciplines of hip-hop culture at 360°. First of all he is passionate about the German style, being inspired by rigid and dynamic shapes, moving to a hybrid between style block and throw up without ever neglecting the main concept and the evolution of his letters. This path has led him to obtain a versatile and dynamic style. He is an active member of the WILD BOYS, a Neapolitan crew born in mid-2009, and the famous French crew VMD. Several times guest of events around Europe, he participated in the XIII Biennial of young European artists in Bari. One of his works created in collaboration with the Neapolitan artist ZEUS 40 is installed on the building of the Youth Department of the Council of Ministers. He boasts artistic collaborations with commercial brands such as Adidas, Converse, Eastpak, and many more. In the last years he has approached the world of characters inspired by the New York style of the 80s, managing to create a more complete vision of the concept wall by integrating characters (designed by him), letters, and background.

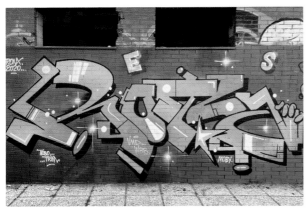

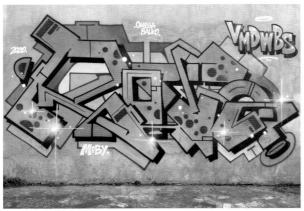

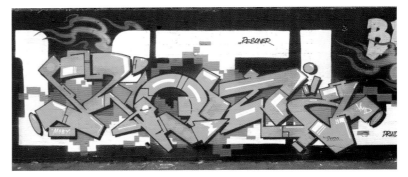

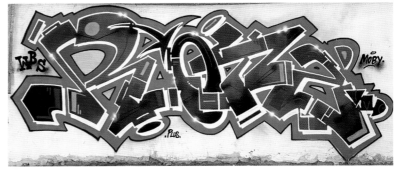

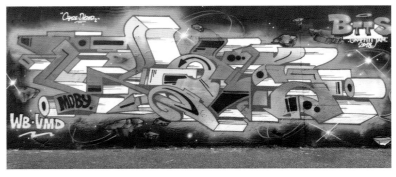

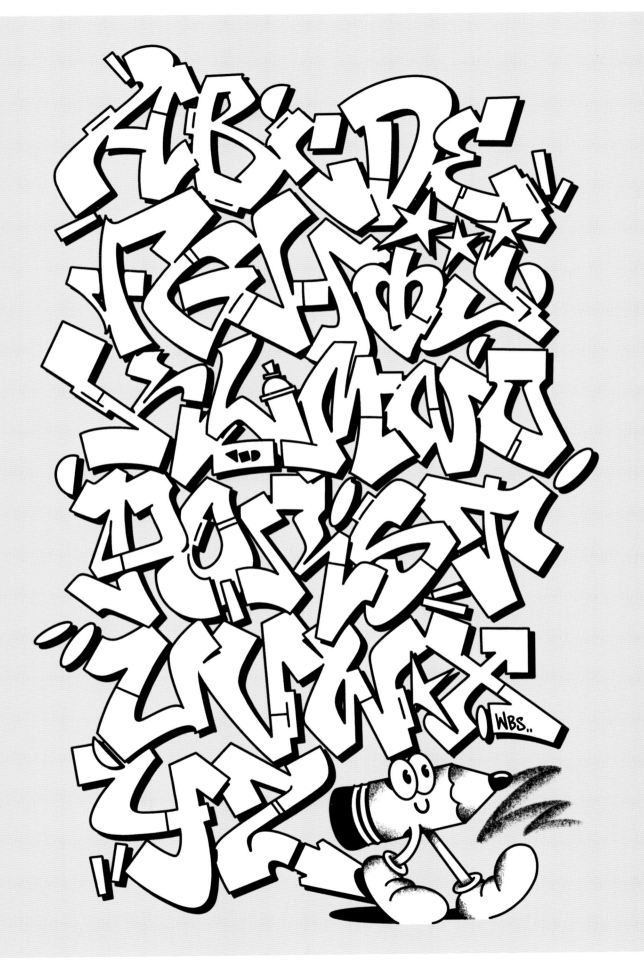

SANE2

Caen, France

📷 @sanetwo

TRACKLIST:
Sickick - *Bermuda*
Nipsey Hussle - *Rap niggas*
KyeBills - *235th*
IAMDDB - *More*
Jessie Reyez - *Gatekeeper*

Born in 1976, Sane2 has been drawing since childhood, for hours on end. He came across graffiti by chance thanks to the rise of hip-hop culture in France in the 90s. For him, a positive breath is needed for a whole youth in search of new modes of expression. Trying on many walls in his city, swollen by his thirst for the forbidden, Sand2 is inspired by the book *SprayCan Art*, his graffiti reference, and decides in 1997 to devote all his energy to his passion for urban art. Since then, he has invested more and more and has created a series of colorful creations, rethinking the alphabet and energizing the letters. He also created the AERO association and joined the Bandits Crew during his trip to Germany in 2002, thus becoming a benchmark artist on a European scale. It was in 2009 that he tried his hand at tattooing, a logical continuation of his artistic development. Seeking through these new media and supports that are the dermograph and human skin to transcribe the energy of his urban creations. He invested 200% and finally opened the Calvanostra boutique in Caen in 2016 with his photographer friend Big Daddy. The place brings together an exhibition space, and two residents are joining soon. Many tattoo artists from all walks of life also set up as guests from time to time, making this new brand in less than a year a hub of alternative culture in Normandy.

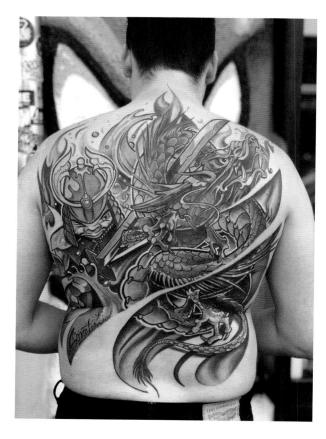

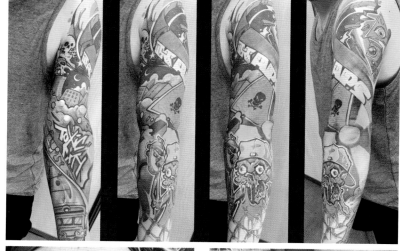

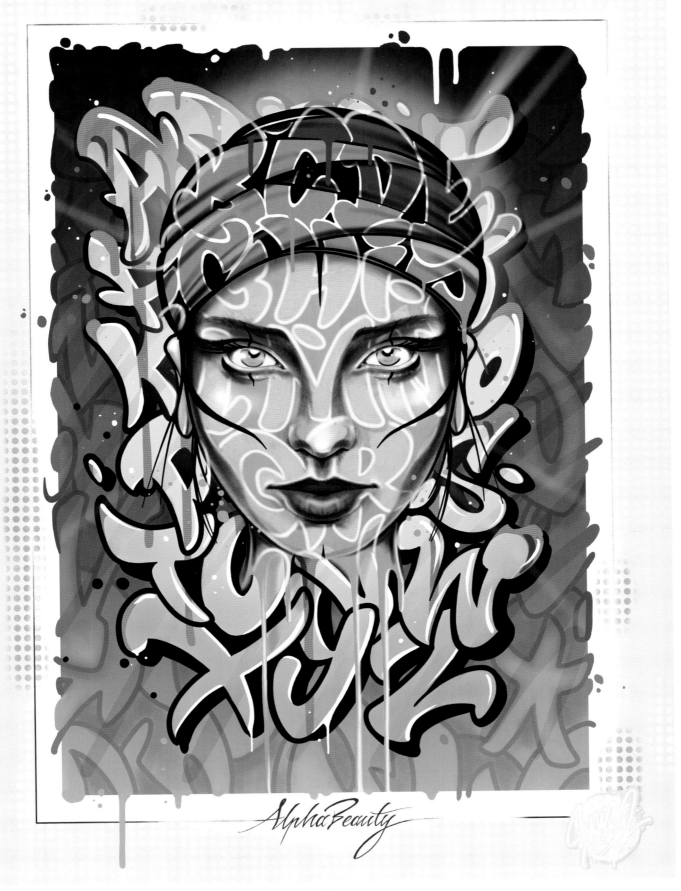

AlphaBeauty

SETH ONE

Caen, France

@graffolyse.by.sethone

TRACKLIST:
NTM - *Authentik*
Wu Tang Clan - *36 Chambers*
Notorious B.I.G. - *Ready to Die*
Mobb Deep - *The Infamous*
La Cliqua - *Conçu Pour Durer*

Marked by the proliferation of tags and graffiti in Paris and its suburbs in the 80s, Seth One began making graffiti in the 90s within the STS groups and then CLM, on the many supports that urban areas offer. He then worked for associations or municipalities, where through initiations and workshops he conveys his vision of graffiti and seeks to transmit this culture to participants. His work on canvas developed later with the desire to work the dynamic of his letters in a different way than on the wall. This process, which he calls graffolysis, consists of the disappearance of a letter, its degradation that leaves room for components, ornaments, dynamics, and strong lines to create an overall snapshot in movement. In addition to this transformation, there are many influences such as pop art and the imagery of skate, surf, and comic book culture from the 90s. Seth One also has developed a more figurative treatise that allows the staging of tools or supports specific to the practice of graffiti with, in particular, the Capman series and Capumulations (caps, markers, trains, etc.). In recent years Seth One has participated in many festivals, exhibitions, and collaborations with artists in France and abroad.

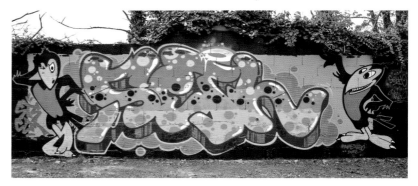

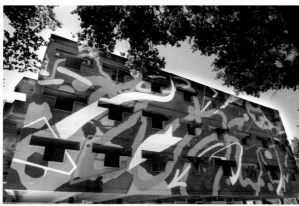

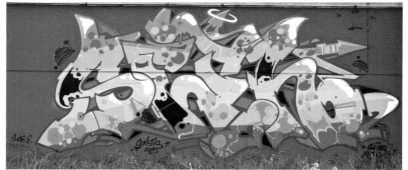

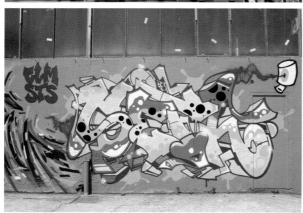

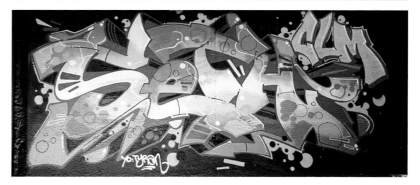

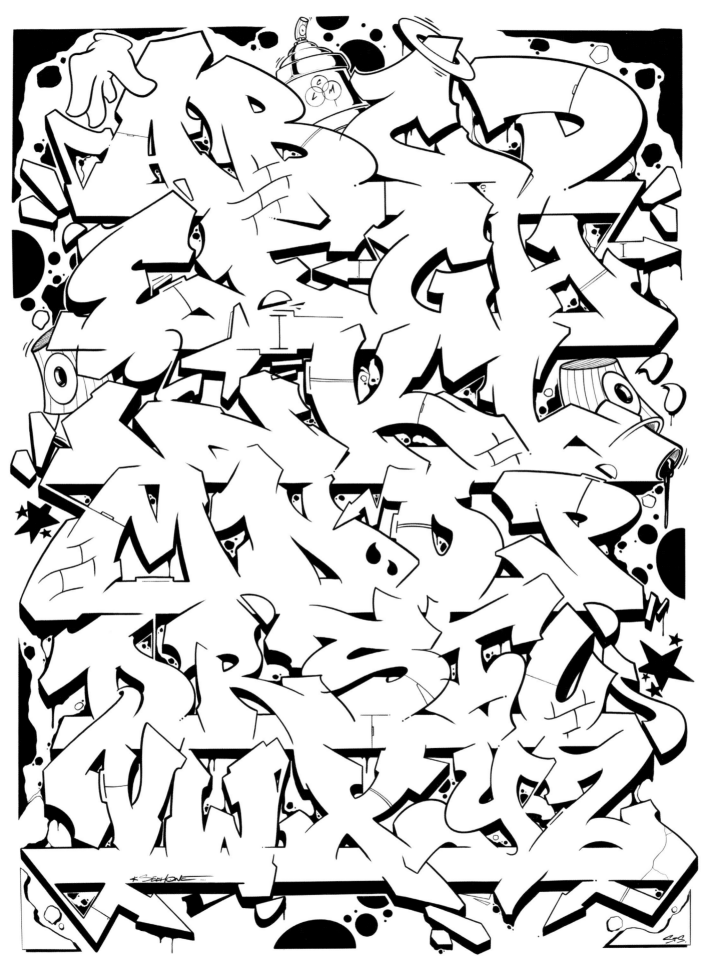

SIMON DELART
Nantes, France

📷 @s2lart

TRACKLIST:
Rone - *Motion*
The National - *A Skin, A Night + The Virginia EP*
Hans Zimmer - *Man of Steel Soundtrack*
Daniel Pemberton - *King Arthur Soundtrack*
Ours Samplus - *Orphan Loops*

Simon Delart was born in Amiens in 1987 and has been a professional illustrator for eight years. After training as a graphic designer at LISAA in Nantes, he became artistic director for the Galerie Chevalier in Paris. At the same time, he developed his illustrator activity and quickly joined the ARTtitude collective, with which he worked for clients such as Ubisoft, Bethesda, and 2K. He is also the artistic director of the collective and takes care of the layout of the books and magazines produced by ARTtitude and Public Domain. In the United States, he joined the Poster Posse collective, which allowed him to work for studios like Disney/Marvel, Fox, and Warner. For the past several years he has collaborated regularly with the French cinema magazine *CinemaTeaser* by producing cover illustrations. Simon uses several techniques, ranging from vector drawing (low poly/vector art) to digital drawing, painting, and customization of objects (controllers, consoles, canvases, sneakers).

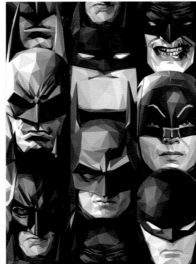

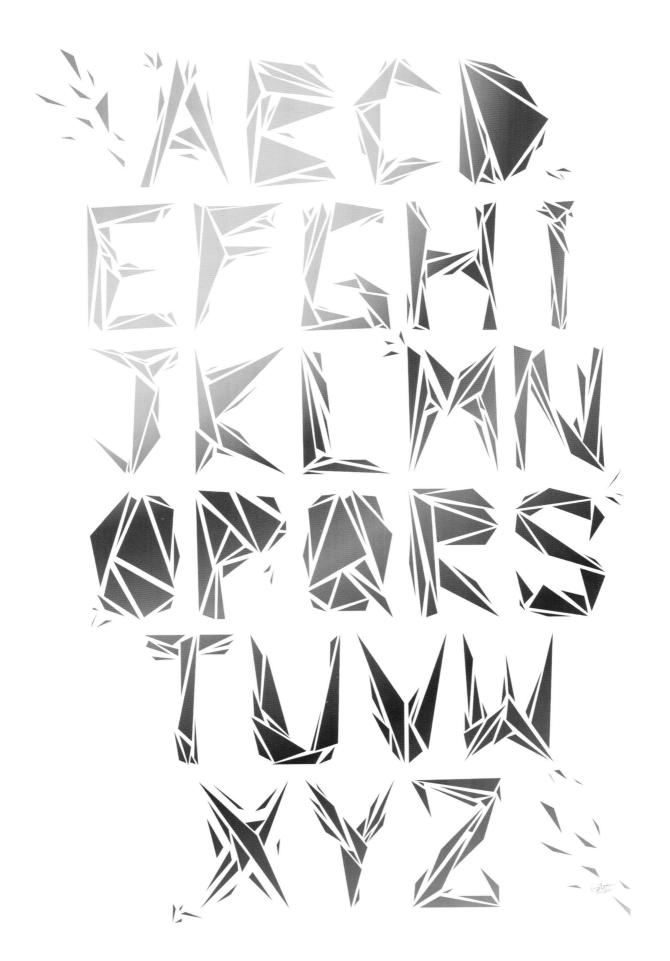

SKET ONE

Long Beach, USA

[instagram] @sket_one

TRACKLIST:

Led Zeppelin - *Physical Graffiti*
Ride - *Going Blank Again*
Hammock - *Raising Your Voice Trying to Stop and Echo*
Diamond D - *Stunts, Blunts, & Hip Hop*
Sammy Dread - *M16*

Sket One, born August 16, 1970, is an American artist. He was raised in New Haven, Connecticut. He started off his artistic career as an American graffiti artist in the 1990s; he created and ran Unitee Clothing, a shirt design company, while looking for full-time work as a designer. He eventually landed a position as creative director for the Silverman Group. Sket began his career as a graffiti artist in the late 80s. In 2003 he started designing toys for toymakers including Superplastic, Kidrobot, 3-D Retro, Red Magic, and more. He has succeeded in exhibiting his custom work in canvases both nationally and internationally in various galleries. He has a passion for uniting distinct components of pop culture into pieces of art that are startlingly cohesive and original. Such innovation has led him to work with Facebook, CBS, Universal Music, EMI, DC Comics, Ford, Toyota, Coca-Cola, Warner Bros., Zoo York Skateboards, and more.

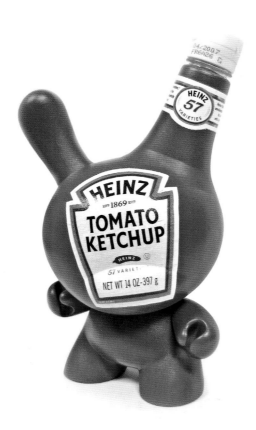

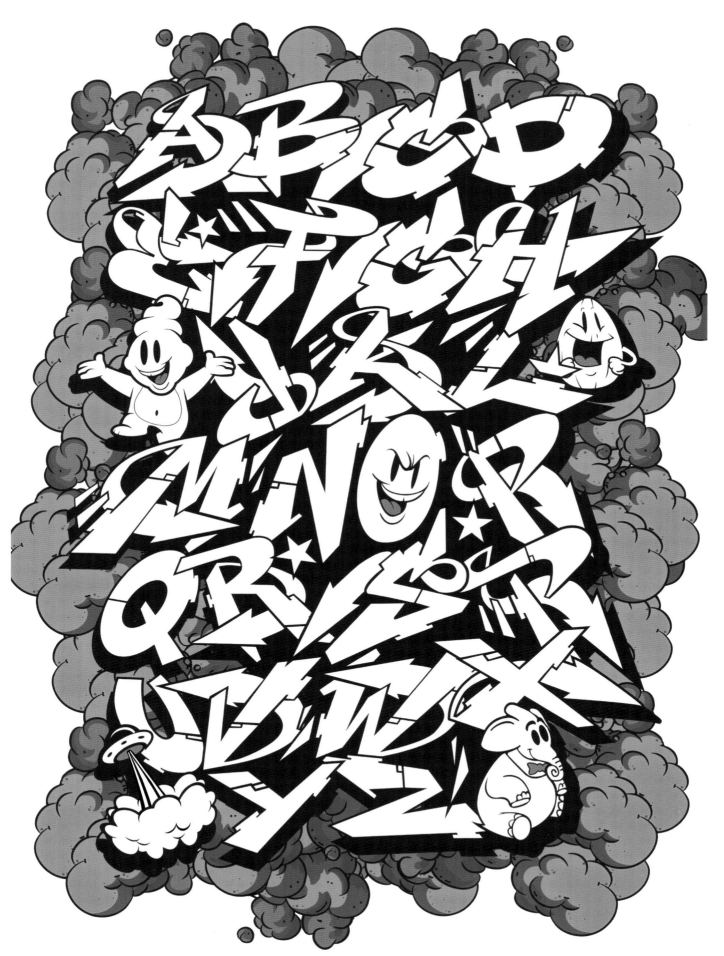

SKORP

Pontorson, France

@skorp_drawings

TRACKLIST:
Studio Ghibli OST
Fleetwood Mac - *Dreams*
Myd - *The Sun*
Yuksek, Polo & Pan - *Cadenza*
Samaran - *Paris Madness*

Gérald Nguyễn Pigeon, aka Skorp, is a Franch illustrator and graphic designer with retro, geek, and cultural urban influences. Gérald grew up in Caen and did the local art school: Brassart. He likes to play with pop culture. He needs to start new challenges, which is how he went from paper to wall to digital art. Being one of the young guns of ARTtitude, a collective of international artists from pop culture, he's had the opportunity to collaborate on Paris Games Week, Biome Skateboard, Bethesda, Microsoft, and Capcom. Entering the collective allowed him to officially work for brands and video games he loves. This was the first big step of his young but promising carreer. He also loves nature, running, and riding his bike outside. In short, Skorp likes to say that he is an illustrator, designer, and a gamer.

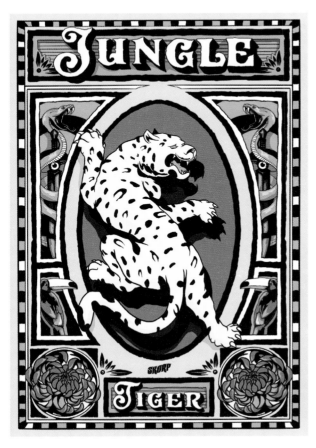

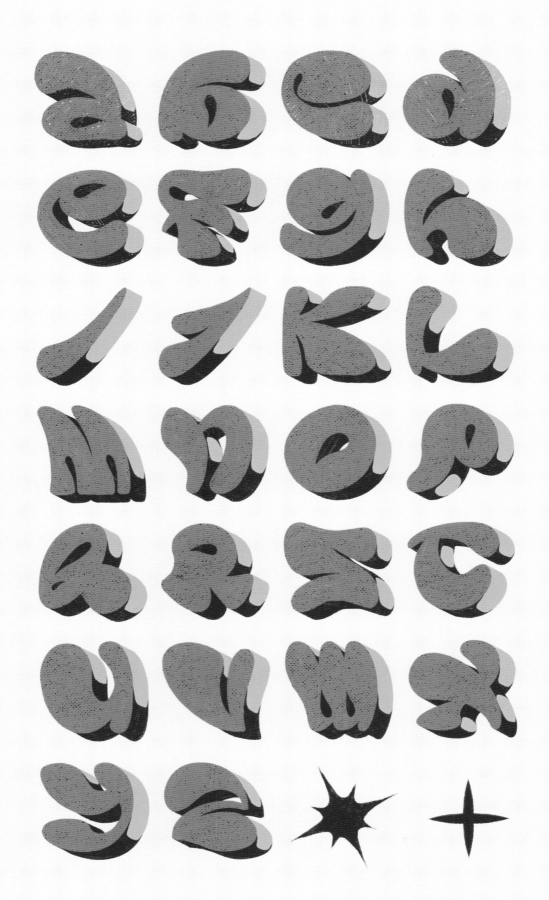

©Zamojski Barthélémy

SNEK

Grenoble, France

@snek_graffiti_and_calligraphy

TRACKLIST:

Akhenaton - *Métèque et Mat*
Shurik'n - *Où je vis*
Oxmo Puccino - *Opera Puccino*
Scred Connexion - *Ni vu ... Ni connu ...*
NWA - *Straight Outta Compton*

Marc-Alexandre Pisicchio, aka Snek, Originally from Grenoble, he has always been drawn to the artistic world and to graffiti in particular. Self-taught and passionate about mural painting, he has been crafting his art for over ten years both in France and abroad. After acquiring solid skills in specialized craftsmanship in woodworking trades, Snek decided to make his artistic career his main professional activity. His graphic universe is recognizable by his realistic portraits and his calligraphy, which come to life according to his desires and the subjects that inspire him. This universe is expressed during huge art sessions in festivals, individual shows, or group exhibitions. In a constant search for evolution, Marc-Alexandre likes to exercise different styles and techniques to create his works, both on canvas and in murals. At the beginning of 2019, he created Mural Studio, a company with Étien, in order to respond to clients looking for XXL-sized murals.

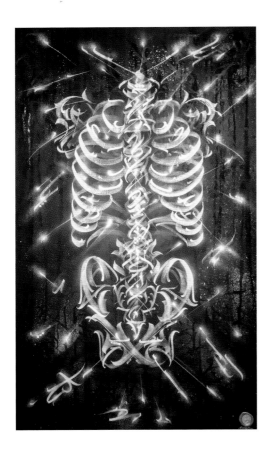

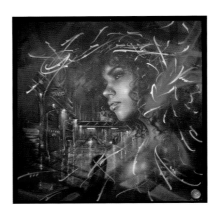

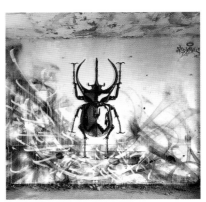

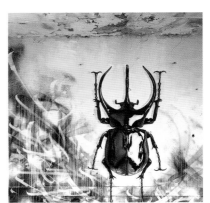

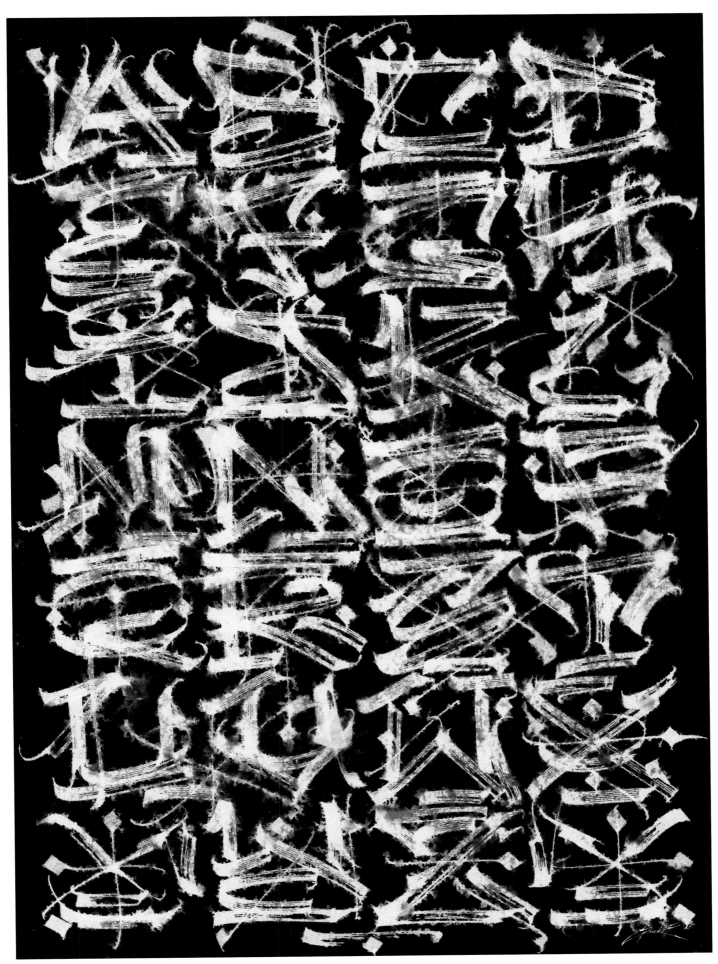

SOLO CINK

Brussels, Belgium

 @solo_cink

TRACKLIST:
Ill Bill & Vinnie Paz - *Heavy Metal Kings*
Madlib - *Beat Konducta Vol. 3 & 4: In india*
Amon Tobin - *Foley Room*
Nicola Cruz - *Siku Reworks*
Eight Lamas from Drepung - *Tibetan Sacred Temple Music*

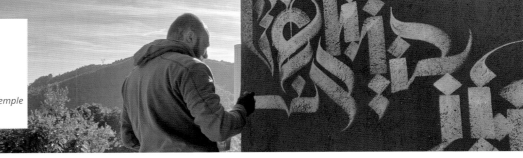

Belgian artist Solo Cink comes from graffiti. His travels quickly led him to discover calligraphy. He appropriated it in a very personal way. The power of his work is in balance, which marks its productions and its mastery in the composition of geometric shapes. His motives then appear with great symbolic, even sacred, force. His work, however, follows the inspiration of the place where it intervenes. It then arises from a complex and detailed universe, a cleverly organized chaos, or in other cases, with equal force, a more austere and somber inspiration, absolutely minimalist. Never abstract, his works are always imbued with meaning.

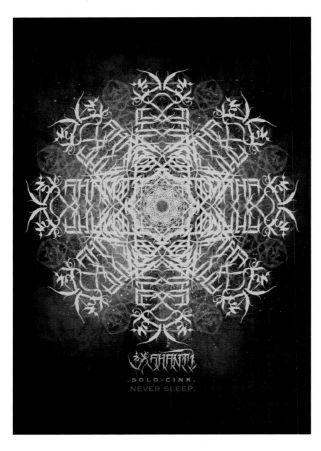

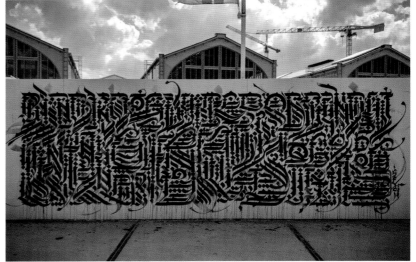

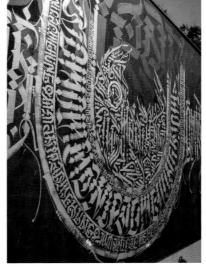

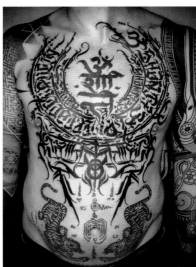

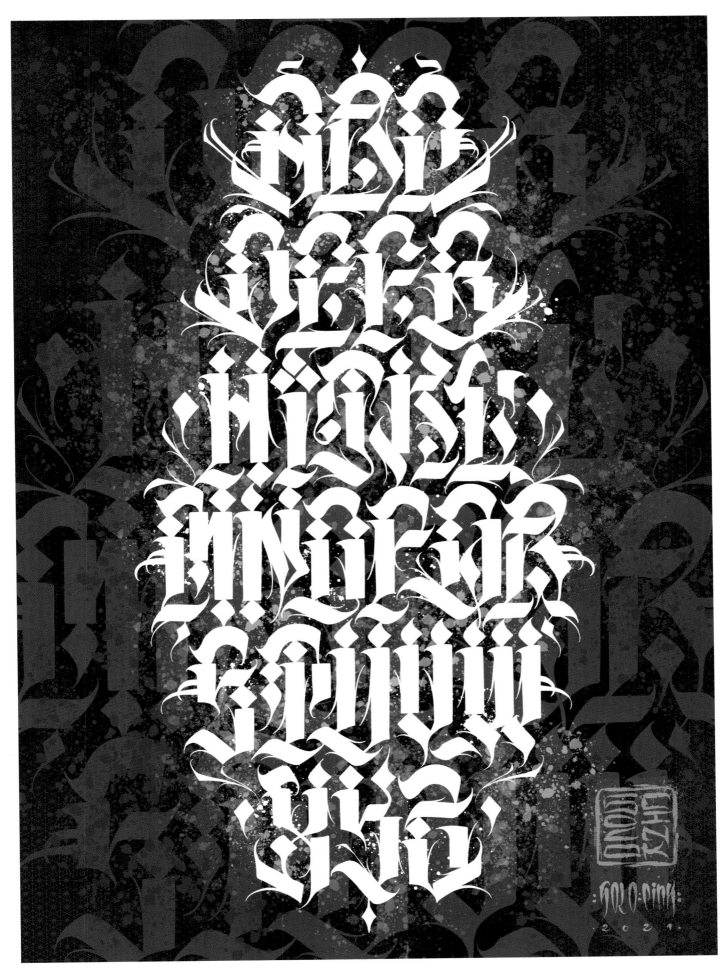

STÉPHANE CARICONDO

Bordeaux, France
@carricondostephane

TRACKLIST:
A Tribe Called Quest - *People's Instinctive Travels and the Paths of Rhyhtm*
Las hermanas caronni - *Navega Mundos*
Dhafer Youssef - *Sounds of Mirrors*
Miles Davis - *Kind of Blue*
Gabin Dabiré - *Kontome*

Linked to a creative process that he seeks to be free and spontaneous, Stéphane Carricondo's work echoes the powerful forms of the primitive arts in its broadest definition. Attached to the energies that build our relationships with the World and the Other, his spirituality, readable under its lines, undoubtedly evokes his primary need to deal with universal laws: we are all beings of vibratory energy, where the information is energy that vibrates and moves freely. His art is the work of an introspective feeling that he considers necessary. Observer of a society increasingly detached from the values of sharing, union, and exchange, his plastic vocation is of the order of a practice essential to the mental balance of our distracted and polluted brains. This approach is reflected in other aspects of his life, for he is a founding member of a collective of artists, the 9th Concept, evolving since the 1990s for and through others. Since friendship is essential to his way of life, it is with his two lifelong friends and artists, Ned and Jerk 45, that he has accomplished the feat of evolving together and bringing to life for more than 30 years a group made up of diverse individuals at the service of art and the public. Always seeking to disseminate his insatiable desire to unite and share, he has been involved since 2018 with the Desperados Foundation for Urban Art as an expert in the field and artistic director.

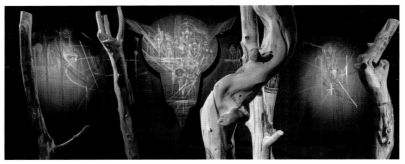

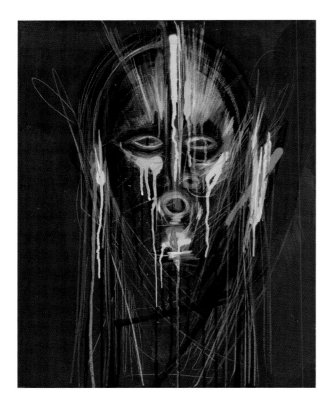

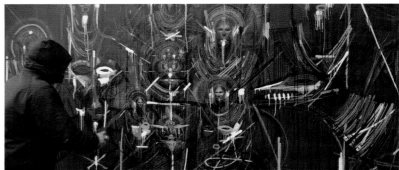

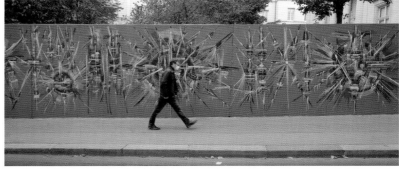

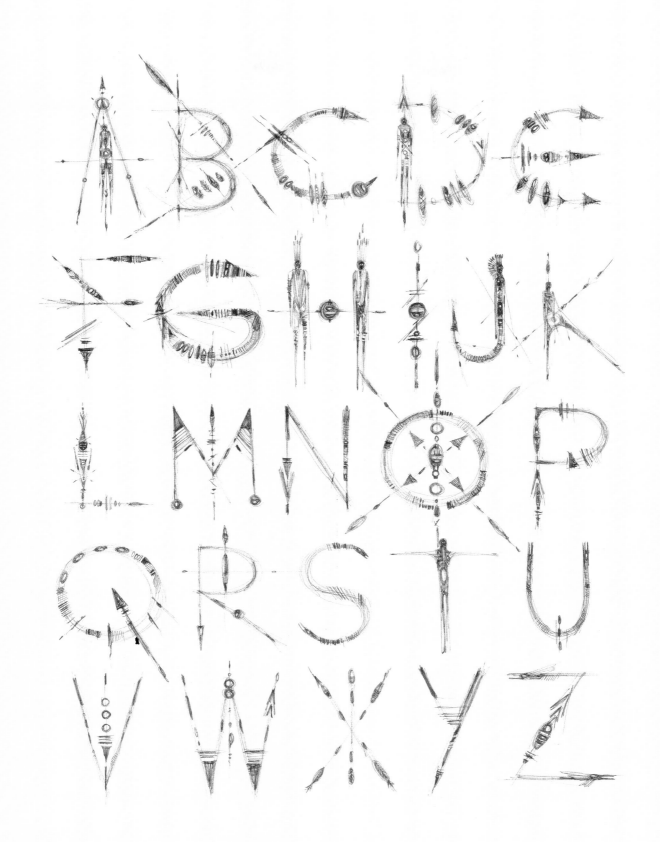

TAREK BENAOUM

Marseille, France

[instagram] @tarekbenaoum

TRACKLIST:
Lunatic - *Mauvais oeil*
Kas:St - *Road to Nowhere*
Arnaud Rebotini - *Music Components*
Pop Smoke - *Meet the Who*
Nicolas Jaar - *Space Is Only Noise*

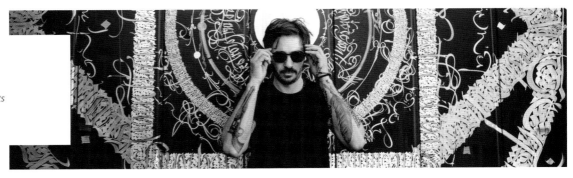

Captivated by the graffiti wave at the dawn of the 90s, Tarek manifests the need for express freely. At the age of 14, with a spray paint can in his hand, he devoted himself to this art that from then on will never leave him. As he explores this path he turns to calligraphy, which he considers to be a continuity inherent in his passion for Scripture (letters, lettering, etc.). This training, at Scriptorium in Toulouse, for four years, allowed him to explore other means of speaking out. Tarek then put his weapons to the test through Latin calligraphy courses (calligraphy, writing, and typography). In addition, he received the teachings of renowned professors. His playground: public places, city murals, hotel, restaurants, night clubs . . . Everything that looks directly at itself, appealing to the words of each and everyone (love, violence, experience, happiness, life, sex, music). His expression: broken words; phrases, quotes, texts, poems, aphorisms: a universe takes shape in new spaces. Tarek explores a semantic scrambling, unconventional and innovative. Indeed, his art highlights the dilution of time by a technique of embedding letters and words, overlays, vertical stretching, horizontal: a wavy photo. In this way, his know-how transposes and transcends the codes of calligraphy—revisited, inscribed, and renewed. His postulate: to use scriptures, calligraphy, and typography as a decorative medium in its own right. Artistically this allows him to push the limits of an academic vision.

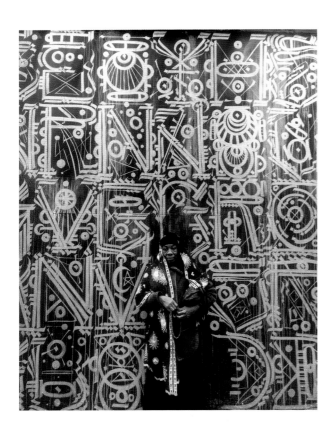

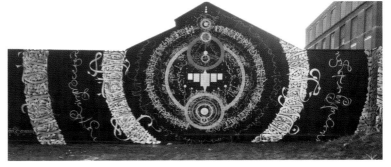

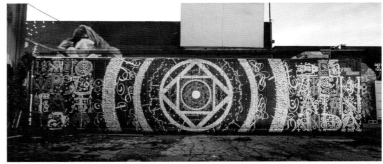

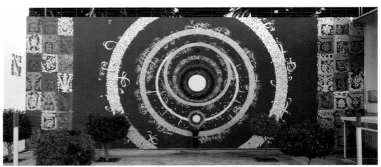

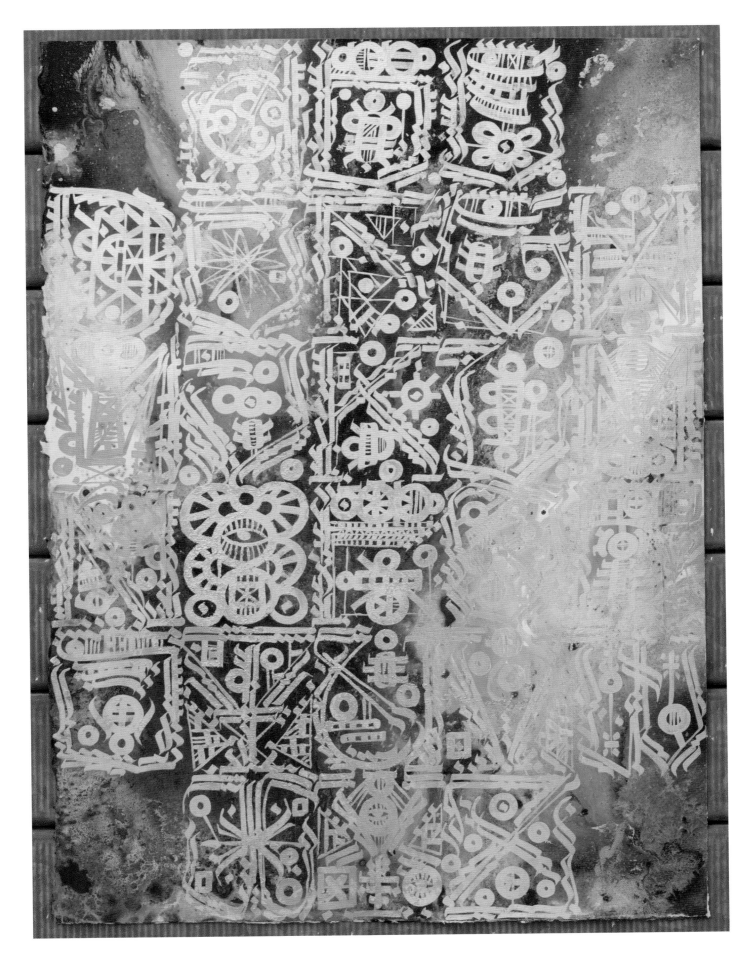

TASHI MANNOX

Hay-on-Wye, Great Britain

@tashimannox

The name Tashi Mannox represents both the Eastern and Western artistic disciplines in his 40-year journey as a painter and calligrapher. Born British to an Irish family named Mannox, at the age of 22 he became a Buddhist monk of the Tibetan Kagyu order, receiving the name Tashi. During his 17 years as a monk Tashi apprenticed with some of the greatest masters of Tibetan art and Buddhist philosophy. The groundwork of his calligraphic discipline was established as a scribe while copying ancient Tibetan manuscripts. Since laying down his monastic robes at the turn of the millennium, Tashi has built on his disciplined training and meditative approach to produce a substantial body of calligraphy and iconography artworks, which are currently exhibited across the globe, from the US to Bhutan. At its foundation, Tashi's practice is a vehicle to communicate and transmit Buddha dharma, while adapting and updating his approach within and for a contemporary context of dharma art. His practice also serves to help preserve the Tibetan written language and the multiple traditional script styles therein. Tashi teaches and leads workshops worldwide to keep such traditions alive. He is also a published author on this speciality.

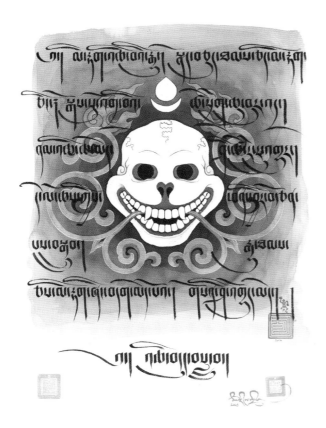

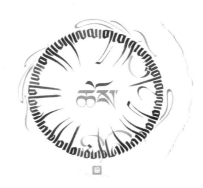

THE DARK INKER

Brighton, United Kingdom

(i) @thedarkinker

Born in east London, Stephen Sampson lives with his wife Becky and crazy cat Haku on the south coast of England. A comics artist, mainly illustrator for 2000AD - Judge Dread, Stephen has now moved into the mobile gaming industry as an illustrator and concept artist. As with his stint in the comic book industry, let's not pretend: one of his latest games is CSR Racing from Natural Motion. The game has already been downloaded several million times. Stephen does not abandon pop culture any less since he is part of several collectives, including the famous Poster Posse. The works he offers are beautiful and his interpretation of films is truly original. If you had to sum up his karma in one sentence: Stephen wakes up every day with the good fortune to be able to make a living doing what he loves most. And that is priceless.

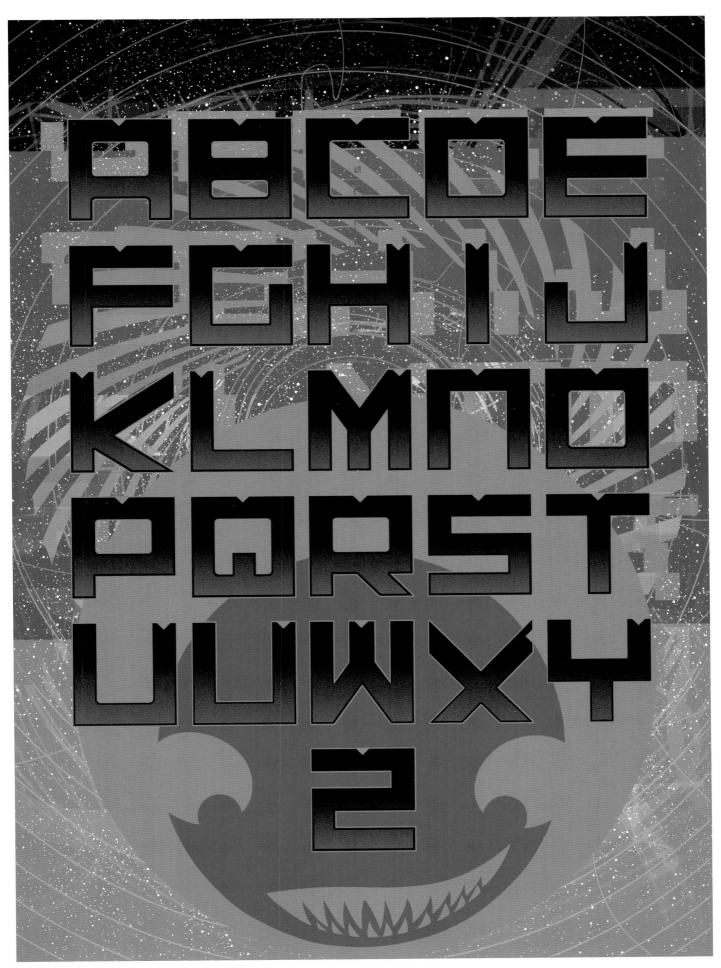

TOM RYAN'S STUDIO

TOM RYAN

Torrington, USA

@tomryansstudio

The name is Tom Ryan, and he's just your friendly neighborhood geeky artist. He's a Connecticut-based artist who is inspired by comics, street art, pop culture, video games, and anything geeky. Tom would say that his art is a combination of all the things he loves, past and present. His paintings consist of fantastical animals with a "street art" feel, brought to life using bright, vivid colors and bold line work. His graphic design work, including art prints, skateboards, and enamel pins, is largely based on nostalgia. He draws inspiration from old gig posters and he enjoys combining that look and 1980s pop culture references along with some epic video games. As a freelance artist his art and pins have been sold worldwide. He's also a graphic designer who has done professional work in corporation logos, restaurants, and of course Beer Cans (check out Mispillion River Brewing in Milford, Delaware). You can find more of his art on all social media or Tom Ryan's Studio. As he says: always be safe, be kind, and get your geek on!

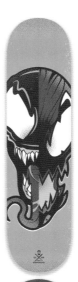

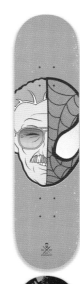

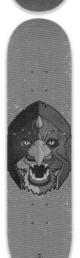

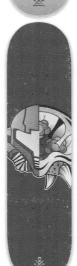

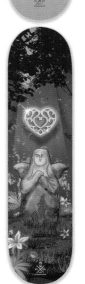

ABCDEFG
HIJKLMN
OPQRSTU
VWXY+Z

TRES

Caserta, Italy
@tony_tres

TRACKLIST:
Peter Tosh - *Can't Blame the Youth*
Donald Faghen - *The Nighftly*
Erykah Badu - *Mama's Gun*
Public Enemy - *Fear of the Black Planet*
Tormento & Primo - *El micro de oro*

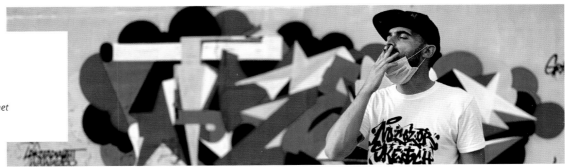

TRES, a writer and artist, was born in 1980 and has been active since the early 2000s. He is a member of two important collectives active in the cities of Caserta and Naples. He graduated with a degree in conservation of cultural heritage in 2007. His studies and his work direct him toward a path that will mark his approach to artistic works, mainly linked to lettering, with scrupulous and methodical action, made of constant analysis and research. In 2010 his documentary passion led him to conceive and artistically handle the production of a catalog with works by artists from all over the world. The catalog showcases a fundamental part of the artistic production, the preparatory drawing, which highlights the profound research that is hidden behind an art form that by its nature seems made of improvisation due to a communicative urgency. This curatorial work gave birth to a research laboratory that borrows the name from the catalog, No Color Sketch. It has been carrying out this research work at events, schools, and art happenings since 2010 with the involvement of numerous international artists. In 2019 an open and monographic project called Style diary began, in which the study methods of the individual artists are analyzed. After the long work contract, TRES devoted himself completely to art, arriving through a path of subtraction from a personal synthesis between shapes and colors. Thus he began to produce his first works on canvas and his first interventions on large surfaces. Focusing on the details of graffiti, thus began the Macromia project.

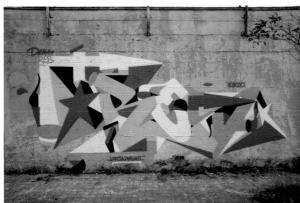

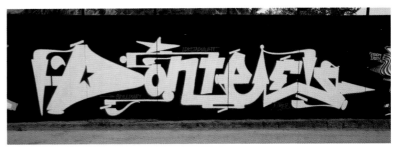

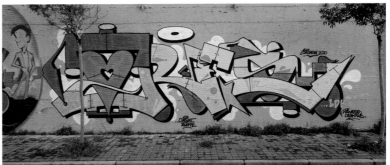

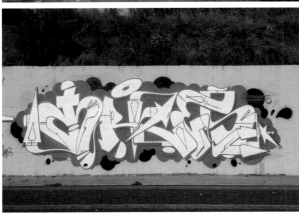

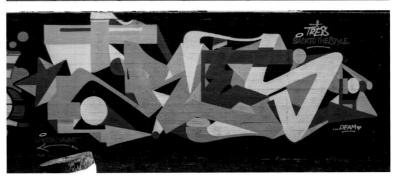

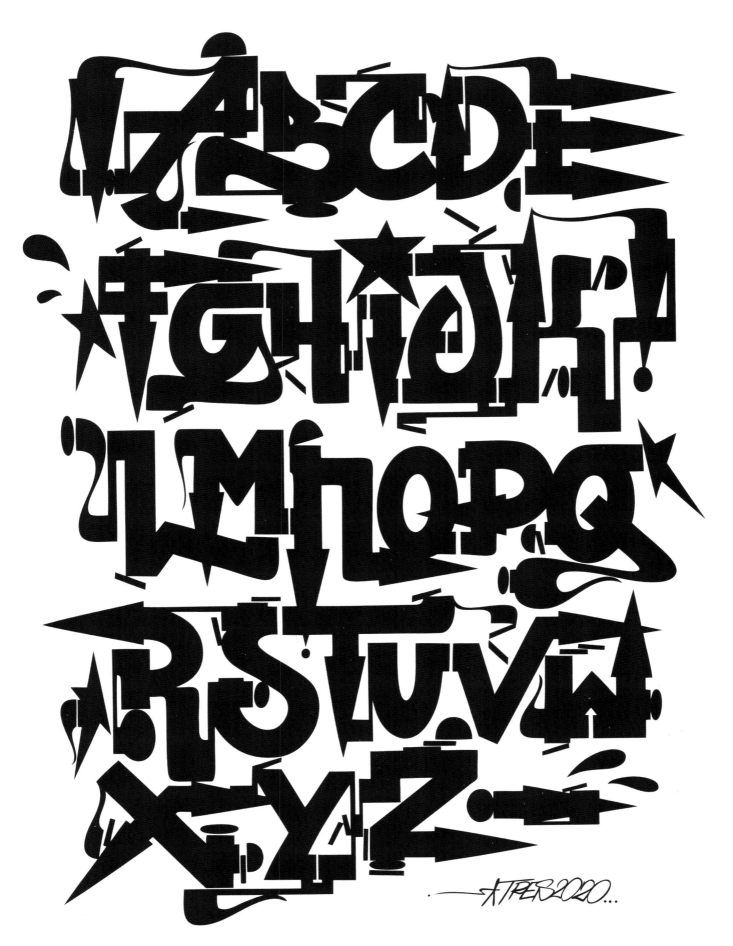

TUSCAN CALLIGRAPHY

Florence, Italy

📷 @tuscan_calligraphy

TRACKLIST:
Opeth - *Ghost of Perdition*
The Black Dahlia Murders - *Nocturnal*
Daft Punk - *Random Access Memories*
Post Malone - *Beerbong and Bentleys*
The Weeknd - *Starboy*

Andrea Pareti, aka Tuscan Calligraphy, was born and raised in a small town near Florence, Italy. He studied graphic design there until 2007. When Andrea was younger, he had a strong passion for electric guitars. He started to play at that time. He spent his whole youth playing alone or with bands. In 2015 he started to study calligraphy and in 2017 he graduated with a focus on tattoo. After attending a lot of tattoo classes he started to organize his own workshops for important calligraphy artists such as Claudio Mezzo, Rossella Manganelli, and Michele Perusin. Andrea is now a tattoo artist resident in one of the best tattoo studios in Florence. With calligraphy he discovered a way to be able to leave a mark, and this evolution has led him to leave his mark on people as well. From hand to paper, from paper to skin.

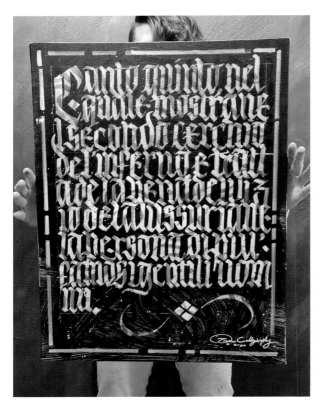

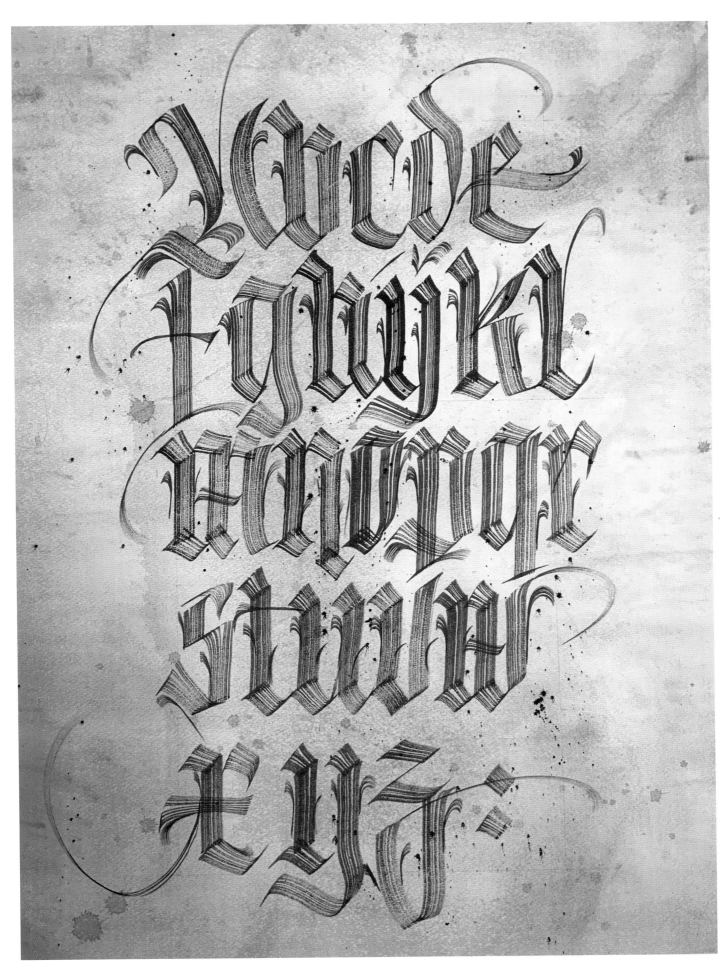

USUGROW
Tokyo, Japan
@usugrow

TRACKLIST:
Peter Tosh - *Can't Blame the Youth*
Donald Fagan - *The Nightfly*
Erykah Badu - *Mama's Gun*
Public Enemy - *Fear of the Black Planet*
Tormento & Primo - *El micro de oro*

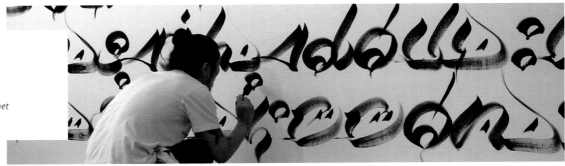

Usugrow began his artistic activity by creating flyers in the underground punk and hardcore music scene in early 90s. Since then, he has been involved in various album cover designs for bands and musicians regardless of genre, art direction, and merchandising. He has also collaborated with many skateboarding brands and fashion brands. Usugrow expanded the range of his activity and has done several solo exhibition at art galleries in Japan and overseas since 2005; he has also published his first monograph. In addition to his solo shows, he has been curating group exhibition and book projects with Japanese artists since 2009. He currently works on illustration, painting, and calligraphy as well as live painting, collaboration projects with other artists, and three-dimensional artwork.

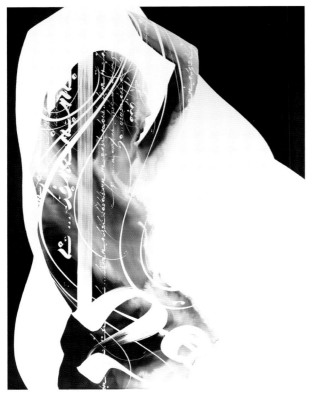

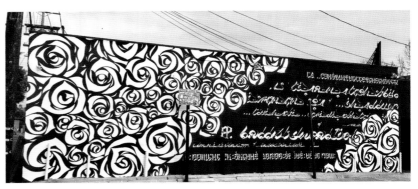

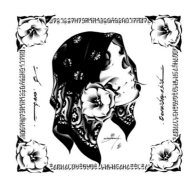

VENUS

Caen, France

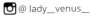 @ lady__venus__

TRACKLIST:
Jedi Mind Tricks - *Servants in Heaven*
Nipsey Hussle - *Victory Lap*
Nefaste - *Dans mon monde*
Young M.A. - *Herstory in the Making*
TSR Crew - *A quoi ça rime?*

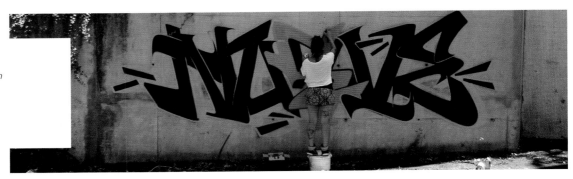

My name is Venus. I am 36 years old and I live in Normandy, near Caen, France. I discovered graffiti through my brother-in-law in 1998 when I was 13 years old. One day he took me to Paris, and when looking at the graffiti, a huge Mars block made me hallucinate. I immediately found the idea of planets interesting. I remember that I had prepared a pocket with sheets and a pen in it; I started to write down all the planets and Venus was obvious. It was quite short, it sounded a bit feminine. It was gone.

I really started painting in 2001 when I was 17. At first I was more vandal-oriented. With my crew at the time, we did no artistic research. We wanted to paint and turn everything over. Over time, and after drawing a lot, I realized that I wanted to evolve. Now a mother of two, I have to say that the vandal has given way to land and other abandoned spots, and that suits me very well.

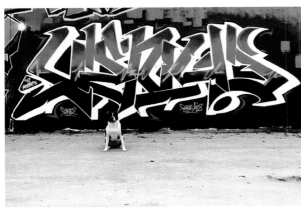

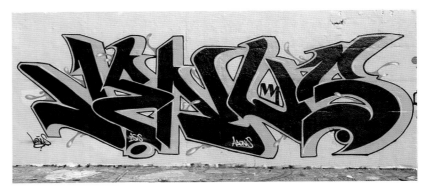

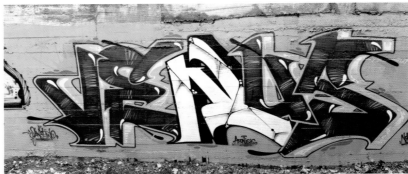

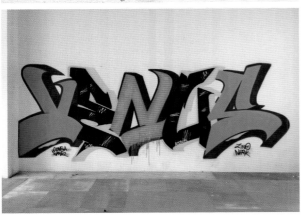

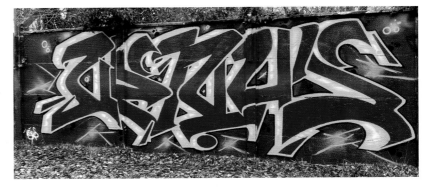

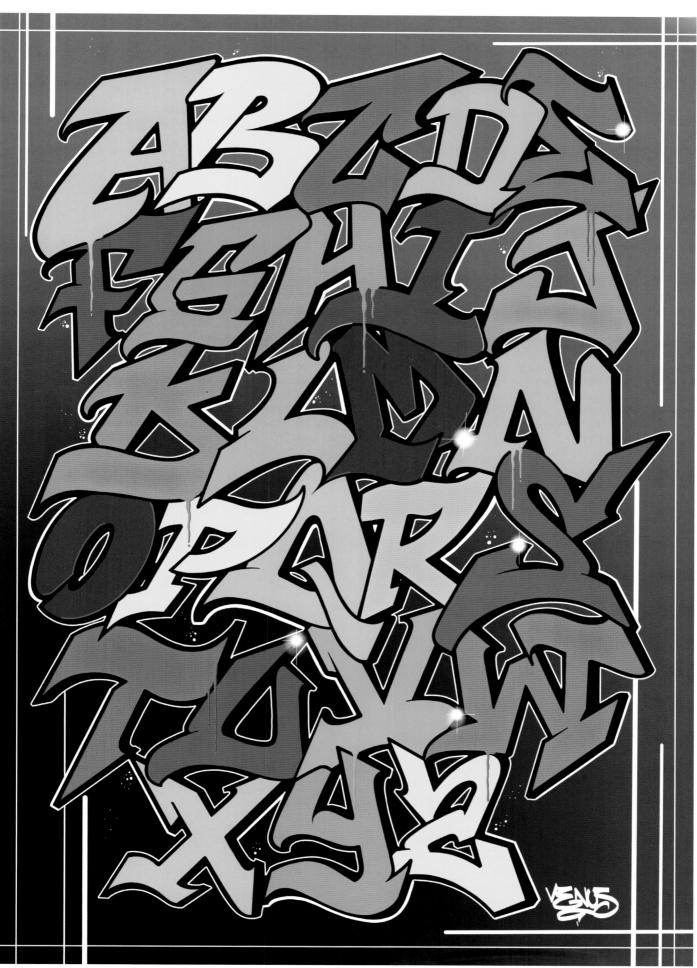

WILL ARGUNAS

Lille, France

 @willargunas

TRACKLIST:
Pink Floyd - *The Wall*
Faith No More - *Angel Dust*
Type O Negative - *October Rust*
Sepultura - *Chaos A.D.*
Bodycount - *Bloodlust*

Born in Lille in 1972, Will decided when he was very young that he would one day be a comic strip designer. So he left to study applied arts in Poitiers after his baccalaureate. He graduated three years later, in the illustration/advertising design section. After having fulfilled his military obligations, he went to Paris. After five years of hardship during which he worked as a cashier handling alongside various small artistic jobs, he ended up working in communication and advertising as a roughman for brand catalogs and as a colorist of roughs and storyboards for advertising films for the great Dominique (Toto) Gelli. At the same time he published his first comic books, first with small publishers, then with Casterman in 2007. His visit to Hellfest in 2009 caused an upheaval in his head and represented a turning point in his life. Indeed, by attacking a long series of portraits of festival-goers at the fest, he realized that we can draw music, not just listen to sound while drawing. So he stopped advertising in 2010 to turn to screenprinting for concerts, then illustration. Will is a fan of big sound, making festival posters, album covers, artworks for rock and metal merch, and covers for the specialized press. He has worked with various publications, and for te, years he's been the artistic director of Radio Metal, the largest media specialized in this kind of music in France. His work gained momentum in 2017 following the publication of eight illustrations made for a book on the world-famous band Ghost. Since 2001 he has published around 25 books.

ABCDE
FGHIJK
LMNOP
QRSTU
VWXYZ

WIPEOUT

Lahr, Germany

📷 @antistatik119

TRACKLIST:

DJ Krush - *People's Kakusei*
Two Fingers - *Stunt Rythms*
Assassin - *L'Homicide Volontaire*
Beastie Boys - *Paul´s Boutique / Check Your Head*
Pendulum - *Hold Your Color*

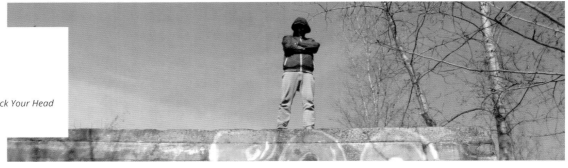

From a purely instinctive approach came the adaptation of the letter to the medium. Tracing should not lose its momentum; on the contrary. It's brutal, bestial. The reflection is done before or after the act, certainly not during. The letter cannot be blocked for having a certain aestheticism or belonging to an artistic discipline. Clone each other. Here is the definition from Wipeout.

Close to the French artist Antistatik, well known for his futuristic approch to graffiti (called the graffuturism movement), he learned a lot through him and the east side French crew Orbit119 as well as with one of the pioneers of the French graffiti scene, Lokiss. Time is not his best friend, but it brings him to search and think about graffiti differently. A lot of work on paper, via sketching, is behind his approach. The words can be minimalist. Go to the essential! Wipeout operates alone, mostly outside, to keep the full freedom and force of this futuristic wildstyle creation. He likes to keep his work in the real world, writing, riding, rolling, traveling through Europe.

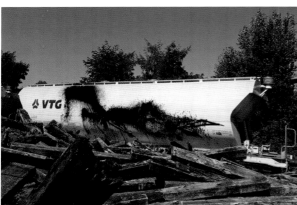

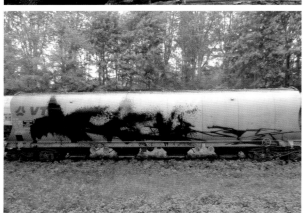

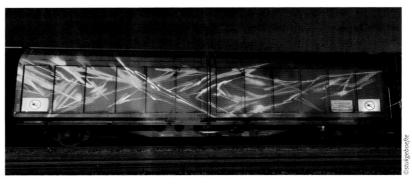

©stukgeboefte

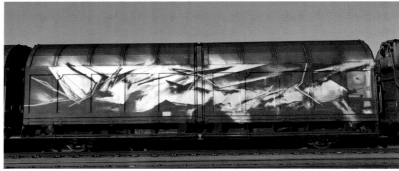

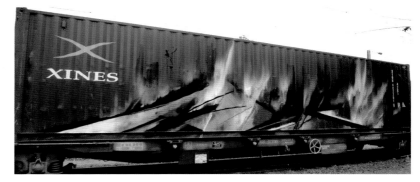

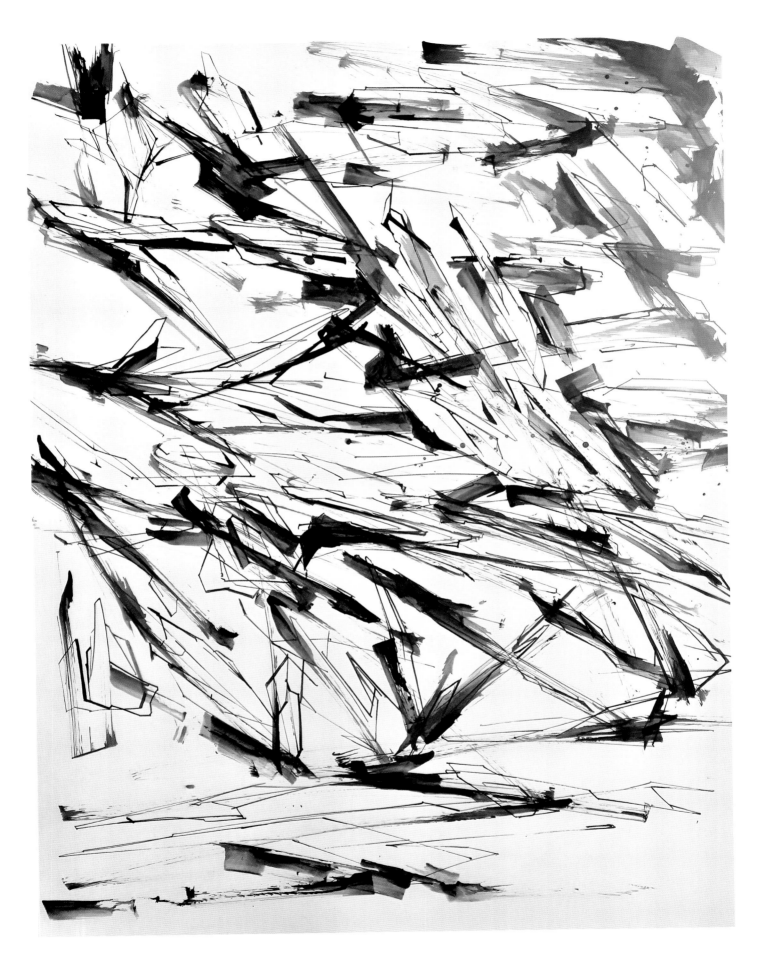

YOME

Paris, France

@yomeone

TRACKLIST:

Snoop Dogg - *From Da Streets to Da Suite*
Jóhann Jóhannsson - *Sicario Soundtrack*
Mokadelic - *Gomorra*
Pac-Man - *Da Gunman My Section*
Cng - *Detour*

Yome was born at the end of the 1970s in the western suburbs of Paris. Before finding his own personal inspiration, it was his grandfather Jacques Bracquemond who taught him the basics of drawing and calligraphy. It is a perpetual tribute that Yome pays to his grandfather and his family in each of his works. As a teenager he discovered the world of hip-hop and especially the world of graffiti, which will never leave him. Between 1994 and 1998, it was with his hands full of paint that he tried his hand on the walls of various cities. In 2008 Yome officially became a member of the VMD group and increased collaborations with artists from the collective. Over time, he perfected his style and took the path of classic American graphic art. New York is a strong influence for Yome, who makes the Big Apple his new hometown. After all these years in the world of graffiti, Yome wants to perpetuate the family tradition and its know-how to integrate it into another art form: tattooing. He seeks to find a balance between graffiti—the engraving—and the graphic style in black and to develop what he calls Yomism. The goal behind his pieces is to have a strong identity, with his style mixing all his universes and inspirations, which would identify him at first glance. In 2015 he opened his own tattoo studio in Paris: Ravenink Tattoo Club.

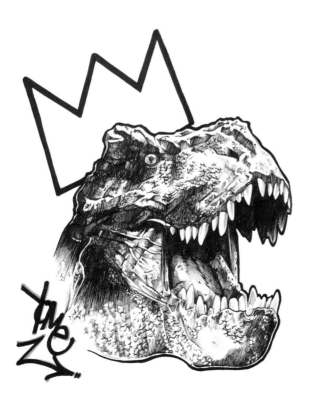

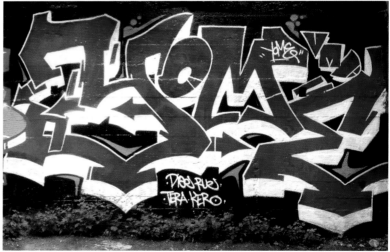

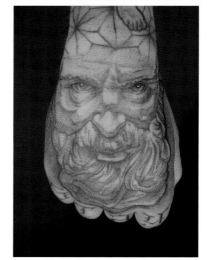

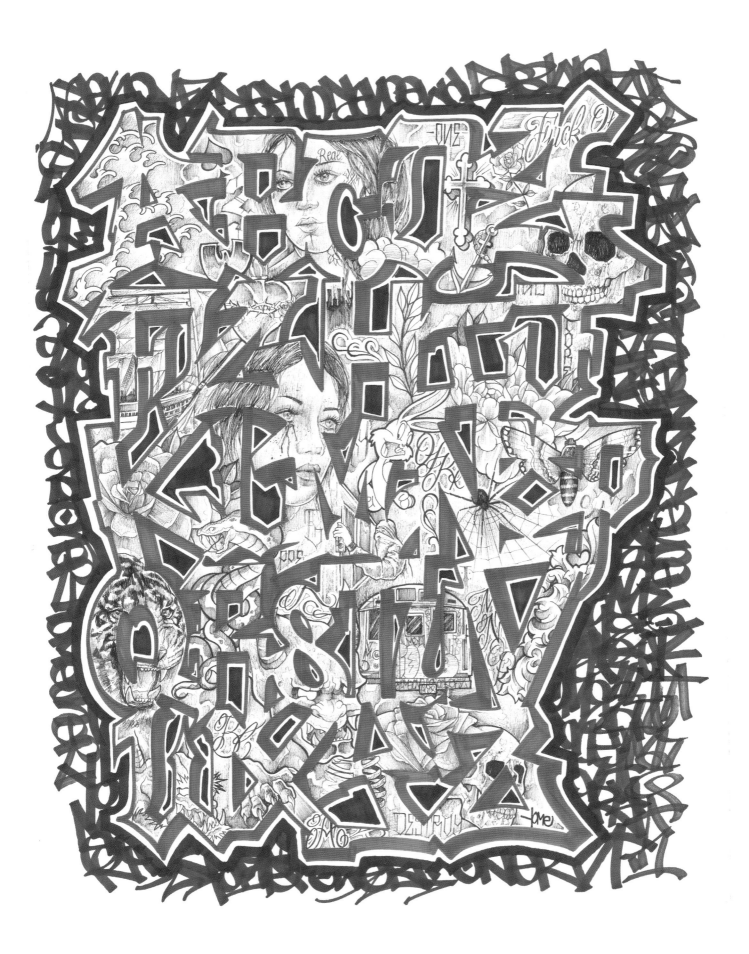

ZEUS40

Naples, Italy

@zeus40_wb_vmd

TRACKLIST:
Run The Jewels - *RTJ4*
Afrika Bambaataa - *The Light*
Anderson Paak - *Malibu*
Travis Scott - *Astroworld*
Grace Jones - *Nightclubbing*

Luca "Zeus40" Caputo was born in Naples on February 8, 1980. He began painting in 2000 when, fascinated by the graffiti surrounding the outskirts of his city, he decided to follow in the footsteps of the great writers of his region. In the early years he was strongly inspired by the New York wildstyle, but with constant and in-depth study he managed to move away from the classic standards, developing an innovative and personal lettering. During these years he was a guest at the most important graffiti events, exhibited in various international exhibitions, and painted at the XIII Biennial of young European artists; one of his works is installed inside the building of the Youth Department of the Council of Ministers. He is a member of the Bereshit cultural association, which carries out many urban restyling interventions and organizes writing workshops for the diffusion of aerosol cultures. In 2014 he was one of the protagonists of the documentary *Naples, l'absurde et la grace* for the French broadcaster France3. He subsequently collaborated with Belton Molotow, one of the largest spray-producing companies in the world, which chose him as its spokesperson. In 2018 he started working on large surfaces and created three large-scale murals in Naples.

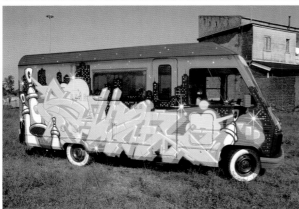

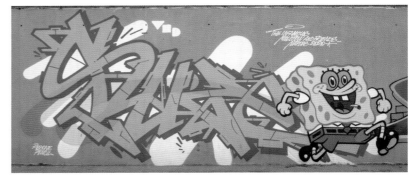

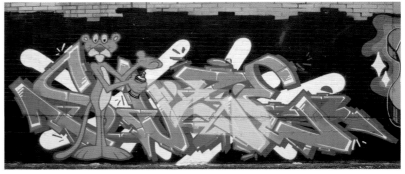

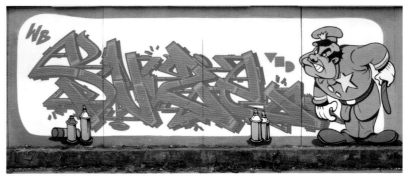

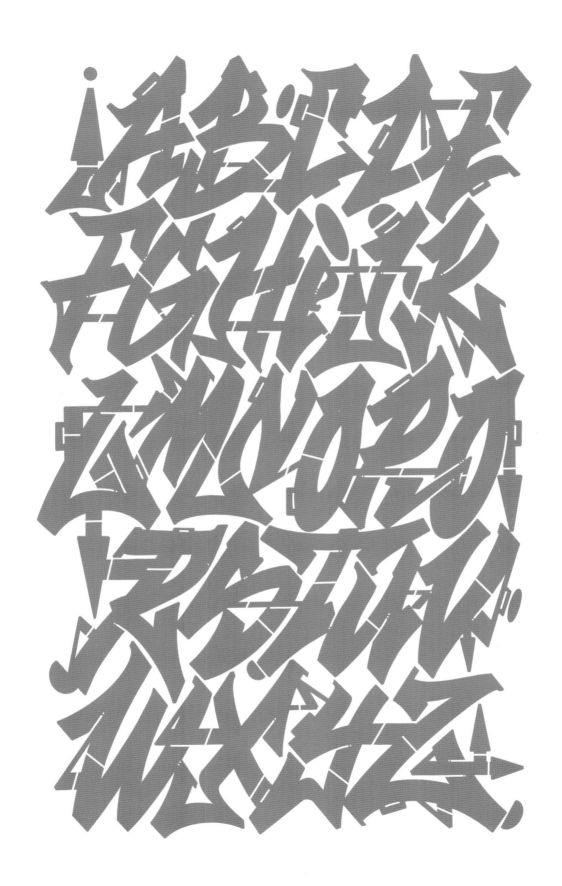

PARTNERS OF PUBLIC DOMAIN

ACKNOWLEDGMENTS
Pete Schiffer, Gareth Dummer, Lee Jones, Stéphane Helbert, Odile Miel, Caroline Côte, Baptiste Claquin, Stéphane Longeard, William Chiriaux, Soraya Marquez, all the artists involved in this art book, all the artists form the ARTtitude collective, SELL, Paris Games Week

CREDITS
Public Domain is a registered trademark of Frédéric Claquin & Plan9 Entertainment
ARTtitude is a European Registered trademark
Public Domain / ARTtitude: www.publicdomain.paris
Curator: Frédéric Claquin
Art Director: Simon Delart
Cover Artwork : Pierroked

ADDITIONAL CREDITS
Deuzoner's profile picture : TCM photographie
Edge's profile picture : Marlène Boulad
Etien' : Murals by aerodrone alpes
Wipeout's profile picture : @stukgeboefte
Ned's bio: Renaud Faroux (extract)
Urban Lord's porfile picture : Céline Troffigué

OTHER SCHIFFER BOOKS BY THE AUTHOR:

ARTtitude, ISBN 978-0-7643-4628-6

ARTtitude 2, ISBN 978-0-7643-4795-5

PosterSpy: Alternative Movie Poster Collection, ISBN 978-0-7643-5475-5

SCHIFFER BOOKS ON RELATED SUBJECTS:

An Introduction to Calligraphy, Véronique Sabard, Vincent Geneslay, and Laurent Rébéna, ISBN 978-0-7643-5230-0

Tattoo Lettering & Banners, Britt Johansson, ISBN 978-0-7643-5215-7

100 New York Calligraphers, Cynthia Maris Dantzic, ISBN 978-0-7643-4898-3

Copyright © 2022 by Frédéric Claquin

Library of Congress Control Number: 2021945825

Production design by Christopher Bower
Cover design by Justin Watkinson
Type set in Catamaran/Open Sans

ISBN: 978-0-7643-6415-0

Printed in India

Published by Schiffer Publishing, Ltd.
4880 Lower Valley Road
Atglen, PA 19310
Phone: (610) 593-1777; Fax: (610) 593-2002
E-mail: Info@schifferbooks.com
Web: www.schifferbooks.com

For our complete selection of fine books on this and related subjects, please visit our website at www.schifferbooks.com. You may also write for a free catalog.

Schiffer Publishing's titles are available at special discounts for bulk purchases for sales promotions or premiums. Special editions, including personalized covers, corporate imprints, and excerpts, can be created in large quantities for special needs. For more information, contact the publisher.